FOCUS ON PHOTOGRAPHY

Ron Graham and Virginia Bolton

Hodder & Stoughton
LONDON SYDNEY AUCKLAND TORONTO

ISBN 0 340 48707 0

First published in Great Britain 1990

© 1990 Ron Graham and Virginia Bolton

Typeset by Keyset Composition, Colchester
Printed in Hong Kong for Hodder and Stoughton Educational, a
division of Hodder and Stoughton Ltd, Mill Road, Dunton Green,
Sevenoaks, Kent, by Wing King Tong Ltd.

Contents

ACKNOWLEDGEMENTS

The publishers would like to thank the following for their kind permission to reproduce photographs in this volume:

The University of Texas/Musée Nicéphore Niépce (Fig. 1.3); Collection Société Française de Photographie, Paris (Fig. 1.4); The Fox Talbot Collection, Science Museum, London (Figs. 1.5, 1.9); The Royal Photographic Society, Bath (Figs. 1.6, 1.8, 1.12, 1.13, 1.14, 1.15(a), 1.15(b), 1.16(a–c), 1.17, 1.19(a), 1.19(b), 1.20, 1.21(a), 1.21(b), 1.21(c), 1.22, 1.32); International Museum of Photography at George Eastman House (Fig. 1.18); Victoria and Albert Museum, London/© 1981 Arizona Board of Regents, Center for Creative Photography, Arizona (Fig. 1.24); The Royal Photographic Society, Bath/ copyright © by the Trustees of The Ansel Adams Publishing Rights Trust. All rights reserved (Figs. 1.25, 1.26, 4.7); Victoria and Albert Museum, London/by permission of Nora Brandt © 1989 (Figs. 1.27, 4.12, 4.15); The Royal Photographic Society, Bath/Angus McBean (Fig. 1.28); Library of Congress, Washington, DC (Fig. 1.29); Magnum Photos Ltd/© Robert Capa (Fig. 1.30); Victoria and Albert Museum, London (Fig. 1.31); Harold E. Edgerton, MIT (Fig. 1.34); Victoria and Albert Museum, London/Andreas Feininger (Fig. 4.11); Magnum Photos Ltd (Fig. 4.13); The Royal Photographic Society, Bath/ Madame Halsman (Fig. 4.14); Eamonn McCabe (Fig. 4.16); John Hillelson Agency/© Ernst Haas (Fig. 4.17); Magnum Photos Ltd/© Chris Steele-Perkins (Figs. A1, A.2); Mr Max Scheler/PPS Galerie, Hamburg (front cover).

1

The History of Photography

'Photography is a fine art?!' exclaimed a well-known painter. 'Why, it is entirely dependent on camera and chemicals.' 'In like manner,' rejoined Fenton, 'as the painter is dependent on pencils, colours and canvas.'

(Roger Fenton, 1819–1869)

Photo: Virginia Bolton

INTRODUCTION

Before the invention of photography in 1839, image-making was available only to those lucky few with the artistic ability to create images, both real and imaginary, with the use of paints, clay and other traditional art materials.

Photography mechanised the image-making process and made it available to the world at large. The manufacture and availability of these images have become cheaper and easier over the years, and nowadays nearly every home has at least one camera. And with the application of this new imagery for practical, personal and artistic purposes, photography has now become an important part of contemporary life.

In this chapter, we will look at the evolution of photography, its innovators and its users, and see how the advancement of the technology has been interwoven with its application by photographers both past and present.

EARLY HISTORY: THE KEY INITIATIVES

Photography was born of the fusion of two separate developments: one in chemistry (the discovery that silver salts were photosensitive had been made by Johann Schulze, a German physicist, in 1725), and the other in optical science, namely the camera obscura.

The camera obscura had evolved since ancient Greek and Roman times and during the Middle Ages was used by Arab scholars to observe the sun. A tiny hole in a darkened room could provide images of the outside world. When these images were projected on to a white screen, they could be traced by hand (see Fig. 1.1) and even though they were upside down and reversed left to right, they were

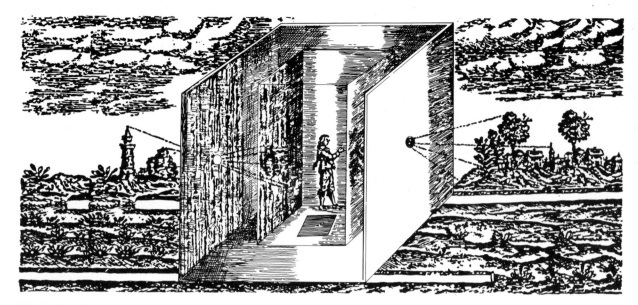

Fig. 1.1 Portable camera obscura, *c.* 1646.

considered remarkable nonetheless.

With the flowering of the Italian Renaissance in the sixteenth century, the camera obscura filled a labour-saving need. Reduced in size, this portable box, now complete with lens, focusing mechanism and a mirror to project the image upwards on to a tracing screen, was a useful aid to artists concerned with the new concept of linear perspective (Fig. 1.2).

It seems strange that by the mid-eighteenth

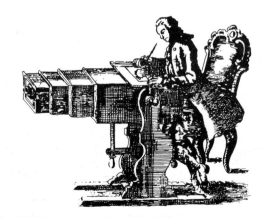

Fig. 1.2 Table camera obscura, *c.* 1769.

century the chemical and optical requirements for photography were known but it was not until one hundred years later that progress towards the invention of a practical working process began to be made.

At the end of the eighteenth century, Thomas Wedgwood experimented with silver chloride on leather and paper. He succeeded in producing contact images of leaves on exposure to sunlight, but he was unable to fix his attractive 'photograms' and he failed in his goal to record images from a camera obscura. Meanwhile, in France, Joseph Nicéphore Niépce had been experimenting with lithography (a method of printing directly from a flat surface), which led him to investigate photography. In 1816, using silver chloride sensitised paper and a camera obscura, he succeeded in recording a view from his attic window. However, due to the reversed tones of the negative image which appeared strange to Niépce, he was dissatisfied and turned to other methods. Little did he know how close he had been to finding the key to photography; he had a negative which needed only to be printed on to similar paper to form a positive, but he let this chance slip away.

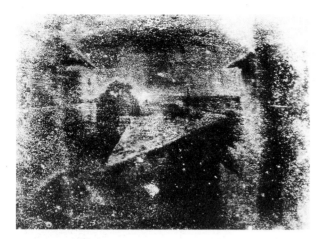

Fig. 1.3 Nicéphore Niépce: First successful photograph from nature, 1826–27.

As a lithographer, Niépce sought a positive image for direct printing and years later his patience was rewarded by the discovery of a process he named 'heliography'. This involved the coating of a pewter plate with Bitumen of Judea. This 'emulsion' hardened on exposure to light and unexposed areas were then washed away with a mixture of oil of lavender and white petroleum, leaving a permanent image. Using this process in 1827, Niépce produced the first photograph from nature, a scene of a courtyard at his home in Le Gras (Fig. 1.3). Taken in a camera obscura with an exposure of eight hours' duration, the image shows shadows on both sides of the yard at once – a visual record of the sun's movement during the day. Heliography worked, but the lengthy exposures necessary to record a visible image made it impractical.

The most important partnership in the history of photography began in 1829; Niépce joined forces with Louis Jacques Mandé Daguerre, a fellow Frenchman. Daguerre was the creator of the Diorama in Paris in 1822. This was a vast panoramic light-show, involving large painted backdrops – a popular entertainment spectacle in its time. It was the time-consuming task of transferring drawings made with a camera obscura on to the large screens that led Daguerre to dream up a way of making these images record themselves.

Shutting himself away in his homemade laboratory, Daguerre began to experiment, much to the concern of his wife who was sure he would become insane. Upon hearing of Niépce's work, Daguerre sought him out, and after much persuasion and an exchange of ideas they formed a partnership on 10 December, 1829. At Daguerre's suggestion, they turned away from heliography and began to research the light-sensitive properties of silver iodide. The death of Niépce in 1833, however, left his partner devastated and unable to continue experiments for almost a year.

When he did continue his work with some assistance from his new partner, Isodore Niépce (Nicéphore's nephew), the first practical photographic process was born. It was named the Daguerreotype. One of the earliest of these silver iodide images is dated 1837. A still life by Daguerre himself, it is a rather artless array of plaster casts on a window-sill. The image quality was far finer in detail than any made by means of heliography, and the exposure took only minutes as opposed to hours; how had this been achieved?

The Daguerreotype was a complex and demanding process, taking about one hour to complete with precise timing essential. The procedure was as follows:

(a) A silvered copper plate was cleaned and polished.
(b) The plate was sensitised in an 'iodine box', allowing iodine vapour to react with the plate's surface to form light-sensitive silver iodide.

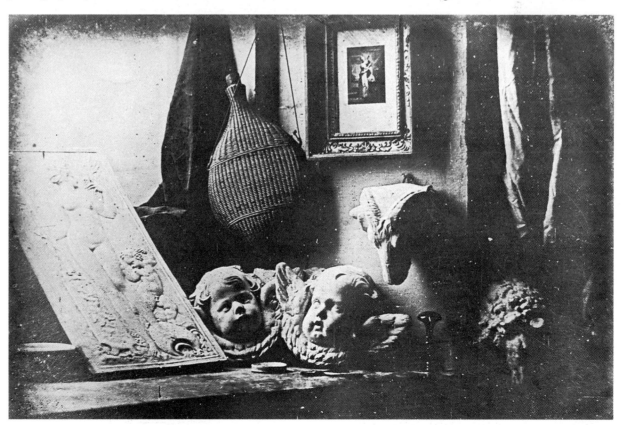

Fig. 1.4 L.-J.-M. Daguerre: Daguerreotype of still life in his studio, 1837.

(c) The plate was then exposed in the camera for up to 20 minutes in bright sunlight. The exposure produced a latent image which was not visible.

(d) The image was developed by placing the exposed plate in a box over mercury vapour. The reaction between this vapour and the silver iodide that had been exposed to light formed a visible image.

(e) Finally, the image was fixed with sodium thiosulphate (known as 'hypo'), which had been discovered by Sir John Herschel.
 After rinsing and drying, this delicate silver image was placed behind glass for viewing.
It was this development of the latent (invisible) image that was the key to shortened exposure times and is still an essential part of photography today. These extremely fine, detailed images were a wonder to behold, but, unfortunately, they were direct positives and, as such, each unique exposure could not be reproduced, a factor which contributed to the method's eventual downfall.

In 1839, the invention of the Daguerreotype was publicly announced, following its sale to the French Government. Daguerre received a life pension for his efforts and the process was given free to the world, a world which welcomed this miracle with open arms.

However, we must not award Monsieur Daguerre all the glory in our historical survey, for the rumours of his discovery brought into the open many other experimenters who were striving to find solutions to the photographic problem. Of these, the most important to photography's future was an Englishman, William Henry Fox Talbot.

A gentleman scientist, Talbot's fascination with photography stemmed from frustration at his own artistic inability. Using a camera obscura during a trip to Italy in 1834, he kept jiggling the camera out of alignment while tracing a scene, and found it 'most difficult to get back again so as to point truly in its former direction'. This problem led him to experiment with ways of capturing light and shade directly in the camera obscura without the skill of hand tracing.

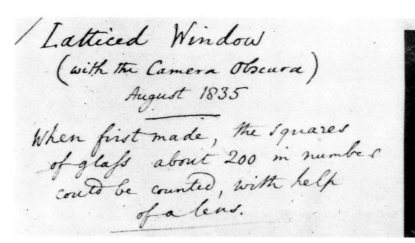

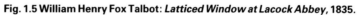

Fig. 1.5 William Henry Fox Talbot: *Latticed Window at Lacock Abbey,* **1835.**

Approaching the problem in a similar way to Wedgwood, Talbot coated 'superfine writing paper' with silver nitrate or silver chloride and exposed it in a homemade camera obscura. In this way, he was able to produce negative images. Unlike Niépce, Talbot realised that by contact printing these paper negatives directly on to similarly coated paper in sunlight, a positive 'photogenic drawing' could be made. The oldest surviving negative produced in this way is a 'Latticed Window' taken at his home, Lacock Abbey in Wiltshire in 1835 (Fig. 1.5). This 'calotype' (as Talbot called it) lacks the fine detail of the Daguerreotype, having a more textured and softer charm due to the fibrous qualities of the paper, but it had the advantage that it could be reproduced. The principle of printing a negative to form a positive is the basis of photographic reproduction today, and so we must credit Talbot with the title of 'father of photography'.

Upon hearing of Daguerre's work in 1839, Talbot decided to prepare a paper on his calotype or Talbotype process, as it was sometimes called. However, it did not receive the same recognition as the Daguerreotype at first, and it was not until 1841 that it was totally refined. By this time, he, too, had discovered the development of the latent image, thereby reducing his exposure times to a few minutes. The procedure was as follows:

(a) Fine paper was coated on one side with a silver nitrate solution.

(b) After drying, this was placed in potassium iodide to form light-sensitive silver iodide.

(c) Just before exposure in a camera obscura, the paper was floated in a bath of gallo-nitrate of silver.

(d) The exposed paper with its latent image was developed by washing with gallo-nitrate of silver before fixing with hypo, and washing.

(e) Fine paper negatives were then varnished to make them semi-transparent.

(f) The contact print was made on silver chloride printing-out paper which involved a long exposure to sunlight to form an image which required no development.

(g) Finally, the positive print was fixed, washed and dried.

We may note that both of the processes we have looked at used 'hypo' as a fixing agent, as discovered by Sir John Herschel. Born in 1792, Herschel was an Englishman with a keen interest in everything new in an era of great historical change. A brilliant man, he was intrigued with Daguerre's discovery and took it upon himself to investigate photography. Within one month he had discovered 'hypo' as an alternative and

superior fixer to common salt or the acid solutions previously used to remove unexposed silver halides. As well as giving us 'hypo', Herschel coined the term 'photography', and was the first to apply the words 'negative and positive'.

PHOTOGRAPHY: ITS EARLY APPLICATIONS

Today we tend to take photography for granted; it is readily available to us and so we use it to record information, to communicate ideas and to express ourselves to others. But how was this concept of mechanical imagery accepted in the Victorian era of its birth? It was, after all, a strange crossbreed of art and science.

This is an issue we must consider in order to appreciate the role of photography in society from 1839 to the present day.

The Daguerreotype was invented during the industrial revolution. Humankind no longer relied on muscle power, animals, wind and water alone. Coal-burning machinery was taking over. Photography was the image-making aspect of this revolution, similarly providing a mechanical rather than a human means of production. Time and labour could be saved, and the picture-making process could be broken down into simple steps that almost anyone could learn, regardless of artistic skill. Mass production of images became possible, and the unit cost was greatly reduced in consequence.

The affluent climate of the industrial revolution was ideal for the growth of photography. But what kind of photographs did people want at this time? Most of all they wanted pictures of themselves, their families and loved ones. The romantic movement in the arts placed emphasis on the individual expression of emotions, thereby providing a perfect base for the establishment of photographic portraiture. These 'self images' were a reminder of past youth and served as keepsakes of people far away or dead.

There was a demand for other images too – those of society's achievements. This was a time of great migration; people were exploring the world, and taking trade and industry with them. Railroads were being built, and communication systems in general were advancing. It was not long before photographers were going out into the field, working under incredibly difficult conditions, to become the eyes for all those at home unable to visit distant lands. Photographs from afar satisfied inquisitive minds and provided valuable documents of world history.

The birth of photography was bound to have extensive artistic consequences. 'From today, painting is dead!' cried the French artist, Paul Delaroche. His horror upon hearing the announcement of the Daguerreotype was something of an overreaction, but, nevertheless, with the arrival of photographic portrait studios many portrait painters went out of business. Over the years, photography and art can be seen to have had something of a love-hate relationship, influencing and affecting each other for better or worse! Photography had, after all, been invented primarily as a labour-saving device for artists – letting the sun do all the drawing – and some welcomed the new discovery and intended to use it to advantage. Daguerre and Talbot were, after all, not in search of a new means of visual expression so much as a way of saving time and effort. The camera was extremely helpful, for example, as an aid to figure painting, as several poses could be photographed in one sitting, to be copied later on to canvas.

But in spite of its value to artists, photography was looked upon as a mere mechanical procedure. To what extent could photographers possibly call themselves artists? After all, their images were products of mechanics, optics and chemistry, not human hands alone. And to what extent could photographers impose their own vision on the camera? These questions were to arise to a greater extent towards the end of the nineteenth century and were not to be resolved until some considerable time later.

THE DAGUERREAN ERA: PORTRAITURE (1839–58)

From the time of its publication in August 1839, the Daguerreotype achieved instant popularity, and it remained popular for twenty years before being superseded by alternative techniques. Artists, scientists and entrepreneurs alike began to explore its potential. It was possible to purchase a complete photographic kit containing camera, chemistry and plates, and producing these beautifully detailed images of reality became a craze. A Daguerreotype mania began.

Naturally, there were drawbacks. The apparatus was bulky and heavy, and exposure times were in the region of several minutes, due to the insensitivity of the emulsion. As a consequence, a tripod had to be used, and while a landscape or still life could be photographed successfully, to take a portrait without recording subject movement was virtually impossible.

Two technical improvements soon increased the scope of Daguerreotype photography:

(a) *The Petzval lens of 1841*
This new four-element lens designed by Max Petzval had an aperture of f/3.6 and was six times 'faster' than any previous lenses.
(b) *The increased sensitivity of the Daguerreotype emulsion*
By treating the sensitised plates with chlorine fumes (an 'accelerator') prior to exposure, exposure times could be reduced to about one or two minutes, or less, in bright sunlight.

Before the end of 1841, photographic portraiture had at last become practical, and studios began to appear all over the major cities. The popularity of photographic portraiture was incredible. Now everyone could obtain a likeness of themselves, whereas in the past this had been a privilege afforded to very few (Fig. 1.6 on p. 10).

Fig. 1.6 Antoine Claudet: Portrait of William Henry Fox Talbot, Daguerreotype, *c.* **1846.**

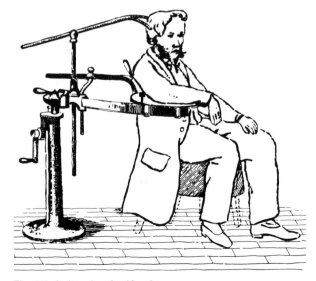

Fig. 1.7 A sitter 'posing' for the camera.

These early photographers needed a lot of light and often worked in top-floor studios with glass roofs to let the light pour in. To have one's photograph taken in those times was something of an ordeal. Faced with the blazing heat and brightness of a photographic 'greenhouse' you would sit stone-like and stare into the camera lens. Even the shortened exposure times of seconds rather than minutes meant that no movement was permissible if fine detail and sharpness were to be obtained. To ensure this, the sitter would have the support of a neck clamp and back braces (Fig. 1.7). Is it any wonder, then, that we now view these records of our ancestors, with their severe and almost pained expressions, as almost inhuman? The most that could be done to make these portraits more natural and pleasing to the eye was to add a little warmth by hand tinting.

It is rare indeed to see a candid, relaxed portrait of those times. However, a fine body of calotype portraits was produced by the Edinburgh team of David Octavius Hill and Robert Adamson. Hill, an artist, and Adamson, a young chemist, produced images which broke away from traditional poses and produced beautifully sensitive portraits revolutionary in their style and approach. Through their use of the textural calotype process and Rembrandt-like lighting, these partners demonstrated the power of the new medium beyond merely copying reality (Fig. 1.8).

THE PAPER CALOTYPE

As the Daguerreotype process was improved, so too was Talbot's process, the key being the 'development' of the latent image. By processing the exposed paper negative in a solution which proportionally added silver to the exposed areas of a scene, it was possible to reduce camera exposure times considerably.

Although the calotype was never as popular as its competitor for portraiture, in some ways it was

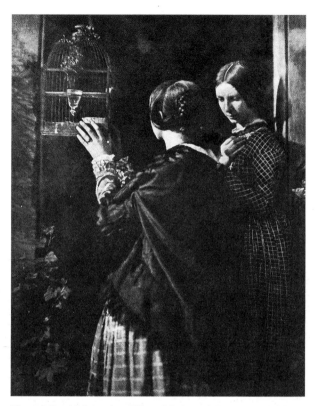

Fig. 1.8 David Octavius Hill and Robert Adamson: *The Bird-cage,* **calotype,** *c.* **1844–6.**

superior. A less cumbersome, less complicated and less time-consuming process, it was consequently more convenient for field work. Paper was also cheaper than metal plates, the negatives were reproducible and, as such, the calotype was the precursor of photography as a publishable medium. Naturally, it was far from perfect. It was 'slower' (less light-sensitive) than the Daguerreotype, and its images were 'softer' (lacking contrast) and 'grainier' due to the paper texture of the negative being printed through on to the positive image. For these reasons, the Daguerreotype was preferred by the majority of photographers.

The calotype negative could be enlarged for printing, thereby allowing camera sizes to be smaller and, consequently, more portable. To prove its worth, Fox Talbot used the calotype in his publication

The Pencil of Nature, which was the world's first photographically illustrated book (1844). This was produced in sections, with hand prints (4,800 were required in total), for which he set up a mass processing facility in Reading. Despite his previous frustrations with drawing, Talbot had an artistic eye which he applied through the photographic medium. As can be seen in his photograph 'The Open Door' below, there is a clear aesthetic sensitivity in the arrangement of elements within the scene. The picture almost tells a story and one waits to see if someone will enter the scene and take up the broom.

The publication of *The Pencil of Nature* illustrates a real problem for photographers of the day: other than through the sale of industrial prints, there was at this time no direct means of bringing these images to the public at large. Today, we take the media and their informative imagery so much for granted that it is hard to imagine a world without photographic reproduction techniques. However, the first significant step towards these techniques was not taken until 1851 (the year of Daguerre's death) when an issue of *The Chemist* reported a new technique devised by the Englishman Frederick Scott Archer. This involved a substance called collodion, used for sensitising glass plates, and was to make both the calotype and Daguerreotype obsolete within just a few years.

Before we move on to investigate this new process, let us reflect upon the achievements in photography during its first two decades. The first hand-coloured and stereoscopic images appeared during this short period, as did the first portraits. Topographic studies were made, and numerous exhibitions held. Photography was established as a profession and alongside it grew the manufacturing industries which provided the necessary equipment and sensitive materials. The first enlargements of photographs were made and the first illustrated publications produced using photographic images. Through these developments, ordinary people were becoming more familiar with photographs, and so photography was gradually to become an integral part of their lives.

THE WET COLLODION ERA

The wet collodion process was discovered in 1851 by Frederick Scott Archer and was considerably more successful than its predecessors. The advantage was that the wet collodion emulsion was coated on to glass rather than paper; this made it possible to reproduce the image to a high quality. Scott Archer combined the quality of the Daguerreotype with the negative–positive system seen in the calotype within one new process. He was not the first to use glass in this way, but his collodion substance proved to be superior to any predecessor and was widely used for about 30 years.

The wet collodion process required fewer steps than the Daguerreotype; it was also less difficult and less expensive than the calotype as well as being finer in quality. However, the new emulsion was no faster than those used before; exposure times still had to be at least 5–15 seconds (hence the continuing

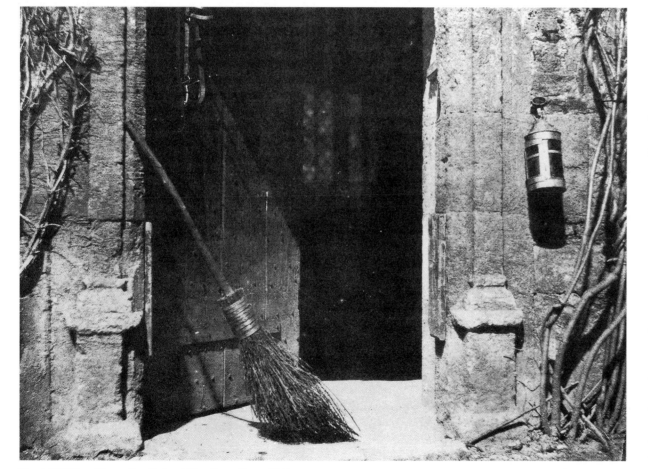

Fig. 1.9 William Henry Fox Talbot: *The Open Door*, 1843.

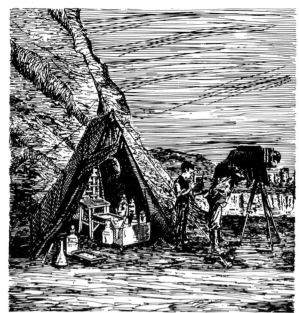

Fig. 1.10 Dark-room tent in wet collodion period, *c.* 1875.

popularity of landscape and still-life portraits). Also, it did have the big drawback that once each plate had been prepared it had to be exposed and processed while it was still moist; otherwise, its sensitivity would be lost. This meant that wherever photographer and camera went, a darkroom had to follow (Fig. 1.10). Roger Fenton, who used the wet collodion process to document the war in the Crimea, had to travel with a fully equipped carriage and two helpers.

The wet collodion process operated as follows:

(a) Immediately before exposure, a mixture of collodion (an early form of celluloid) and potassium iodide or potassium bromide was poured over the glass plate.

(b) In orange-coloured safelight, the 'tacky' plate was dipped in a silver nitrate solution.

(c) Exposure took place while the plate was still moist (5 seconds–10 minutes).

(d) The plate was developed immediately in pyrogallic acid.

(e) The plate was fixed in hypo or potassium cyanide (highly poisonous).

The wet collodion process was an awkward one to master and one requiring dedication and self-discipline; one of the results of this was that those who strove to learn the art of the wet collodion produced some of the finest images in photographic history. The development of the wet collodion process, although primarily used for landscapes and still life, also affected the field of portraiture, where the Daguerreotype fell out of popularity and was replaced by two less expensive collodion competitors, the Ambrotype and Tintype, which were used widely in portrait studies of the 1850s and 1860s.

The Ambrotype was an under-exposed collodion negative placed against a dark background, thereby appearing as a positive. Usually mounted in a case, these were duller images than the Daguerreotype but were cheap and effective, and they became extremely popular.

The Tintype was even cheaper, an inferior version of the Daguerreotype involving collodion-plated iron. The plates were exposed in multi-lens cameras allowing up to 36 exposures on one plate. After processing, these small images were cut up into individual Tintypes, costing mere pennies.

Even more devastating to the status of the Daguerreotype, however, was the application of the collodion process in the form of paper prints: the carte-de-visite. Patented in 1854 by a Frenchman, Adolphe-Eugène Disdéri, these were contact prints which were the size of calling cards and which were made in a multi-lens camera with a movable plate holder. This allowed the recording of a dozen different poses on one negative and at one sitting, which would then be printed and cut into separate portraits.

The carte-de-visite resulted in yet another photographic craze – they were given or exchanged as calling cards and thereby collected. The question of what to do with all these tiny images led to the production of the first photograph albums, so starting the traditional family archive present in nearly every home today.

THE PHOTOGRAPH AS A WITNESS

In the early years of the wet collodion era, the photo-documentary tradition of using 'straight', unmanipulated photography began. With careful composition, viewpoint and framing, the photographers of the wet-plate school produced richly detailed images which the public could view at leisure.

Many of these records were taken using stereoscopic cameras which had been devised in the early years of photography. These produced a closer representation of reality by taking two exposures of the same scene with two lenses slightly displaced from one another (a similar distance to that between the human eyes). Human vision would cause the two images to appear as one when the images were seen through an appropriate viewing apparatus, and the resulting image had a three-dimensional quality.

Like the family album, a stereo-viewer and a set of stereograms became a common means of entertainment in Victorian homes. As a result, stereo photography boomed in the 1860s and 1870s, and people bought and collected stereograms of everything from landscapes and architecture to nudes and scenes of war (see below).

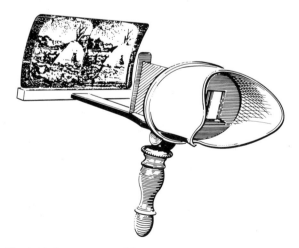

Fig. 1.11 Stereoscope with stereogram.

Despite this thirst for knowledge, it was no more possible in the late nineteenth century than it had been in the 1830s (the birth of photography) to reproduce these images directly into the illustrated press. The two media remained incompatible until the turn of the century, and the public had to be satisfied with the work of woodcut engravers and their interpretation of a photograph.

THE FIRST WAR PHOTOGRAPHER: ROGER FENTON

Roger Fenton was the personal photographer to Queen Victoria, before he was assigned to photograph the Crimean campaign of 1854–55. However, the 300 or so images that he took suggest that he may be considered to be more of a documentary photographer than a war photographer. His photographs are, for the most part, picturesque or romantic scenes – not ones of horror and death with which we are more familiar today, but there are clear historical reasons for this. At that period, the social attitude to war was one of mystery, romance and heroics – something far removed from the realities of everyday Victorian life. In consequence, there was a social constraint on Fenton's work: it was not for him to shatter dreams or illusions nor to reduce morale, and he probably viewed the 'gentleman's' war in the same way as the people at home and the brave men fighting it.

Social reasons aside, we must also allow for the technical difficulties of the photographic process Fenton used. Exposure times were lengthy, and a darkroom was required on site. Insensitive emulsions made 'action photography' impossible, and front-line coverage was very dangerous, because of the time it took to set up equipment. If Fenton had attempted to capture a more 'realistic' view of war he would probably have ended up with a blurred image of frantic movement – or, worse still, ended up dead!

So while we may find Fenton's picture of colonels taking tea somewhat absurd, his desolate landscape of a thousand cannonballs in 'The Valley of the Shadow of Death' may conjure up a vivid picture of the horror of war and an appreciation of how many lives were lost (Figs 1.12 and 1.13).

In contrast, the American Civil War five years later was recorded in horrific detail by Mathew Brady and his self-financed team of photographers. These memorable images of internal feud are still haunting today. This was the first war to receive media

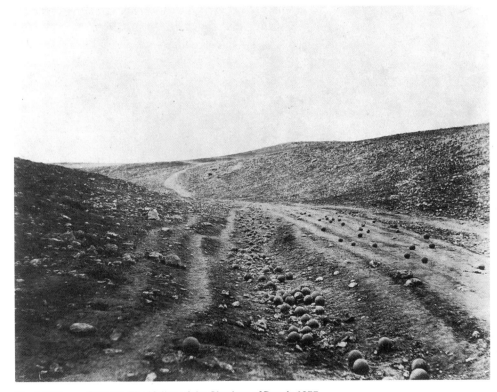

Fig. 1.12 Roger Fenton: *The Valley of the Shadow of Death*, **1855.**

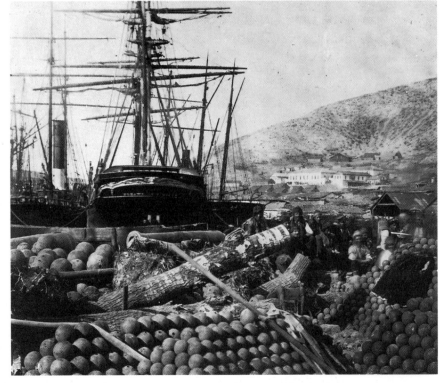

Fig. 1.13 Roger Fenton: *Balaclava Harbour, the Ordnance Wharf*, **1855.**

coverage; artists' impressions of photographs were printed in the press for public consumption. The photographers risked all to transport their cumbersome wet-plate equipment wherever fighting and destruction were taking place, and the photographic records were sent home for sale to a morbidly fascinated audience.

Following the Civil War, the expanding American West attracted many photographers to its vast and splendid landscapes. Travelling in government survey teams or working alone, they applied their technical expertise to such subjects as mountains, canyons and plains never before seen. One such master of the wet plate, William Henry Jackson, compiled a set of large-scale photographs of Yellowstone which expressed more than the written word could ever hope to achieve. The collection was partly responsible for the decision taken by the American Congress to make this place of beauty into the first protected national park – a mark of the influential power of the photographic image.

ART AND PHOTOGRAPHY

As the medium grew in popularity and application, so did the question of its relationship to traditional art forms.

Realism in art had continued from the Italian Renaissance into the nineteenth century, shaping the attitudes of artists at the time of photography's

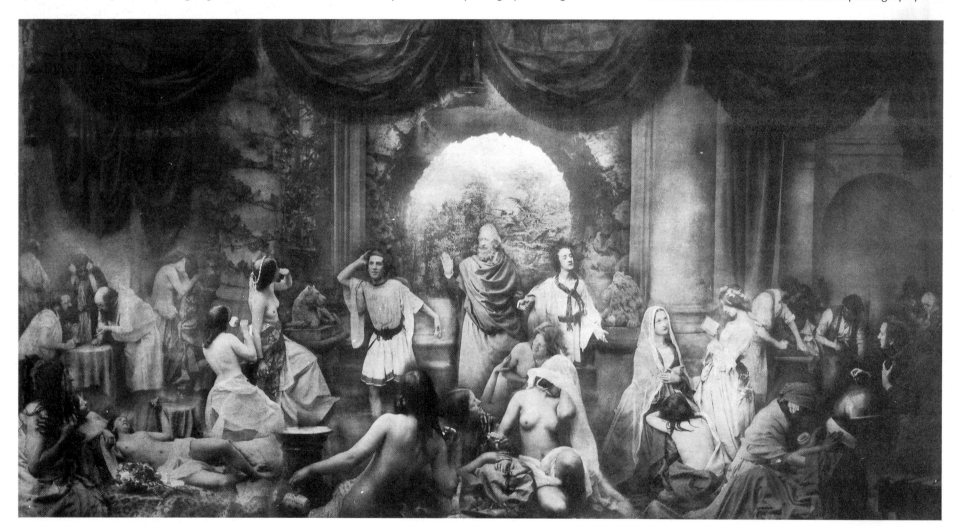

Fig. 1.14 Oscar Gustave Rejlander: *The Two Ways of Life*, 1857.

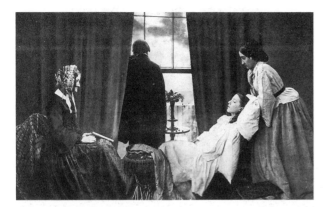

Fig. 1.15(a) Henry Peach Robinson: *Fading Away*, **1858.**

birth. In consequence, the fine detail and realism of the photographic record were much envied by artists and used as an aid in painting. The result of this was direct copying from photographs. So who was the 'artist' in such productions on canvas – the painter or photographer?

When artists looked to photography to expand their vision and understanding of light and perspective, their world was enriched. But close copy work only degraded art itself, producing lifeless images.

As the arts in the late nineteenth century moved away from realism towards less representational imagery (such as Impressionism in painting), there was a strange reversal of roles, and photographers strove to be artistically creative and to imitate painting – with equally detrimental results. This was the start of the pictorialist movement in photography.

However, slowly but surely it was realised that the camera need not be an objective tool but could also be used as a means of self-expression for the photographer. It was only natural for those artistically inclined photographers to look towards the old schools of painting and their theories of composition, balance and imagery.

Earlier, some photographers like Oscar G. Rejlander and Henry Peach Robinson used theatrical tricks, manipulated prints and photomontage

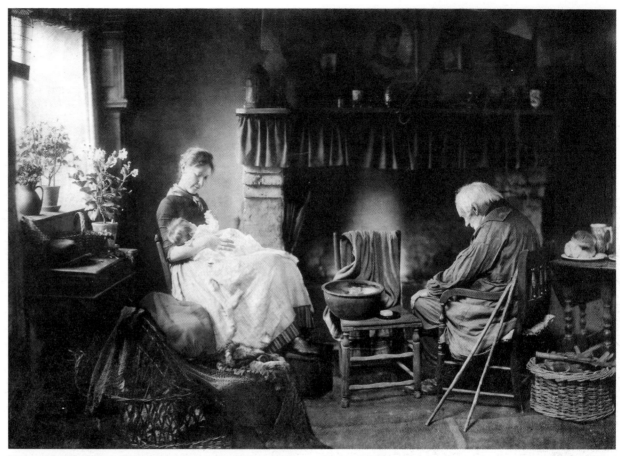

Fig. 1.15(b) Henry Peach Robinson: *Dawn and Sunset*, **1885.**

(multiple printing) in an effort to bring some of the scope of painting to photography.

Rejlander's best-known work is called 'The Two Ways of Life'. Produced in 1857, it is a montage of some 30 negatives representing two opposing moral lifestyles (Fig. 1.14). Robinson applied even greater trickery, resulting in images such as his staged 'art' picture 'Fading Away' of 1858 (Fig. 1.15(a)). This traumatic scene of a dying girl and the grief-stricken family at her bedside was widely acclaimed in its day, as was his 'Dawn and Sunset', 1885 (Fig 1.15(b)).

Another innovator who, unlike the two professional photographers mentioned above, was an amateur, was Julia Margaret Cameron. A lady of wealth and leisure, she took up photography in her fifties when she was given a camera by her children. Taking up the 'messy' wet-plate process, Cameron converted an outhouse into a darkroom and began in a haphazard way with trial and a great deal of error, to record her aristocratic friends in some of photography's most sensitive portraits.

Using large plates and long lenses, which she did not focus accurately, she produced soft-focus, ethereal images of character and imagination (Fig. 1.16(a), (b) and (c)). Lengthy exposure times resulted in subject movement (further softening her

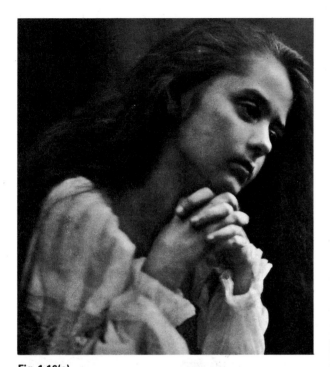

Fig. 1.16(a)

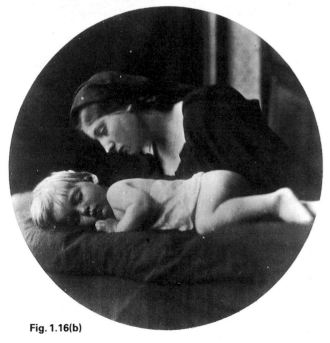

Fig. 1.16(b)

candid portraits), and her clumsy methods led to damaged negatives which necessitated the cropping of final prints to eliminate finger marks. Cameron had a magical sensitivity and a unique Pre-Raphaelite vision. In contrast to the miniature and impersonal cartes-de-visite of the time, her large portraits attempted to reveal something of the inner self of her sitters. As such, this collection of work was an insight into how photography would one day establish an identity as a creative medium independent of previous art traditions.

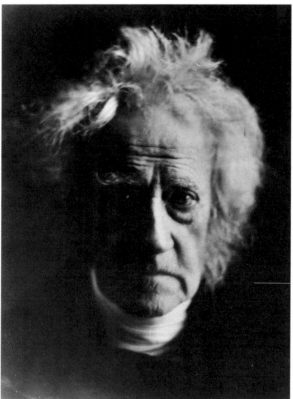

Fig. 1.16(c)

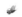

Fig. 1.16(a) Julia Margaret Cameron: *The Prayer*, 1872.
Fig. 1.16(b) Julia Margaret Cameron: *My Grandchild*, 1870.
Fig. 1.16(c) Julia Margaret Cameron: *Sir John Herschel*, 1867.

THE GELATIN DRY PLATE: THE START OF THE MODERN ERA

The invention of the wet-plate process, with its cumbersome equipment, brought about many attempts to find a more convenient method of producing photographs. The key was to find a substance to contain light-sensitive silver salts that would retain their sensitivity to light even when dry. The answer was discovered with gelatin.

In 1871, Dr Richard Leach Maddox announced in the *British Journal of Photography* how to make a gelatin emulsion containing silver bromide, a jelly-like substance that could be poured over glass plates to sensitise them. Over the next few years, the production of the emulsion was refined, and in 1878 Charles Bennett discovered that if the emulsion batch was allowed to stew at 90°F (about 32°C) for several days, the result was an amazing increase in sensitivity.

Photographers no longer had to coat their own plates in a laborious fashion. It was now possible to buy boxed (pre-coated) dry plates. Manufacturers adapted Bennett's 'ripening process' and so were able to produce plates so sensitive that exposure times as short as 1/25 second were possible. Although the photographer was finally free of the travelling darkroom and could now produce never-before-seen images of frozen movement, the new concept was not immediately popular because the old wet-plate process had been cheaper, in that it allowed glass plates to be reused. But the old ways gave way to the new as the unit cost of dry plates dropped and their quality improved in consistency.

THE HAND-HELD CAMERA

There had been no significant advance in camera design until the 1880s. Professionals and amateurs alike used large, tripod-bound plate cameras with

characteristic black bellows, and submerged themselves beneath dark cloths in true 'watch the birdie' fashion.

But the appearance of the dry plate on the market stimulated many changes in camera design. The main change was that the new cameras were specifically designed to be used in the hand. For the first time, these small black 'detective' cameras incorporated mechanical shutters to facilitate the shorter exposure times now possible. Together with the fast plates, these lightweight cameras eliminated the need for tripods.

Following the box-type cameras, small folding cameras with a lens mounted on collapsible bellows were introduced around 1890. The appeal of taking 'candid' pictures was immense and brought about a wave of strange and wonderful gimmick cameras. These took on the shape of neckties, stop-watches and other small objects. Now one could take photographs without being noticed at all! It is little wonder, therefore, that the photographer has been named throughout history as a 'peeping tom'.

Thanks to these easy-to-use hand-held cameras, photography lost some of its élitism and became more widely available to the general public. Technical expertise was no longer a prerequisite for success.

A MOMENT PRESERVED

It soon became apparent that by using the new sensitive dry plates in a camera with an instantaneous shutter, time could be sliced very thinly indeed. Images were produced that showed a radically different view of the world from that made during an exposure of five minutes when figures were seen as a blur or not there at all! Street scenes no longer looked like ghost towns and people walking could now be arrested in motion. The camera actually enhanced human perception by making it possible to capture and study movement in human limbs as never before.

Eadweard Muybridge was an extraordinary English photographer who studied extensively the motion of both man and animals. Working in the bright California sunshine during the 1870s and 1880s, this Englishman captured motion on gelatin plates at 1/2000 second. Muybridge used not one camera, but a series of twelve to produce his famous sequence revealing the horse in motion (Fig. 1.17). The cameras were arranged in a line, each one with a high-speed shutter activated by springs and rubber bands as the horse passed by. Having produced some 100,000 negatives and compiled a book called *Animals in Motion* (still used as reference material today), Muybridge went on to invent the 'Zoopraxiscope'. This machine was a projector which allowed up to 200 mounted slides to be viewed in rapid succession, thereby creating the earliest version of cinematography.

This process significantly increased human understanding of motion and was to have far-reaching consequences in art, artistic photography and, eventually, photojournalism.

Fig. 1.17 Eadweard Muybridge: *Annie G with jockey (.031 secs).* **From 'Animal Locomotion' plate 175 published 1887.**

PHOTOJOURNALISM AND PHOTODOCUMENTARY: THE EARLY YEARS

In the final twenty years of the nineteenth century, there were two experiments which were to lay the foundations for photojournalism: the appearance of the first half-tone illustration in a newspaper and the first photo-interview.

Until the invention of the **half-tone screen**, it had been impossible to reproduce a continuous-tone photograph, with its subtle range of greys, on to the printed page, which used only black ink on white paper. This new method meant that instead of reproducing the careful work of a photographer as an artist's engraving, it was now possible to break up the original image into a fine screen of dots, thereby allowing it to be printed with black ink. The pattern of dots was arranged so that where they were dense the image appeared black, and where sparse, light grey. As the dot density for a given area varied, so did the tone in that area. Look closely at today's news photographs and you will see this effect clearly.

The first half-tone screen image appeared in 1880. In 1886, an issue of *Le Journal Illustré* appeared in Paris with the first photo-interview. The French inventor, Michel Chevreul, was interviewed and photographed on his hundredth birthday; the result was a candid photo-story. Yet despite this early indication of the potentially powerful combination of words and half-tone pictures, it was not until the early 1900s that these new methods were widely applied.

Cameras at this time were in the main the toys of the middle and upper classes, and the working classes not only had no access to photography but were not considered worthy subjects of it. However, just as there were people who saw the effects of the industrial revolution not in terms of its great wealth so much as in terms of its poverty and slums, so there were photographers who sought to arouse public sympathy by depicting the impoverished living conditions of the less fortunate. This was the start of social documentary photography.

Early pioneers of this persuasive medium were Dr Barnardo, John Thompson and Jacob A. Riis. The latter photographed the slums of New York using the new invention of flash powder to illuminate the dark interiors of the homes of the poor in that city. The result was his book *How the Other Half Lives* (1890) which was instrumental in bringing about housing reforms. Riis proved that photography could actively influence public opinion and individual attitudes, as it does today.

PHOTOGRAPHY BECOMES AVAILABLE TO ALL

George Eastman, an ex-bank clerk, was only 25 when he became interested in photography. A mere three years later he went into dry-plate manufacture before experimenting with flexible roll film on a paper base. The latter could be rolled on to a spool, thereby saving space as well as being far lighter than glass plates. But when sales were disappointing, Eastman realised the need to make photography even simpler in order to appeal to the general public.

The result of his endeavours was the Kodak camera, introduced in 1889 (Fig. 1.18). A small black box, with a 57 mm f/9 lens, it gave a wide angle of view and good depth of field. A viewfinder was not necessary. It was so simple to use that all you had to do was point and shoot! Eastman invented the word 'Kodak' as one that would be easy to advertise, easy to remember and would not be found difficult to pronounce in any language. You bought the camera ready loaded with film, providing 100 circular negatives of $2\frac{1}{2}$ inches diameter at a price of $50. When you wanted the film to be processed and printed, you returned the camera to the Eastman factory where it was eventually reloaded and returned to you. More than 13,000 cameras were sold in the first year, helped by the advertising slogan

Fig. 1.18 George Eastman holding a Kodak, 1890, recorded by a second Kodak.

'You press the button – we do the rest'.

By 1890, Eastman had begun to use celluloid-based film in 12- or 24-exposure rolls which could be loaded in the dark by photographers themselves. In 1895, a protective black paper backing was introduced which made it possible for photographers to load film in daylight without fear of fogging the film. Early in 1900, George Eastman's simple 'Box Brownie' camera was available on the market, at the greatly reduced price of one dollar. It was now possible for even the youngest children to become image-makers: there was no need to have an artistic or scientific training. Everyone could make pictures.

THE SNAPSHOT

The increased availability of photography gave rise to a new expression. The word 'snapshot' was coined by Sir John Herschel to describe an informal photograph taken quickly with a hand-held camera.

And while these impulsive moments snatched from life were essentially personal documents of places seen, people loved and fun had, these early snapshots contributed to a major aesthetic revolution in the arts. Sensitive photographers and artists alike responded to this new imagery and began to adapt its qualities to their work, as we shall discuss in the next section.

PHOTOGRAPHY AS AN ART FORM

While some traditional artists continued to use photographs for direct copy work, the young expressive artists of the Impressionist movement used photography to assist them in a different way. Rather than coldly reproducing a photograph on canvas with paint and palette, this group of artists looked to the camera and its images for new insights into the natural world.

Like photographers, the Impressionists wished to capture moments in time and also the changing qualities of light and weather. Claude Monet used broad brush strokes to do this; this technique resulted in canvases which upon close inspection reveal jumbled, overlapping daubs of colour not

Fig. 1.19 (b) Peter Henry Emerson: *Gathering Waterlilies,* plate IX, 1887.

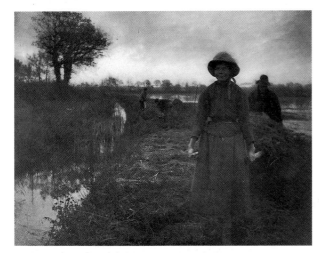

Fig. 1.19(a) Peter Henry Emerson: *Poling the Marsh Hay,* 1886.

unlike the grain of out-of-focus areas seen in photographs.

Monet was not alone in his recognition and use of photography. Edgar Dégas was a keen amateur photographer who worked from his own 'snaps'. Henri de Toulouse-Lautrec used photographs as reference for his poster-like Parisian scenes. Georges Seurat and Paul Gauguin also used the camera in their own way.

There had been a continuous interchange of ideas between artists and photographers since 1839. But to what extent could photographers themselves claim to be artists?

One of the earliest advocates of the *art* of photography was an outgoing and energetic Englishman, Dr Peter Henry Emerson. A trained medical man and devoted amateur photographer, Emerson despised the manipulative world of Henry Peach Robinson and strongly expressed his belief in the need for 'naturalistic photography'. Publishing a book under that very name in 1889, Emerson stressed the need for photographers to choose subjects of natural origin, such as landscapes and working folk – a real world as opposed to one of theatrics and contrivance. Influenced by the landscape painters, Corot and Turner, Peter Henry Emerson photographed the rural life of East Anglia and the Norfolk Broads (Figs. 1.19(a) and (b)).

However, following from where Rejlander and Robinson left off, some photographers applied every form of manipulation and trickery to produce what was considered to be an 'artistic image'. Using soft-focus, camera movement and manipulative techniques on homemade materials, these 'pictorialists' believed the printing to be of utmost importance in image production. The negative, meanwhile, was looked upon merely as a stepping-stone towards the final artistic concept.

What better way could there have been for the 'serious-minded' photographers to stand out from the common 'snap-shooters' of the period than to spend many hours over artistic manipulation? The

Fig. 1.21(a) Alfred Stieglitz: *The Terminal, New York*, **1892.**

Fig. 1.20 Edward Steichen: *The Pool*, **1898.**

less *photographic* the image appeared, the closer to art it was – or so the pictorialists naïvely believed. This illustrated a grave misunderstanding of photography for, as we shall see later, it was not until photographers realised and appreciated its unique qualities of detailed representation and extreme sharpness in portraying reality that photography could ever hope to be considered as an independent art form.

However, it cannot be denied that pictorialist groups the world over, such as London's 'Linked Ring' led by George Davison and Henry Peach

Robinson, did achieve much by setting up photographic exhibitions. Of equal importance was the pictorialists' use of careful and considered composition, as in the wet-plate days, together with a sensitive appreciation of lighting as learnt from the art schools.

One of the most influential pictorialist movements of the early 1900s was formed in America. The 'Photo-secessionists' were a group of dedicated artistic photographers, working under the direction of Alfred Stieglitz, who were 'seceding' from ideas of what had previously been described as 'Art

Photography'. The leading light of the group was young Edward Steichen, co-founder and avid pictorialist, who was not averse to kicking his tripod to achieve a desired soft-focus effect (Fig. 1.20). While Steichen strove to achieve the ethereal, romantic images possible with large plates and gum bichromate fine prints, Stieglitz achieved a unique mood in his own work by using a hand-held camera in a straight documentary style.

Since purchasing his first camera as an engineering student in Berlin, Alfred Stieglitz had been obsessed with photography and the ability to depict reality in fine detail. He always photographed what interested or intrigued him in his environment, whether it was the steaming horses at a New York tram terminal in the dead of winter (Fig. 1.21(a)), mysterious cloud patterns ('equivalents' of his inner emotions), or a strongly composed scene like 'The Steerage', showing the division of rich and poor socially and graphically (Fig. 1.21(b)).

Stieglitz was certain that photography was a fine art and dedicated his life to proving it. He inspired and promoted the work of young aspiring photographers and artists. At the secessionists' '291' galleries, Stieglitz exhibited new work in photography, art and sculpture side by side, and with his quarterly magazine, *Camera Work*, was able to show the world the portfolios of these talented individuals, together with the work of writers and playwrights.

This meticulously produced, limited edition quarterly, was not a technical publication but rather a centre for ideas. In the final edition of *Camera Work* in 1917, just prior to the disbanding of the Photo-secessionists, Stieglitz published the photography of Paul Strand – totally modern, visionary and of clear inspiration to Stieglitz. 'The White Fence' (Fig. 1.22), an example of this collection, is so stark, honest and abstractly compelling that it is hardly surprising that Stieglitz realised he had finally shown the pictorialists the photography of the future. This modern realism was well in line with the shell-shocked world that followed The Great War – a time for modernism and a 'new vision'.

Fig. 1.21(b) Alfred Stieglitz: *The Steerage*, **1907.**

Fig. 1.21(c) Alfred Stieglitz: *Spring Showers, New York*, **1898.** ▶

Fig. 1.22 Paul Strand: *The White Fence*, **1917.**

CHANGING STYLE: CHANGING TECHNOLOGY (1920–60)

The end of World War I marked a time of great change, not only in photography but also in society itself. In contrast to the financial cutbacks enforced by wartime, industrial manufacture increased, allowing photographic technology to advance in leaps and bounds. A similar advance was made in the creative use of photography by photographers such as Paul Strand. These changes, both technical and stylistic, are the concern of this final section and, as we shall see, the two are inextricably linked.

1920s: THE 'CANDID' CAMERAS

The post-war period saw the manufacture of the first miniature cameras that were to become professional tools. Up to this time, amateurs were those who used George Eastman's box cameras for 'snaps', or perhaps a model with a folding lens-panel. But the professionals and the more serious-minded continued to use large-plate cameras for quality image production.

Without hand-held cameras, fast lenses and sensitive emulsions, photojournalism as we know it today could never have occurred. Prior to 1914, press photography was of a very brash nature; rarely were photographs regarded as important as type, or used as an integral part of the layout.

After the war, three things would change this long-established approach to press work, namely: new equipment in the form of the Ermanox (Fig. 1.23) and Leica miniature cameras; creative young photographers in Hungary and Germany; and new magazine publications with open-minded editors and designers.

The Ermanox was a small-plate camera marketed in 1924 with a folding eye-level viewfinder and a

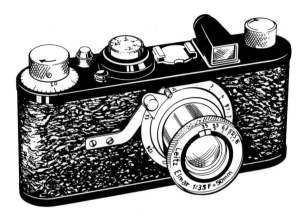

Fig. 1.23 *Top*: **The Leica 35 mm camera, 1925.** *Bottom*: **The Ermanox small plate camera, 1924.**

focal-plane shutter allowing speeds of up to 1/1000 second. Although its 4.5 × 6 cm plates were only 32 ASA, its fast f/2 lens allowed enough light to pass so that the photographer could work in low light levels. One year after the Ermanox was born, the first 35 mm camera became available. The Leica, designed by Oskar Barnack, was the miniature camera that altered the course of photography. Fitting neatly into a pocket, it had an f/3.5 lens, eye-level viewfinder and a focal-plane shutter giving

speeds from 1/25 to 1/500 second. But its greatest feature was its 36-exposure, 32 ASA roll film, allowing a succession of images to be taken, thereby almost matching the fluidity of a movie camera.

The effect of these unobtrusive cameras was the emergence of a spontaneous style of photography; its users could now capture a fleeting moment, a human emotion or gesture and truly depict the realities of everyday human life. The Leica especially, with its roll film, allowed sequences to be shot, mistakes to be covered with additional exposures, and led to the birth of the 'photo-story' in journalism. With improvements in the half-tone screen, magazines began to use photographs more widely, and their openminded editors realised the potential of the photograph as an integral and informative part of the layout design. With the technology at their finger tips and the market for their work in picture periodical magazines, innovative young photographers such as Alfred Eisenstaedt and André Kertész were able to produce memorable and sensitive images.

THE 'NEW VISION': CREATIVE PHOTOGRAPHERS SINCE THE 1920s

The pictorialist style (depicting beauty, nature and romantic notions) lingered on into the 1920s, but a new photographic conception in line with the changing social ideals of the post-war years was also being developed, as 'The White Fence' (Fig. 1.22) demonstrates. A stark and realistic photograph, without romance or manipulation, it is a true reflection of a realistic world. Yet it is still an 'artistic' representation: without need of effects, it relies purely upon photography's unique qualities. This new movement of 'straight' photography was one of sharply focused, unstaged images of things as they truly are, rendered in the endless range of tones from black to white only possible with photography.

These modern images were produced entirely within the optical and chemical bounds of photography; they did not attempt to copy art or to borrow from painting, and, as a result, they finally established photography as an independent art form.

While Strand was not prolific as a photographer, his influence on the subsequent progression of the art, like that of Stieglitz, was immense.

One young photographer falling under this great influence was the American, Edward Weston. Born in 1886, Weston started his career as a portrait photographer in the pictorialist style of the times. In 1915, he saw an exhibition of modern art which, together with a meeting with Stieglitz in 1923, changed both his direction in photography and his life.

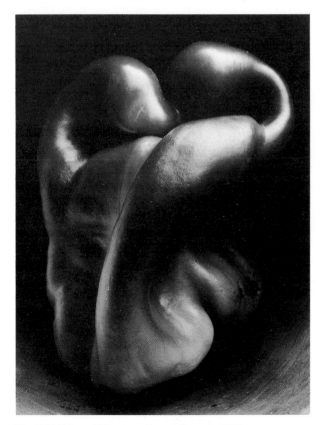

Fig. 1.24 Edward Weston: *Sweet Pepper*, **1930.**

Weston abandoned romanticism in favour of realism and sharpness; his work shows a great concern for detail and surface structure, as can be seen in his larger-than-life images of mushrooms, cabbage leaves and a glowing nautilus shell, all photographed around 1930. Working mainly in the tradition of 10 × 8 inch plate cameras, Weston contact-printed his finely detailed negatives on to glossy paper for maximum resolution. His intense images of the natural and inorganic are both abstract and real. Some of his work – such as 'Sweet Pepper' of 1930, showing an almost human muscular strength and hidden sexuality – may hint at a disturbed emotional state and a restless mind (Fig. 1.24). Weston's credo was that of 'previsualisation'; he felt it essential for the photographer to see clearly in his or her mind's eye how the subject would appear in the final print. The rendering of tones from highlights to shadows was, for Weston, a truly emotional response to the individual nature of the subject. The negative, he felt, should be a true representation of the subject and the print a positive in all its original detail, requiring no unnecessary manipulation to make the subject more than it was. However, we may see in Weston's work an accentuated realism, for some of his inanimate subjects seem larger than life and somewhat surreal when presented this way – almost possessing human character.

Although we may recognise Weston as one of the greatest ever masters of the art, he lived a humble life, always depending on portraiture for a living. Unable to devote himself solely to images of personal expression, he spent much of his life frustrated and regretful. He died of Parkinson's Disease in 1958.

A fellow Californian photographer of large-format, 'straight', powerful imagery was the great landscapist, Ansel Adams. Born in 1902, Adams started life as a concert pianist who dabbled in pictorialist photography until an informal dinner engagement with Paul Strand in 1930 changed his life, as a similar meeting had changed Weston's. He, too, turned to the unmanipulated, detailed contact

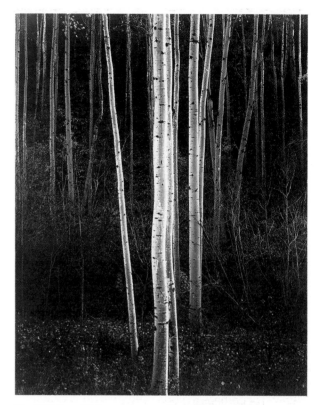

Fig. 1.25 Ansel Adams: *Aspens, New Mexico*, **1958.**

print in an effort to do justice to the reality of natural form and the capabilities of the photographic medium. Unlike Weston, Adams was able to make a considerable living through the sale of his personal work up until his death in 1984.

Together with Weston, Adams formed the f/64 group in 1932, devoted to images of sharpness and depth of field. The name relates to the smallest possible aperture found on a large-format camera. In spite of its dispersal in 1935, the short-lived f/64 group has had an immense influence upon the art, particularly on landscape photography.

Adams was a master technician as well as a highly sensitive photographer, whose meticulous hand-printing together with his critical exposure measurement techniques resulted in absolute tonal range control and outstanding print quality (Figs. 1.25 and 1.26).

A man at peace with his world, Adams saw America as an endless paradise, whose vast landscapes he sought to capture in the delicate language of natural light. His vision and great body of breathtaking images are an inspiration to all who aspire to photograph the world around us.

EXPERIMENTAL IMAGERY

The post-World War I period saw a reaction against Victorian conventions in all areas of the creative arts, including photography. During this time, Stieglitz produced his most powerful portraits and even the master pictorialist, Edward Steichen, switched to sharply focused images in his portrait work for *Vogue* magazine. The German portraitist, August Sander, produced an outstanding collective portrait of his native people. His modern stark photographs bore great similarity to the austere style of bygone Daguerreotype portraiture, and recorded in unretouched images German social classes from butchers to professional businessmen.

These contributions to progressive photography were individual efforts. The Bauhaus, on the other hand, was a strong centre of activity and 'new vision'; this school of contemporary design in Weimar Germany opened in 1919, and from the start photography was appreciated as the image-making device of the modern world. A leading teacher at the school was the Hungarian-born László Moholy-Nagy, who advocated the importance of non-representational art, based upon the abstract elements of light, texture and balance of forms. This led him to experiment in the production of photograms where the camera was dispensed with altogether, leaving photography in its purest form – the play of light on photo-sensitive emulsions.

Moholy-Nagy had great aspirations for photography and in 1928 said, 'The illiterates of the future will not be those who are ignorant of writing but those who are ignorant of photography.' Seeing photography as the prime art form of a progressive

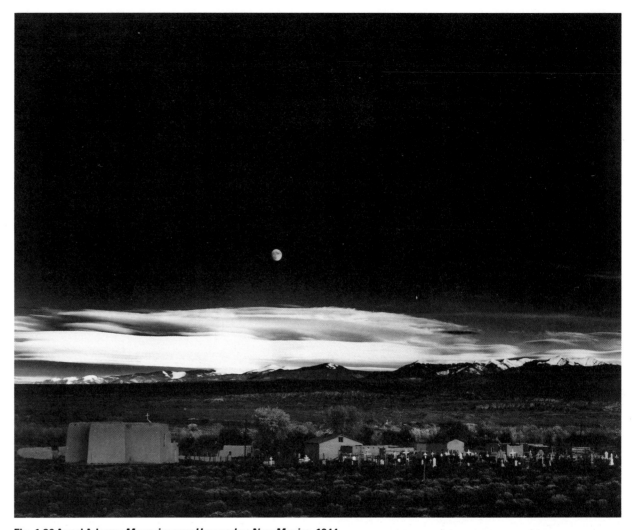

Fig. 1.26 Ansel Adams: *Moonrise over Hernandez, New Mexico,* **1944.**

society, he felt it to have no limitations and broke with Renaissance traditions of perspective by photographing from high viewpoints, and also experimenting with X-rays and photomicrography (taking photographs through a microscope).

In a similar vein, the American painter and photographer Man Ray carried his involvement in surrealism into his camera work, producing what he called 'Rayographs', or photograms. He also used the Sabattier effect (see p. 105) and photomontage to enhance his fashion and portrait work. Although Man Ray's experimental imagery had no practical significance at the time, it did much to uproot outmoded photographic conventions and encourage young photographers such as Bill Brandt and Angus McBean to explore and apply the medium's creative potential.

Born in 1904, Bill Brandt, a British photographer and former student of Man Ray's, was undoubtedly one of the greatest figures in twentieth-century

photography. Whatever the photographic subject, he continued to produce a memorable image from it. In 1948 he said,

'The photographer must have and keep in him, something of the perceptiveness of the child who looks at the world for the first time. We are most of us too busy, too worried, too intent on proving ourselves right, too obsessed with ideas to stand and stare; we look at a thing and think we have seen it, and yet what we see is only what our prejudices tell us should be seen, or what our desires want us to see. Very rarely are we able to free our minds of thought and emotions and just see – for the simple pleasure of seeing, and so long as we fail to do this, so long will the essence of things be hidden from us.'

It is this keen vision and perception of the world that enabled Brandt to produce innovative images of purity and intensity. His early work included social

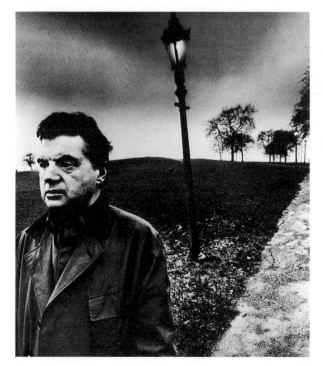

Fig. 1.27 Bill Brandt: *Francis Bacon Walking on Primrose Hill, London, 1963.*

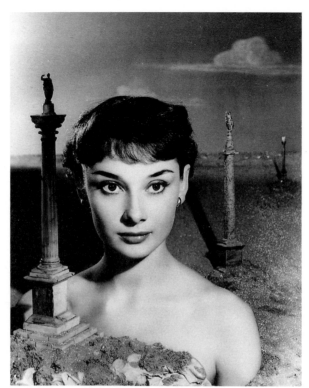

Fig. 1.28 Angus McBean: *Audrey Hepburn, c.* **1950.**

documentation which he collected in a remarkable book *The English at Home* published in 1936.

Brandt was influenced considerably by the surrealists and was interested in the creative potential of high-contrast images. He combined these concerns with a strong sense of atmosphere to produce a series of incisive portraits of poets and writers (Fig. 1.27), together with an extensive study of the nude human form (1950s). In the latter collection, an old plate camera with a pinhole aperture was used to create strange, distorted nudes in rooms and landscapes, which nevertheless seemed familiar.

Angus McBean, the English theatrical photographer, was also influenced by the surrealist movement and had a similar feel for atmosphere. Starting in the 1930s, McBean sought to capture the

fantasy world of theatre with fanciful stage sets and dramatic lighting. McBean produced a long series of promotional photographs (Fig. 1.28) by imaginative use of a large-plate camera, props, masks and the stars of the theatre world.

DOCUMENTARY PHOTOGRAPHY

Photography had been widely recognised as a powerful means of communication and propaganda by the turn of the century, but, with the end of World War I, its strength as a medium of documentation was now also realised. Unlike propaganda and advertising, documentary photography is concerned with an honest and objective depiction of people and events.

One of the earliest photographers in this field was a Frenchman, Eugène Atget. Almost unknown until shortly before his death in 1927, Atget came to photography late in life following a varied career in the Navy and the theatre. His photographic subject was what he knew and understood best – his native city of Paris. With straight, sharp imagery, Atget photographed the people, streets and parks to complete an extensive record of a dying culture.

Meanwhile, in the USA, a school teacher, Lewis Hine, took up the camera to bring to public attention the terrible living conditions of foreign immigrants and the horrors of child labour. Following Jacob Riis, Hine showed how the photograph with its power of realistic representation and capacity to tell stories could lead to change and social reform.

One of the most famous social documentation projects using the camera was that carried out by the Farm Security Administration in North America. Eleven photographers with different backgrounds and photographic strengths were commissioned to record the devastation of the American Midwest during the depression of the 1930s. Working under Roy Stryker, photographers such as Dorothea Lange, Walker Evans, Arthur Rothstein and Ben Shahn were to capture the plight of homeless

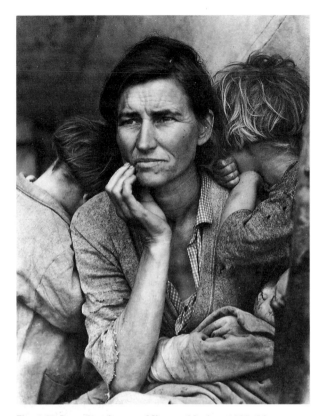

Fig. 1.29 Dorothea Lange: *Migrant Mother*, **1935–36.**

designers, with their diverse talents, escaped from growing Nazi oppression and settled elsewhere.

Following the success of the German picture magazines, the West, too, evolved large picture periodicals as a forum for creative photographic activity and as an important new medium.

In America, *Life* magazine reached the news-stands in 1936, while in Britain and France, *Picture Post* and *Vu* respectively were on sale. The example of extensive use of photography was followed by *Vogue* and *Harpers Bazaar*, printed in colour and still on sale today.

The more the public saw of these illustrated weeklies, with their photo-stories and coverage of both the everyday and extraordinary, the more they demanded. It was not until the advent of television in the 1950s that these magazines began to dwindle in popularity.

Despite paper shortages, the Second World War itself provided the challenges and drama needed in order for the magazines to thrive. The public were eager to know, through the photographers' eyes, what was happening, and never before had war been so widely and comprehensively recorded.

During World War I, journalists had been subjected to heavy censorship, and photography in the battle zones had been punishable by death. Now, with a far greater freedom allowed them, many photojournalists, such as Eugene Smith and Robert Capa, found themselves receiving national acclaim. Capa, using a lightweight Leica, recorded many memorable and dramatic images of action and

farming families in the wake of dust storms and economic disasters. In photographs such as Lange's 'Migrant Mother' (see above), we can sense the unbearable human despair, starvation and bitter cold. The FSA pictures, through their illustration of human suffering, showed the power of the documentary photograph – its ability to inform, to make real and to inspire compassion.

THE PICTURE PERIODICALS

With the approach of the Second World War, there was a flight from Nazi Germany towards the West – and particularly to America and to Britain. Scientists, engineers, photographers, artists, intellectuals and

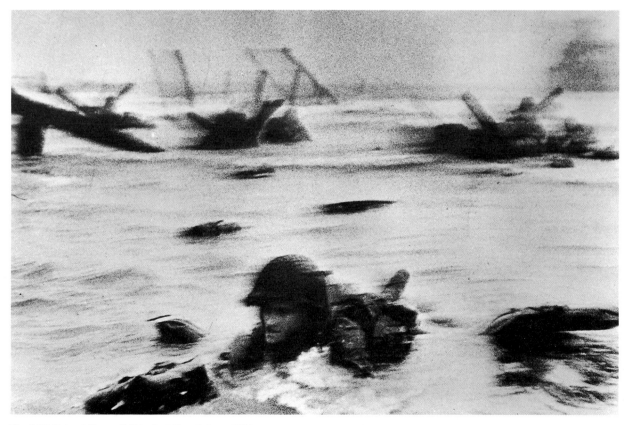

Fig. 1.30 Robert Capa: *D-Day Landing*, **6 June 1944.**

destruction from five major conflicts. The realism of these images, such as 'Death of a Loyalist Soldier' taken in Spain, 1936, makes the true horror of war apparent. Capa's 'D-Day Landing' (Fig. 1.30) is typical of his style. The movement is captured, and the immediacy of the event shows how dynamic the still photograph can be. Capa's saying was 'If your pictures aren't good enough, you aren't close enough', and he produced a great body of work with a sense of 'being there'. However, this active involvement resulted in his death in 1954 when he was killed by a land-mine in Indochina.

Britain, too, had its master of the Leica whose images were seen regularly on the pages of *Picture Post* before and after the war years. His name was Bert Hardy. Born in a poor district of London in 1913 and starting his career as a teenage darkroom boy, Hardy was a natural photographer and proved himself to be a strong all-round camera man. Working on photo-stories for *Picture Post*, Hardy produced an extensive and sensitive series of photographs, varying from the children of the Glasgow Gorbals, Chinese seamen in Liverpool, Londoners of the Elephant and Castle area and firemen in the Blitz, to the Queen's wedding. Whatever the focus of Hardy's attention, in war or peace, he always photographed with an inner compassion and empathy for his subjects. He was a master of light, both artificial and natural, and possessed a trigger sense of when to shoot the picture.

This candid and spontaneous photographic response to life would not have been possible without the availability of miniature cameras such as the Leica. However, it is also important to appreciate that without the creativity of innovative photographers behind the lens, producing a broad spectrum of outstanding work, the Leica and 35 mm film would never have achieved the status they have today. The work of Capa and Hardy helped to establish 35 mm photography as a serious and professional medium. For a creative style independent of other applications, however, we must look to the 'human interest' photographer,

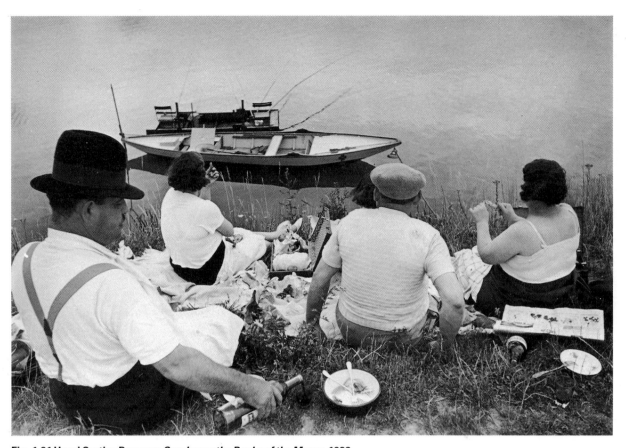

Fig. 1.31 Henri Cartier-Bresson: *Sunday on the Banks of the Marne*, 1938.

Henri Cartier-Bresson.

Born in France in 1908, Cartier-Bresson's approach and unique style is encompassed in his 1952 publication, *The Decisive Moment*. This compilation of images made with a Leica gives a unique insight into the lives of others. No other photographer has aligned him or herself so precisely to the rhythm of a moment and responded so instinctively. Images such as 'Place de l'Europe' (p. 88) capture a fast-fleeting moment, while 'Sunday on the Banks of the Marne' has a feel of suspended time. The rotund characters sit with their backs to us and, seemingly oblivious of each other, enjoy their picnic while down below, in stark contrast, lies their elegant boat. Time stands still and we can only muse on their lives, hopes and relationships (Fig. 1.31).

We have looked at reportage (photojournalism) and documentary (social concern) work as well as 'art' photography or supposedly meaningless experimentation, all somewhat labelled and categorised. It was Edward Steichen who first realised how superfluous these labels were and, upon becoming the director of photography at the Museum of Modern Art in New York in 1947, he set about the task of unifying and promoting photography as a whole. He sought to gain acceptance for the photograph in a museum setting and, during his career at MOMA, exhibited the work of young, relatively unknown, photographers and of those working in the new field of colour.

The culmination of his work came in 1955, when Steichen staged an exhibition of photography – The Family of Man – from 68 countries. In this extensive series of images by 273 photographers, Steichen showed the world that photography as a medium had gained so much strength that one could no longer differentiate between an image produced for art's sake and one produced as a social statement. The technical competence and creative sensitivity of the individuals working in all spheres of the medium had broken these barriers, so that Dorothea Lange's 'Migrant Mother' was as much art as was Weston's 'Zohmah and Jean Charlot at Point Lobos' (Fig. 1.32). The Family of Man exhibition covered every aspect of life from birth to death, with all its joys and sorrows from every creed, colour and nation. It was one of the most challenging and ambitious projects photography had ever attempted.

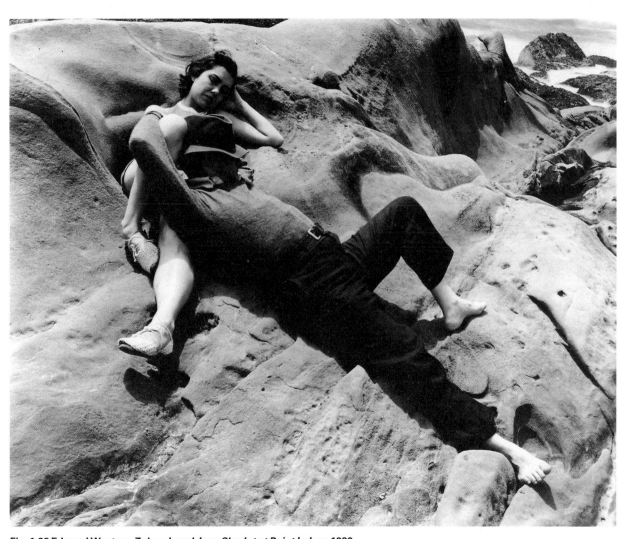

Fig. 1.32 Edward Weston: *Zohmah and Jean Charlot at Point Lobos*, **1939.**

THE PHOTOGRAPHIC INDUSTRY: 1930–60

While most professionals working in portrait, industrial or commercial photography tended to continue working with their large-format cameras and sheet film, the Leica gradually gained acceptance as a serious image-making device, in spite of its tiny negatives. With the help of improvements in design and its widespread use amongst journalists and serious amateurs, its popularity increased, until by the 1960s the 35 mm format dominated the market.

The E. Leitz Company continued to make new and better cameras, as did the Zeiss Company with its Contax model. But the latter was a rather expensive and early attempt to manufacture cheaper 35 mm cameras for the amateur, and it was not successful, mainly due to the economic depression of the 1930s.

The first real success in this area came with the American Argus Model A camera in 1935, which cost all of $12. But the greatest leap in production occurred after World War II when both Japan and the USA entered a period of intense industrial growth. The Canon and Nikon cameras followed the design example of an earlier instrument – the Kine Exakta. Marketed in 1937, it was the first single-lens reflex camera (SLR) produced.

The SLR was a direct descendant of the seventeenth-century camera obscura with the advantage of allowing the photographer to see directly through the 'taking lens' instead of through a separate viewfinder. Now the lens and the photographer saw the same picture, thereby eliminating any problems with focusing, framing and composition. The early SLRs, however, suffered from two drawbacks: first, the image on the ground-glass screen (designed for waist-level viewing) was difficult to see, and secondly, when an exposure was made, the camera view was lost to the photographer as the SLR mirror swung out of the way to allow

image light to pass to the film. The mirror returned to its former (viewing) position only when the film wind-on had been advanced in readiness for the next exposure. These early problems were soon overcome, however. First, there was the Contax S camera (1949) which incorporated a pentaprism above the ground-glass screen to allow for convenient eye-level viewing with correct sense, i.e. without lateral reversal of the image, and then, in 1957, Asahi Pentax invented the instant-return mirror, which solved the second problem. Finally, in 1959, the Nikon Company incorporated the two design features into its classic Nikon F model, from which time the 35 mm SLR has been the most popular camera (Fig. 1.33).

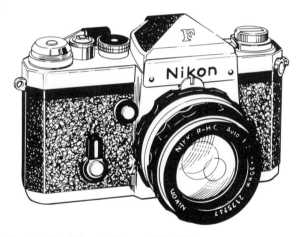

Fig. 1.33 The Nikon F 35 mm SLR, 1959.

As far as artificial lighting is concerned, in 1930 expendable flashbulbs superseded the dangerous magnesium flash powder that had been used at the start of the century. To begin with, these flashbulbs were both expensive and bulky, but both cost and size were soon reduced which made them available to amateurs and professionals alike. Bulbs could be synchronised with the shutter to make instantaneous flash pictures possible, and they could also be used with a reflector dish to control the direction of illumination.

Dr Harold Edgerton of the Massachusetts Institute of Technology (MIT) (USA) was one of the first to experiment with high-speed or 'strobe' flash photography. Using ultra-fast discharges of electrical energy, he was able to slice time more thinly than Muybridge had done to produce awe-inspiring images of, for example, a golfer's swing (Fig. 1.34), bursting balloons or a splash of milk.

Electronic flash was soon simplified and miniaturised so that by the early 1960s portable, battery-powered units could be purchased at a reasonable price as an alternative to bulbs. While these were not as powerful as studio units, they were far more economical than bulbs, which burn only once and are then discarded. This new technology obviously had an effect on the photographic styles of the time, and the 1950s and 1960s became the era of artificial light, especially in fashion photography and portraiture, where there were new multi-exposure effects possible. Gijon Milli, a photographer for *Life* magazine, became renowned for his fascinating motion studies which he produced using electronic multi-flash.

Flash photography became more and more popular with studio photographers, but there was at the same time a strong reaction against it. This came from a band of pictorialists, who, with their candid 35 mm photography, advocated the use of natural light alone, feeling that any use of artificial light was sinful.

Early colour processes were based on the additive synthesis of colour. The Autochrome process of 1907 relied upon red, green and blue dyed starch grains, randomly sprinkled over a light-sensitive plate, over which a panchromatic emulsion was coated. Subsequent to exposure (via the glass side of the plate, so as to filter the image light through the tiny coloured elements), the plate was processed by a reversal method to yield a positive image. This resulted in a colour transparency since the individual colour elements were too small to be seen at normal viewing distances.

In a similar fashion, the Finlay colour system used a regular red, green and blue ruled screen, which could be employed with any suitable panchromatic

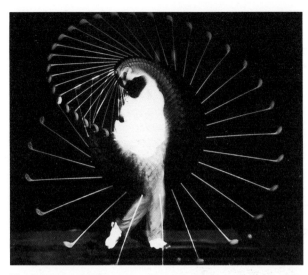

Fig. 1.34 Harold E. Edgerton: *Multiple-flash photograph of the golfer Dennis Shute, c.* 1935.

plate. All that had to be done was to expose the emulsion under the Finlay screen, process the plate to a positive, and view it under a similar screen that took into account the nature of artificial (viewing) light.

By the 1930s, Finlay had given way to the more commercially developed additive colour process known as Dufaycolor. Now manufactured as roll-film, Dufaycolor incorporated a very fine ruled screen capable of reproduction.

The first convenient and reliable colour emulsions were not introduced until the mid 1930s with the advent of the integral tripack emulsion, the system now in use today. The term 'integral tripack' indicates the nature of the material – an emulsion pack constructed like a sandwich of three layers. Each layer is sensitive to either red, green or blue light and is linked with the necessary dyes and **colour couplers** to produce a full colour image with a single exposure.

The most successful of these new colour films were Kodachrome (1935) and Agfacolour (1936), the former being the invention of two American musicians and amateur photographers, Leopold Mannes and Leopold Godowsky Jr. Working for

Eastman Kodak, they were able to devise a reversal film which produced richly saturated, sharp colour slides for projection. At first, Kodachrome was only available in 35 mm size, thereby further encouraging the use of small-format cameras. In 1941, Kodacolor negative film came on to the market, allowing for the relatively cheap reproduction of colour prints. The immense popularity of Kodacolor in amateur circles firmly established colour photography's future until by 1960 its sales exceeded that of black and white materials.

Most professional photographers of the day tended to use large-format colour films, preferable for quality. Two of the highest-quality systems of the immediate post-World War II years were the Tri-chrome Carbro, and Kodak Dye-Transfer colour-print processes. As far as colour photography was concerned, until the 1950s, most professional photographers tended to use large-format colour films, which were time-consuming and difficult to handle, but which gave superb colour quality. Nevertheless, the use of large-format equipment had a bad effect on the colour work done in fashion portrait and still life, making it static and boring.

Two photographers who broke away from this staid approach to colour were Ernst Haas, a photojournalist, and Irving Penn, a fashion and still-life photographer for *Vogue*. Haas used 35 mm film in the 1950s to produce beautiful and poetic colour images. These incorporated deliberate subject movement, thereby creating mood and allowing a freer use of the colour medium. Penn enlarged small portions of 35 mm transparencies to reveal the impressionistic intricacies of grain.

In spite of these great steps forward, the most revolutionary photographic invention was that in 1948 of the Polaroid Land camera and film by Dr Edwin Land. Land wanted to produce an *instant* photograph without any need for time-consuming processing and printing. What he did, in effect, was to incorporate the darkroom chemistry into one small sheet of film, so that when an exposure was made and the film ejected, a pod was broken to release the chemistry required to develop and fix the image as a positive print.

Polaroids were at first messy, inconsistent in quality and also expensive to produce. However, the novelty of the instant picture, coupled with Land's determination to succeed, meant that the Polaroid was here to stay. With gradual improvements, it eventually established itself, particularly in scientific laboratories where the almost instant record taken from microscope or oscilloscope saved valuable time and money. Polaroid also found favour with professional photographers who, working in field conditions, could now have graphic evidence concerning the exposure and composition of an expensive photograph before making the final exposure on colour materials. Polaroid materials have also been fully exploited as a creative medium in their own right: Andy Warhol and David Hockney are just two artists who have made extensive use of Polaroids in their own work.

In terms of the history of the world, photography is still very young, but, as it passes its 150th birthday, we may reflect upon its many achievements, both technical and creative, and only wonder at its future.

We have seen photography develop from two basic fields of science – chemistry (light-sensitive materials) and physics (camera instrumentation) – to a future which seems destined to rest in electro-optics. We already have holography, providing truly three-dimensional imagery, and this, too, must be included in future developments.

So where do we go next? Forward or back? It is a strange fact that as technology progresses people become increasingly interested in techniques and styles of the past. One well-known example is the rebirth of the creative appeal of black and white photography in all its simplicity.

Now, however, having briefly run through the history of the medium, let us look at the science behind it.

2

Optics and

Visual

Perception

'Of what use are lens and light
To those who lack in mind and sight?'
(Translation of Latin inscription on a Brunswick thaler in 1589)

Photo: Virginia Bolton

LIGHT

Photography is a convenient method of representing something seen. But it is only a two-dimensional representation, whether in monochrome (black and white) or colour. Furthermore, a photograph is only a slice of time, whereas human vision provides a continuous flow of images, backed up by a brain that allows us to interpret what we are seeing (in terms of our previous experience). Indeed, if it were not for the fact that the human eye is a direct extension of the brain, we would find it hard to understand the relatively primitive images provided on a flat piece of paper, i.e. photographs or drawings.

We shall return to this topic later in the chapter. Meanwhile, let us disregard the complex differences between eye and photograph for a moment, and consider what is responsible for both forms of imagery – light.

Light is strange stuff. We cannot see it, but we see by it! So what is light? We know it comes from the sun but, as we shall discuss further in Chapter 3, it is possible to create light from artificial sources as well and many of these are very important to photography.

Light is energy, streaming as radiation from a source, and unless you are looking directly at that source, it is invisible – a ray of light passing through empty space cannot be seen. Light is simply that band of electromagnetic radiation (EMR, see Box 2.1) that is capable of stimulating the eye. Like all such radiation, it travels at a speed of 300 000 000 metres per second in free space. (300 000 000 metres per second can be written as 3×10^8 m/s for short. The number 8 gives the number of zeros that follow the 3.) The study of light is a branch of physics called optics, but by definition 'light' requires an 'eye' in order to be sensed – and so we have to bring humanity into the science as well. 'Visual science' therefore involves some knowledge of anatomy (eye and brain) as well as psychology. The important thing to remember is that *the spectrum of radiation we call 'light' is defined by the properties of the human eye.*

BOX 2.1

Electromagnetic radiation (EMR)

Light is only a small portion of the entire spectrum of energy known as **electromagnetic energy** which, as the name suggests, exists in the simultaneous form of electricity and magnetism. These two forms of the same energy are transmitted together as electromagnetic radiation (EMR). One cannot exist without the other: a flow of electric current always produces magnetism, and magnetism is used to produce electricity.

When a current is passed through a conductor (such as a length of copper wire), a **magnetic field** is created round the conductor. This can easily be seen by putting a small compass needle close to the conductor where, under appropriate conditions, the needle will deflect as soon as the current is switched on. If a second compass needle is now placed a short distance away (Fig. 2.1), this too will be deflected, but this second deflection will take place a very small fraction of a second later than the first. This short delay is an important clue to the nature of EMR: it is obvious that the magnetic field (induced by the current being switched on) does not appear instantaneously through the whole of space. It takes time to reach the second compass needle. In fact, it is propagated outwards from the source at a velocity of 300 000 000 metres per second (3.8×10^8 m/s). Since the magnetic field created in this way also has an electrical field associated with it, the two are known as an **electromagnetic field** and are propagated through space as EMR.

The electromagnetic spectrum is continuous, but for convenience we usually divide it up into sections corresponding to the different methods of generating (and detecting) this energy. The groups of electromagnetic energy in order of decreasing wavelength (see Box 2.2) are as follows: alternating currents (domestic electricity); radio waves; microwaves; infrared radiation; the visible spectrum of light; ultra-violet radiation; X-rays; gamma rays; and cosmic rays. See Fig. 2.2.

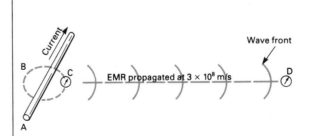

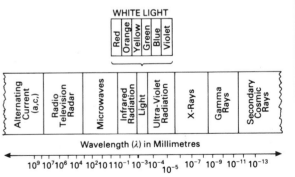

Fig. 2.1 Propagation of a pulse of EMR. When the current is switched on in the conductor, A, it induces an associated magnetic field (B). The compass needle at C deflects instantly, but if the compass needle at D is 300 000 000 metres from C, then the needle at D will not be deflected until one second after the deflection at C.

Fig. 2.2 The electromagnetic spectrum. Note the relatively small visible (light) section. Photographic materials can 'see' further than the human eye and are sensitive a little way into the infrared when specially sensitised for infrared recording. All photographic materials are naturally sensitive to the ultraviolet, x-rays and gamma rays.

It is generally accepted that all EMR, including light, behaves as waves. If a stone is dropped into water, ripples spread out as a series of circular waves along the surface of the water. In the same way, a point source of light positioned in space, like our sun, emits energy in the form of waves spreading out in every direction. This **wavefront** travels at 3×10^8 m/s (see Box 2.2).

Electromagnetic radiation is a basic concept in physics, and the science of light covers many theoretical concepts. We shall limit our understanding of the subject to:

(i) geometrical optics;
(ii) the visible spectrum (light);
(iii) visual perception.

GEOMETRICAL OPTICS

In geometrical optics we think of light as **rays** that travel in straight lines. We call any material that light can travel through, such as air, water or glass, an **optical medium**. The speed of light is different in different materials: it travels more slowly in water or glass than it does in air. The frequency, v, of the light is a constant (it is a property of its source) and so, as $c = v\lambda$ (Eq. 2.1), if c is reduced so also is λ.

When light reaches matter that cannot be seen through (what we call opaque), it is **absorbed** and much of its energy is converted to heat. If the surface of that opaque matter is shiny, then some of the light will be **reflected**. However, when light falls on an optical medium such as glass or water, then we may expect most of it to pass through it (be **transmitted**), although if the surface is smooth then some (or even all) of the light will be reflected. Further interactions with matter include **scattering**, where small particles in air or water, or rough-surfaced glass, can scatter the direct rays to produce what is known as **diffuse-light transmission**. Most important of all, perhaps, is the ability of some materials, such as glass, to **refract** (bend) light, for it is this bending of light that allows us to make lenses.

BOX 2.2

Electromagnetic waves

There are many ways of transferring energy, for example by collision or explosions. One very important method is by wave motion.

Wave motion and the transfer of energy are best explained by looking at what happens to water when a stone is thrown into a perfectly still pool. As the stone enters the water it sets up a disturbance in the water particles to create waves that eventually reach the edges of the pool. But the particles of water do not move towards the edge of the pool. They simply move up and down. Only the disturbance (energy) moves outwards from the stone as a series of wavefronts. A wave in which the particles move at right-angles to the direction of travel of the wave is called a **transverse wave**.

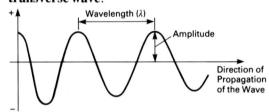

Fig. 2.3 A transverse wave.

Figure 2.3 shows a transverse wave. The distance between one wave crest and the next is called the **wavelength**. It is given the symbol λ (Greek lambda). The maximum height of the wave is called the **amplitude**. The number of waves produced per second is called the **frequency** (symbol v: Greek nu). If three wave crests pass a certain point in one second, we say the frequency of the wave is three per second, or three hertz (symbol Hz).

If we look again at Fig. 2.1 (Box 2.1), we can imagine the conductor carrying an alternating mains current (a.c.) which reverses its direction of flow 100 times per second. When the current flows in one direction, an electric field builds up around the conductor as we saw in Box 2.1. When the current flows the other way, the direction of electric field changes too. But the electric field does not change all at once, and a graph of the electrical field energy against time has the same shape as a water wave (Fig. 2.3). In this example, if the current changes direction 100 times in one second, one complete cycle of the electric field (from positive to negative and back to positive again) will happen 50 times a second. The frequency of this wave is 50 cycles per second or 50 Hz.

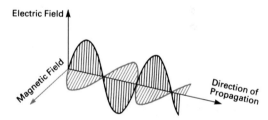

Fig. 2.4 A transverse electromagnetic wave.

The electrical field always has a magnetic field associated with it (Fig. 2.4) and the two together are called an **electromagnetic wave**. The magnetic field is at right-angles to the electric field, and both are at right-angles to the direction of travel of the wave. So electromagnetic waves are transverse waves.

Light waves are electromagnetic waves. However, the interaction of light with matter depends only on the electric field, and so we can ignore the magnetic field and represent light waves as in Fig. 2.3.

The wavelength (λ), frequency (v) and speed of propagation (c) of a wave are related by the formula:

$$\lambda = \frac{c}{v}$$

Eq. 2.1

BOX 2.2 continued

The speed of all electromagnetic waves in free space is 300 000 000 m/s (3×10^8 m/s).

Wavelengths of light

If we refer to Fig. 2.2, we can see that white light is a very small portion of the whole electromagnetic spectrum. The visible spectrum ranges from red (long wavelengths) through green to blue or violet (short wavelengths). The centre of the visible spectrum is green light at a frequency (ν) of 6×10^{14} Hz (600 000 000 000 000 cycles/s). The wavelength of this light in air (which is really very little different from free space), is given by:

$$\lambda = \frac{c}{\nu} = \frac{3 \times 10^8}{6 \times 10^{14}} = 0.5 \times 10^{-6} \text{ metres}$$

which is the same thing as saying 0.5/1 000 000 metres, or half of a millionth part of a metre! Such small units are very inconvenient, however, and so we must introduce a new unit known as the **nanometre** which has the value: 1/1 000 000 000 metre, or 10^{-9} metre.

Note: For those not familiar with scientific notation, the calculation given above can be explained as:

$$\frac{3 \times 10^8}{6 \times 10^{14}} = \frac{3}{6} \times \frac{10^8}{10^{14}}$$

$$= 0.5 \times 10^{(8-14)}$$

$$= 0.5 \times 10^{-6}$$

This is a quick way of dealing with all those zeros.

We can therefore say that our wavelength of 0.5×10^{-6} metres is the same thing as 500×10^{-9} metres, and since 10^{-9} metres is a nanometre (symbol: nm), we can put $\lambda = 500$ nm.

The **amplitude** of the wave shown in Fig. 2.3 indicates the *amount of light* (EMR) associated with that wave. Furthermore, any point on the wavefront (as shown by Fig. 2.1) will travel in a direction perpendicular to the wavefront. As a consequence, we may think of light as travelling in straight lines and in every possible direction from its source. This is the basis of geometrical optics.

The interactions of light with matter have some important implications for photography. We shall consider them in greater detail.

ABSORPTION

Total absorption of light is almost impossible. There is a small amount of reflection from even the blackest of black surfaces. Wherever absorption occurs, the light energy is transformed into heat energy. So we must be careful when using powerful lights in a studio, particularly where inflammable or fragile items are being photographed.

Although we usually think of EMR as a wave, when it is absorbed by matter it behaves as if it were a stream of tiny particles of energy called **photons**. This is how we think of it when we look at how light affects photographic film (see Chapter 3).

REFLECTION

As mentioned earlier, absorption is never total, but the degree of reflection from a surface will depend upon the nature of that surface and, to a varying extent, the nature of the incident light (i.e. the light falling on it). In photography, reflection is more important than absorption since it is the light energy reflected from objects that we record.

All reflective surfaces have a **reflection-factor** (RF) (sometimes called **reflectance**) depending on their nature. The best possible reflection we get in nature is from fresh snow, which can have an RF in the region of 99.8% A good-quality white card will have an RF in the region of 85%, and from best-quality 'black-flock' material (which has small hairs to act as a light-trap) we can expect something just less than 1% reflection. The best possible 'black' that we may get from a glossy photographic print will result from a reflection factor of about 2%, but if the printing paper has a 'matt' surface, then the RF will be much higher – due to the diffuse nature of the reflection (see below).

Two different types of reflection exist, the best known being that called **specular reflection**. This is the kind of reflection you get in a mirror. The laws of specular reflection are simple (see Fig. 2.5). The angle of incidence of the ray of light (i) is equal to the angle of reflection (t), with respect to the normal-to-the-surface (the line that is perpendicular to the surface). For specular reflection to occur, the surface must be highly polished, but there are many instances where mirror-like surfaces, such as smooth water, rain puddles, gloss-paint, etc. can give rise to reasonably good reflected images – all with possibilities for photography.

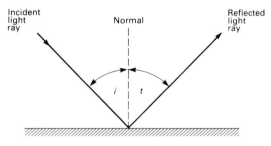

Fig. 2.5 Specular reflection.

The second type of reflection is called **diffuse reflection**, that is to say reflection from objects from which you could not gain a clear image as you do in a mirror. The diffuse nature of such reflection is shown

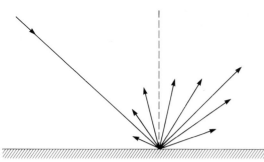

Fig. 2.6 Diffuse reflection.

in Fig. 2.6. The light is reflected in all directions, because the reflecting surface is not perfectly smooth. The distribution of diffuse reflection will depend upon the subject. Some surfaces even allow both types of reflection to occur, but it is important to note it is diffuse reflection that allows us to see the detail and texture of an object.

Reflection can cause light to be polarised – see Box 2.3.

SCATTERING OF LIGHT

As mentioned above, when light passes through our atmosphere (which is not pure air) it is scattered by reflection from small particles (dust, pollen, smoke, etc.). The amount of scattering depends on the size and quantity of the particles present in the air.

We know that 'light' is made up of various wavelengths (λ), and later we shall consider wavelengths in terms of how we 'see' them as colour. Figure 2.2 shows that the shortest wavelengths we can see are blue, and the longest ones are red, and it is the shortest wavelengths that are scattered the most. This is why the sky appears blue. The particles in the air over an industrial city are quite large, of course (because of pollutants), and as a consequence the sky is more grey than blue, because the larger particles scatter the longer wavelengths as well. But over a tropical sea, where the air is filled only with the smallest of particles, we shall always find a blue sky.

BOX 2.3

Polarisation of light

Before we leave the subject of reflection, we should discuss another property of light – polarisation. Look back at Fig. 2.3.

This shows an electromagnetic wave in one plane. In fact, in a normal wavefront coming from a light source, the waves are vibrating in every direction at right-angles to the direction of travel of the light. Seen head on, this can be represented as in Fig. 2.7(a). But when light is 'polarised' the vibrations occur in only one plane (Fig. 2.7(b)). Light may become polarised when it is reflected and, at a given angle of incidence (from the normal-to-the-surface), it will be totally polarised.

We have all experienced the difficulty of seeing objects behind a shop window, where reflections confuse what we see behind the glass. Although we can, in some cases, change our viewpoint to avoid the worst of these effects, this is not always practicable for photography. If we want to take a photograph under such conditions we can use a **polarising filter**. This is placed on the front of the lens and can be rotated to remove light that is polarised in a given direction. Like all filters, the polarising type is selective. In this case it must be rotated in front of the lens (or eye) so that its axis of polarisation is at right-angles (90°) to the plane of polarisation of the reflected light. In that way the material of the

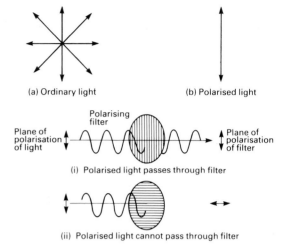

Fig. 2.7

filter absorbs the polarised (reflected) rays, but not those which come from behind the glass.

Light is also polarised by **scattering**. The blue colour of the sky is due to scattered light, and that coming from a clear blue sky (at right-angles to the line-of-sight to the sun) is partially polarised. This fact is useful when in colour photography you wish to darken the blue sky – usually to gain dramatic effects in landscape work. In the same way as above, the polarising filter is rotated, either in front of the eye or over the camera lens, to a position where the (mainly) polarised light from the blue sky is reduced to gain the effect required. (See also p. 74.)

TRANSMISSION

If we neglect the small effects of scattering by the atmosphere, we can say that the sun's rays are **directly transmitted** to Earth, and such direct transmission is characterised by sharp shadows. But if there is a significant amount of scatter, either from smoke, or thin cloud, then the shadows are 'soft' with unsharp edges, and we consider the light to be **diffusely transmitted**. The conditions for perfect transmission are simply that the incident light is neither absorbed nor scattered. For example, observe the shadows around you on a bright sunny day, and consider the reason for their absence when the sky is overcast.

Direct transmission

In a clear pool of water, we may see the bottom distinctly, by direct transmission of light. If, however, we disturb the water, or it is polluted with particles of sand or mud, then we may no longer see the detail, since the light is now only diffusely transmitted to the eye. Furthermore, even if the medium (water or glass) is only semi-transparent (partially absorbing), then direct transmission is still possible – provided that the light is not scattered. In short, direct transmission is essential wherever an *image* is required, as it is in photography, and the glass used for lenses must be of the highest quality, free from scatter and absorption.

Diffuse transmission

With diffuse transmission, light is not necessarily absorbed so much as scattered. Optical media that provide this type of transmission are often called **translucent**. They allow light to pass, but do not reveal detail. There are a number of applications for diffuse light in photography and we employ 'diffusers', such as ground glass, tissue paper, plastic sheets, etc. to provide even illumination for printing (contact printers, enlargers) and in the studio for 'softening' the shadows cast by spotlights. But, most importantly, we use ground glass screens in cameras so that the image may be seen!

REFRACTION

When light passes from one kind of optical medium to another, its velocity (*c*) is changed. For example, if light passes from air to glass then it will be slowed down since it is entering a medium of higher optical density (glass is more dense than air). Similarly, when a ray of light leaves glass and enters air, the light is speeded up.

If a ray of light is directed at a block of glass so that its angle of incidence (*i*) is at some angle to the normal-to-the-surface (see Fig. 2.8), then it enters

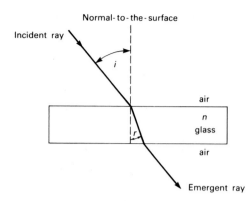

Fig. 2.8 Refraction at a block of glass of refractive index *n*.

the glass at an angle (*r*) to the normal. This *bending* of the light is known as refraction and follows a simple rule:

$$n = \sin i/\sin r \qquad \text{Eq. 2.2}$$

where the constant (*n*) is known as the **refractive index** (RI) for the medium involved (in this case, glass).

Equation 2.2 tells us that the ratio of the sine of the angle of incidence (*i*) to the sine of the angle of refraction (*r*) is a constant value *for a particular optical medium and a specified wavelength* (λ). This constant is the RI for that material. Different types of glass have different RIs, and most values are quoted for yellow light at a wavelength of 589 nm.

Refraction may easily be likened to the effect on a vehicle when it travels from one medium to another. Just as the beach buggy in Fig. 2.9 is slewed round as it reaches the boundary between a road and sand, so does the wavefront of a ray of light change direction when it travels from air to glass, and from glass to air. (Note how, with a parallel block of glass, the emergent ray is parallel to the incident ray, as shown in Fig. 2.8.)

Prisms

In Fig. 2.8, we saw that the light ray is deviated *towards* the perpendicular (normal) when passing from air to glass, but when the ray leaves the glass block (passing from glass to air) it deviates *away*

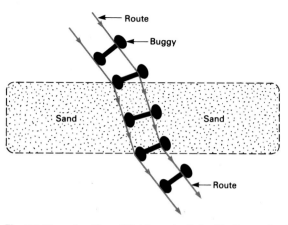

Fig. 2.9 The refraction of light can be linked to the route of a 'Beach Buggy' as it travels from a hard surface over a patch of sand. Note how the 'Buggy' wheels are slewed round as soon as one wheel travels slower in sand (denser material).

from the normal. When light is incident upon a glass prism, as shown in Fig. 2.10, the air–glass and glass–air deviations bend the light towards the base of the prism. If two identical prisms are placed base-to-base, as in Fig. 2.11, then we have formed a primitive lens. We shall consider this further in Chapter 3.

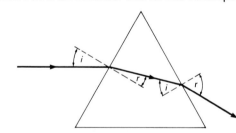

Fig. 2.10 Bending of light by a prism.

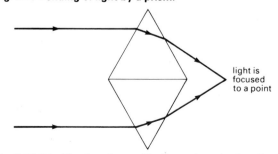

light is focused to a point

Fig. 2.11 Primitive lens formed by two prisms back-to-back.

Dispersion

We have seen that refraction bends light according to Eq. 2.2, and that the degree of bending is also a function of wavelength. The refractive index of a given type of glass varies according to the wavelength of the light passing through it. So if 'white' light is passed through a prism, it will form a **spectrum**, as shown in Fig. 2.12. Red light (longest wavelength), is deviated the least, and blue light (shortest wavelength) is deviated the most.

THE VISIBLE SPECTRUM

The part of the electromagnetic spectrum that is visible to the human eye is shown in Fig. 2.13, where it can be seen to extend from the blue (380 nm) to red (760 nm) at the extremities of human vision. Below the blue end of the visible spectrum is the ultraviolet, to which all films are very sensitive – although it is invisible to the eye. Similarly, those wavelengths immediately beyond the red are known as infrared, and although these radiations are also invisible to the eye, it is possible to purchase special infrared films which are sensitive to about 1000 nm. The eye is most sensitive to green light of about 555 nm, as shown by the visual response curve. (*Note:* the term Vλ shown on the graph of Fig. 2.13 refers to the visual response (V) of the human eye.)

STUDENT ASSIGNMENTS

1 Observe someone smoking a cigarette, when the cigarette is not being actually smoked (either in the hand or in an ash-tray). The rising column of smoke is blue. Yet when the cigarette is being 'smoked' the emitted smoke tends to become grey. Why?
Hint: Scattered light is due to atmospheric particles and scattering may be either selective or non-selective for wavelength depending on particle size.

2 The units used to measure the wavelength of light are very small and can be confusing. In this exercise it is important to notice the different ways in which the same measurement can be expressed.
The visible spectrum extends from 380 nm to 760 nm, with green light of 555 nm as the central peak of human eye sensitivity. In the following example, 555 nm radiation is expressed in different ways:

(i) $555 \text{ nm} = 555/1\,000\,000\,000 \text{ metre}$
 $= 0.000\,000\,555 \text{ m} = 555 \times 10^{-9} \text{ m}$
(ii) $555 \text{ nm} = 555/1\,000\,000 \text{ mm}$
 $= 0.000\,555 \text{ mm} = 555 \times 10^{-6} \text{ mm}$
(iii) $555 \text{ nm} = 0.555 \text{ μm (micrometre)}$
 $= 555 \times 10^{-3} \text{ μm}$
$(1 \text{ cm} = 10^{-2} \text{ m}; 1 \text{ mm} = 10^{-3} \text{ m};$
$1 \text{ μm} = 10^{-6} \text{ m}; 1 \text{ nm} = 10^{-9} \text{ m})$

Make the following conversions:

(a) Blue light of 420 nm to: **** μm
(b) Green light of 500 nm to: $500 \times 10^{**}$ cm
(c) Orange light of 620 nm to:
 ********** m
(d) Red light of 680 nm to: $680/*******$ mm

VISUAL PERCEPTION

As human beings, we rely on our eyes for most of our information. The eye is directly connected to the brain via the optic nerve – thus allowing us to react to visual stimuli within about a tenth of a second.

It is convenient and reasonable to compare the eye with the camera since they are similar in many ways. But we shall see that this comparison is very crude, particularly if we have fallen into the common trap of thinking that the eyes form a kind of three-dimensional picture in the brain. For although we may talk about 'visual images', the eyes actually feed the brain with a continuous stream of information, coded in the form of electrical impulses. These impulses produce patterns of brain activity which, together with previously stored information, cause us to 'see' what is in front of our eyes. The process of 'seeing' has best been described (in *Eye and Brain* by R. L. Gregory) as being rather like a written language. The letters and words on a page have a meaning for those who know the language. They affect the reader's brain appropriately, but they are not pictures. When we look at something, the resulting pattern of brain activity represents the object and to the brain *is* the object. There is no internal 'picture' at all.

EYE AND CAMERA

In Fig. 2.14, the eye and camera are compared. Both use a lens to focus an inverted (upside down) image on a light-sensitive surface (the **retina** in the eye, film in the camera). Both have an **iris** to control the amount of light entering. In dim light, the iris of the eye opens up automatically to admit more light through the eye lens. Similarly, in dim light the photographer may also open up the camera aperture (iris diaphragm) for the same reason. With some modern cameras this too is fully automatic.

In the camera the image is focused by moving the lens closer to or further away from the film, but in the eye the distance between lens and retina is fixed. The eye focuses light by changing the thickness of the lens. The thicker the lens, the shorter its focal length.

Like the human eye, the camera can accommodate a wide range of brightness, but it does so in a very different manner. We have seen that both systems employ an iris for controlling the amount of light that is passed through the lens, but by this device alone (known as **adaptation**) the iris of the eye controls only a small light intensity range. By comparison, the iris diaphragm in the camera lens will usually allow eight times as much variation. However, we cannot leave the comparison there, since the retina of the eye is quite different from film.

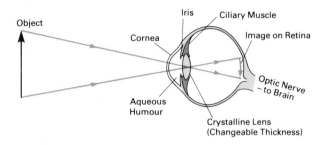

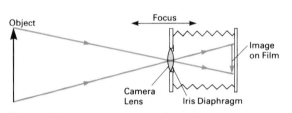

Fig. 2.14 The eye and the camera compared.

The retina is somewhat *grainy*, rather like film, but the grainy structure is made up of thousands of tiny receptor cells known as **rods** and **cones**. The cones are mainly concentrated at a small spot on the retina known as the **fovea**, and these cells are responsible for our daylight vision. When our attention is drawn to a specific subject, the eye focuses a rather crude image on the fovea, where tightly packed cones provide for two important characteristics of vision. First, the concentration of cones at the fovea is very high, so that they give us fine detail (in photography we would say **resolution**, and would require a fine-grained film). Secondly, they respond differently to different wavelengths of light, and so give us colour vision. The other cells, the rods, are spread over the remaining part of the retina and are responsible for our night, and dim-light, vision. Their excitation yields only neutral grey sensations, which accounts for the fact that we have no colour vision at night. (Dim light is not intense enough to stimulate the cones.)

Whereas the eye has dual sensitivity (rods and cones) to deal with large shifts of scene brightness, the photographic system has to employ a range of films. And just as our vision is less clear at night (rods), so are our photographs when we have to use very sensitive (fast) films. Although they allow us to make an image in dim light, the result is 'grainy' due to the larger-sized light-sensitive grains employed in the 'fast' film emulsions. We shall discuss these matters further in Chapter 3.

Fig. 2.12 Prismatic dispersion.

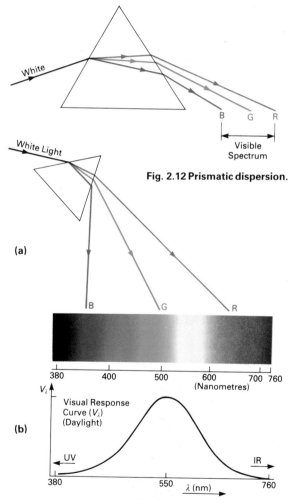

(a)

(b)

Fig. 2.13 The visible spectrum.

A very obvious difference between eye and camera is the necessity to have a shutter in a camera. Whereas vision involves a continuous flow of images, the camera (even a ciné camera) requires a separate exposure for each image. In some respects, photography can take advantage of this. At very low light levels, it is possible to stand the camera on a firm base (a tripod, for example) and make a long (time) exposure – for as long a period as is required to gain an image. A dim light acting for a long time has the same effect as a bright light for a short time. However, if the camera image moves during the shutter period, due to any form of camera movement, or movement of the object itself, then the camera image will become blurred. Thus in order to take a sharp photograph with a hand-held camera, a shutter speed of about 1/30 second is usually considered the longest period advisable.

COLOUR

The physical nature of colour was first understood by Sir Isaac Newton (1642–1727), who used the prism (Fig. 2.13) to display a spectrum from white light. Newton also realised that colour is a *perception*: it needs someone to receive the rays of light in order to interpret them as colour. He made this quite clear in a passage from his major work *Optiks*: 'For the rays to speak properly are not coloured. In them there is nothing else than a certain power and disposition to stir up a sensation of this or that colour.'

If a material absorbs white light evenly throughout the spectrum, then it will appear neutral – as a shade of grey, or, if absorption is almost complete, as black. But most materials absorb only parts of the visible spectrum and reflect the rest. This **selective absorption** gives rise to the sensation of colour. We see the light that is not absorbed. Thus a red dress is red because its colouring matter (pigment) absorbs all the other wavelengths of the spectrum and reflects only red. (See Fig. 2.15.)

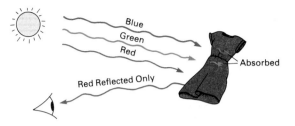

Fig. 2.15 A red dress looks red (when viewed under white light) because its colouring matter absorbs all the other wavelengths (such as green and blue) and reflects only its own colour.

THE TRICHROMATIC THEORY OF COLOUR VISION

We have mentioned that our colour vision relies on special nerve cells in the retina called cones. There are in fact three different types of cones. Each type responds to a different part of the visible spectrum: one to red light, another to green light and the third to blue light. The three types of cone are arranged in a random mosaic in the fovea. If red light falls on the retina, only the red-sensitive cones send signals to the brain, and we perceive the colour as red, and so on.

It was Thomas Young (1773–1829) who first discovered that the eye perceives colours as a mixture of only three different colours. He carried out a famous experiment to demonstrate this, which is illustrated in Fig. 2.16. Three projectors are arranged so that overlapping circles of red, green and blue light are projected on to a screen. At each overlap the coloured lights add to produce different colours. In the centre, all three colours add together to give white light. This is called the **additive synthesis of colour**. These three **primary colours** (red, green, blue) are fundamental to our understanding of colour vision, but more important here, they are (with their **complementary colours**) basic to colour photography.

Just as the additive primaries *add* to form white, so we can use their complementaries, yellow, magenta and cyan, to *subtract* colour. If we take, say, a yellow

filter and hold it in front of a white screen, then we see a yellow screen. And if we now put a magenta filter over the yellow, then we see red. Finally, if we put yellow, magenta, and cyan filters together, we get no light transmitted at all – we get black! What

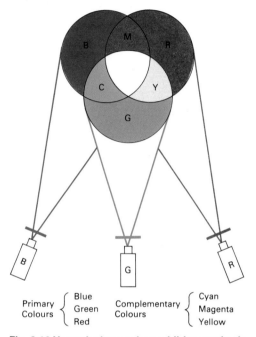

Fig. 2.16 Young's three-colour additive synthesis.

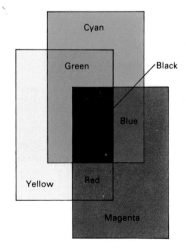

Fig. 2.17 Subtractive synthesis of colour.

we have done is to *subtract* colour from white light, and for this reason the complementary colours are known as **subtractive primaries**.

This type of colour synthesis is shown in Fig. 2.17.

Additive Primary Colours

RED + GREEN + BLUE = WHITE

Thus:

Additive Primaries				Complementary Colour
RED	+	GREEN	=	YELLOW
RED	+	BLUE	=	MAGENTA
GREEN	+	BLUE	=	CYAN

Subtractive Primaries

YELLOW + MAGENTA + CYAN = BLACK

Thus:

WHITE LIGHT – CYAN	=	RED
WHITE LIGHT – MAGENTA	=	GREEN
WHITE LIGHT – YELLOW	=	BLUE

A convenient way of remembering these relationships is to use the simple matrix:

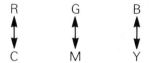

The beauty of Young's experiment is that it conveniently reduces the problem of reproducing colour to only three primaries. But the complete range of colours we can perceive is extremely large, and if we take into account differences in brightness, and the purity (lack of other wavelengths) of a colour, then we can distinguish several million discrete colours.

To be strictly accurate, 'colour' should be discussed in terms of **hue**, **saturation** and **lightness**. One particular method of describing colour in these terms is known as the Munsell system.

Hue is simply the name we give to a colour (red, yellow, etc.) and in the Munsell system these can be represented around a three-dimensional 'colour-tree', as shown in Fig. 2.18.

Saturation (or 'chroma') is the degree of purity of a colour. For example, we have seen that if the eye detects equal amounts of red, green and blue, the result is a grey, and most colours have some grey component in them, that is to say, they are not pure hues. The hue that has no grey in it is considered to be fully saturated. The 'leaf' of constant hue (Fig. 2.18) shows increasing purity (saturation) as the colour squares shift to the right.

Lightness (or 'value') is quite simple to understand. It is a number which denotes the brightness of a colour.

The average observer can detect about 150 different hues in the spectrum, provided that he or she is allowed to make comparisons, and within the green band (to which the eye is most sensitive) shifts as small as 5 nm can be detected.

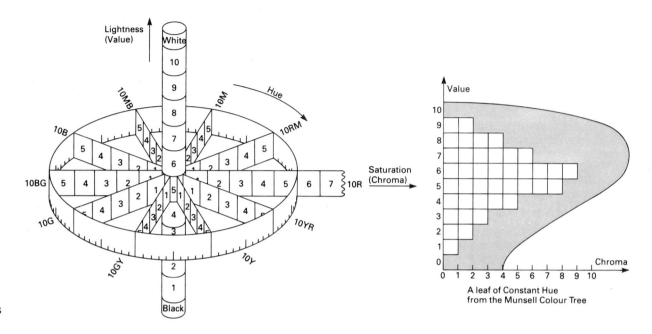

Fig. 2.18 Munsell colour tree.

A leaf of Constant Hue from the Munsell Colour Tree

DEPTH PERCEPTION

Since we have two eyes, we have a wide field of view. The fields of view of both eyes overlap, and this is what gives us **binocular vision**. Most, but not all, of our distance and depth information is due to binocular vision. From the slightly different picture seen by each eye, the brain can work out relative distances of objects. The amount by which the shape of the eye lens needs to be altered to focus the image (**accommodation**) also helps the brain to perceive depth, particularly for close objects. Further aids to depth perception include the movement of our head and eyes, for by such means we may see around objects due to what is known as **parallax** (see Box 2.4 opposite).

If for any reason we have the use of only one eye, then depth and distance perception become more difficult. But we still have useful clues that help us, such as the overlapping of nearer objects over more distant ones, the effect of **aerial perspective** (the hazy appearance of distant scenes caused by scattering of light by the atmosphere), the size of familiar objects, and perhaps most important of all, **linear perspective**.

It is important to know about these monocular clues to depth and distance in order to use them in painting and photography to create illusions of depth.

When we look at a three-dimensional scene or object, we perceive its image, in two (x, y) dimensions, on the retina of the eye. But in our perception of that object we also *know* that the object has depth, i.e. that it has x, y and z dimensions. On the other hand, a photograph is obviously limited to the x, y dimensions of its format. Yet it is still possible to produce the illusion of depth. Our awareness of distance in paintings and photographs (the z dimension) is therefore due to its **representation**, which is not quite the same thing as the **perception** of reality.

STEREOSCOPY

Although the act of seeing in three dimensions is a complex business, involving many of the visual processes mentioned above, it is relatively simple to represent 3D imagery by the process of stereoscopy. Stereoscopy involves the simultaneous taking of two photographs of a scene, each photograph being exposed from a viewpoint separated by the normal distance between the eyes, about 65 mm. Stereoscopic cameras are provided with two lenses for this purpose, but it is perfectly possible to use a conventional camera (for still subjects) and simply take two photographs from separated viewpoints – often much greater than the normal distance between the eyes in order to create greater depth effect.

Not everyone appreciates stereoscopic imagery however, the most common complaint being that

BOX 2.4

Parallax

Parallax is the apparent alteration in the relative position of two objects that occurs when the observer changes his or her viewpoint. Parallax is easily demonstrated. Extend your right arm and, with the thumb pointing upwards, close the left eye and with the right eye only line up a distant object with the thumb. Now, if you close the right eye, and open the left, you will see your thumb displaced to the right. Try this experiment by reversing the order. Line up the distant object with the left eye open. Now close the left and open the right eye — what happens?

Obviously, we are presented with different views of the world according to which eye we use. If we repeat the experiment but this time line up our distant object with both eyes open, we can find out which of our eyes is the dominant one. If, for example, the view seen with both eyes is the same as that perceived when only the right eye open, then the right eye is the **dominant** eye.

Parallax is a term that is often used to describe the difference between two viewpoints. A well-known example is the difference in the picture seen through a camera viewfinder (other than a single-lens reflex camera) and the picture seen by the lens. This is mainly a problem when the camera is close to the subject (less than two metres), but is entirely eliminated by the single-lens reflex (SLR) camera.

when a stereo-pair are viewed (in a stereoscope) the perceived in-depth-image has a rather cardboard cut-out appearance and no parallax (see Box 2.4). Stereoscopy is nevertheless very useful for measuring objects and, among other uses, is employed for making maps from aerial photographs. This process is known as photogrammetry.

Linear perspective

A perspective picture is one in which three-dimensional objects or scenes are reduced to a two-dimensional (x, y) plane in such a way that the observer can mentally reconstruct their original form. And although the term 'perspective' is often used rather loosely, it is possible to give it a strict definition.

The principles of perspective were discovered during the Italian Renaissance period and its laws were described by Leonardo da Vinci (1452–1519) in the following way: if straight lines are drawn from all points of a scene to a certain viewpoint (such as an eye confined by a sight-hole) and if those lines pass through a transparent surface (the **surface of projection**) such as glass, the image traced out on that surface is the **linear perspective** of that scene. In the simple scene shown by Fig. 2.19, the distance

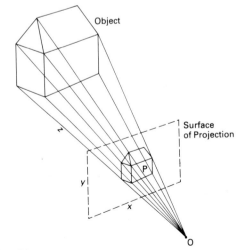

Fig. 2.19 Linear perspective.

between viewpoint O and the **principal point** P (dropped perpendicular from O on to the surface of projection) is known as the **principal distance** and lies along the z axis. (With a photograph, the principal distance is the focal length of the camera lens.)

So much for the basic principles. But there is much more to perspective theory than this, and in order to understand it better we must consider the psychological aspects involved.

Constancy scaling

There is a tendency for the human eye–brain mechanism to compensate for changes in the retinal image due to changes in viewing distance. Thus as an object distance is doubled, so the size of its retinal image becomes halved. But the *appearance* of the object hardly changes! The brain compensates for the shrinking size (we *know* that people don't get smaller as they get further from us). This process is known as **constancy scaling**. Indeed, were it not for this perceptual phenomenon, our recognition of similarly sized objects would undergo all manner of distortions (visual illusions). Thus if we view a long street of identical houses, we do not assume that the ones at the end of the street are smaller than those at the beginning – although this is what our retinal image would suggest. We *know* that they are of constant size and constancy scaling comes to the rescue to give reality to the scene. This is what is known as **size constancy**.

When we take a photograph, the camera provides true geometrical perspective and is representative of the retinal image. But this is not how we 'see' the real world, which is why photographs can often look wrong! Small wonder that in some isolated countries, the inhabitants have been known to reject photographs entirely – not even recognising them as images of their own world. The artist, being aware of these matters, will always attempt to draw the world as he or she perceives it, i.e. after his or her retinal images have been scaled for constancy. As Matisse put it so eloquently, 'accuracy is not the same thing as truth'.

We are often disappointed to find that distant objects, such as the sun, moon or even mountains, can look far too small on a photograph – not at all as we saw them. Again, that is the result of geometric accuracy with no allowance for constancy scaling.

A well-known problem occurs when a camera is tilted upwards to include the top of a building – resulting in a photograph in which the building appears to be falling backwards! The picture is accurate, the perspective being true, but one cannot say it represents reality. Indeed, it is for this reason that professional photographers employ large-format cameras which allow for camera movements such as a 'rising front' (a facility which raises the lens upwards to avoid tilting the camera), thus avoiding the illusion of the building falling backwards. But, in so doing, accurate perspective has been distorted in order to restore reality to the photograph. (See Fig. 2.20.) (For 35 mm cameras, a similar facility can be provided with the aid of a **perspective-control lens.**)

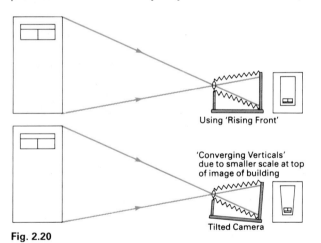

Fig. 2.20

Perspective, viewpoint and perception

When we take a picture, we like to think that we are recreating the impression of the original scene. And although we know that our photograph is a flat (x, y) representation of that scene, it is still possible to use our understanding of perspective, viewpoint and perception to get as close to reality as possible.

Let us take the simple case of a large-format camera of the type that used to be common some years ago – the 'whole plate' ($8\frac{1}{2} \times 6\frac{1}{2}$ inch or 21.6 × 16.5 cm), complete with a standard lens of 10 inches. Furthermore, if we take a photograph with this camera and contact print the negative, we end up with a print with a diagonal of about 10 inches. Now it is an interesting fact that the average observer will view any print at about 10 inches distance – what is known as the **least distance of distinct vision** – and if a 10-inch print is viewed at this normal distance, then the camera perspective (10-inch lens) and viewing perspective are identical, both providing a normal viewing angle of about 50°. (*Note:* Horizontal binocular vision is about 120°.)

If now, with one eye, we view such a photograph through a rectangular aperture, so that we can no longer see the boundaries of the print, it is possible to get a highly realistic impression of the original scene – complete with some elements of depth perception.

Quite obviously, if the viewer is aware of the surface of the print then, psychologically, the scene takes on a flat appearance. But if the surface is free from texture, and viewed in the **aperture mode** as described, then the *constancies* are set more to the appearance of the real scene.

The role of the camera lens in perspective

Perspective is controlled by viewpoint and not by the focal length of the camera lens. Yet there is often much confusion regarding this simple truth!

Typically, when using a 35 mm camera with its standard (50 mm) lens, we sometimes try to fill the frame with the principal subject (to save having to enlarge the print later). This brings our viewpoint so close that we get what is known as a **steep perspective**. In portraiture this can be most unfortunate since the nose (being closest to the lens) is at the greatest scale, and appears oversized! The correct procedure here is to use a longer focal length lens (say 80 or 100 mm) and extend the viewpoint (i.e. increase the distance between camera and

subject). The frame will still be filled, but without exaggerated perspective effects.

We may summarise these effects by saying:

(i) With any single lens, regardless of focal length, changing the viewpoint changes both image size and perspective.
(ii) With any single viewpoint, regardless of distance, altering the focal length of the lens simply changes the image size leaving perspective unaltered.

Perspective ratio

The importance of viewpoint in controlling perspective is best explained by use of the **perspective ratio** (PR), examples of which are shown in Fig. 2.21(a and b). In Fig. 2.21(a) the distance between the camera lens and the front edge of the first cube is 120 cm, whereas the

(a) PR = 0.8.

(b) PR = 0.9.
Fig. 2.21

distance between the front edges of both cubes is 30 cm. If we calculate the ratio of these distances (n), we find that $n = 4$. The PR may now be calculated as:

$$PR = n/(n + 1) \qquad \text{Eq. 2.3}$$

In Fig. 2.21(a), $n = 4$, and from Eq. 2.3 PR = 4/5 = 0.8, i.e. the rear cube has only 0.8 the height of the front one. But in Fig. 2.21(b), the distance between lens and front cube is now 270 cm, giving a much *flatter* perspective, with $n = 9$ and a PR = 0.9. The front cube in (b) is the same size as that in (a) due to increased enlargement of the former negative.

Print viewing and apparent perspective

When we talk about perspective and print viewing it is sometimes referred to as **apparent perspective**.

We have already mentioned the simple case of perspective with a 10-inch focal length lens, and a print viewed at a distance of 10 inches. In this case, the comfortable viewing perspective is identical with that of the camera and we have no **perspective distortion**. But with a 35 mm camera and a 50 mm (2-inch) lens, we would now need to view the contact print at 50 mm in order to gain correct apparent perspective – far too close for the eye to focus correctly. However, a 35 mm contact print is not very useful, being only 36 mm × 24 mm in size, and so it is usually enlarged. And if we now enlarge the diagonal of the contact print about ×5, then we may view it at five times the focal length, i.e. five times two inches, giving us a comfortable viewing distance of about 10 inches and correct apparent perspective.

It is interesting to note that apparent perspective takes on a reverse role to that of camera perspective. If a print is viewed from too far away, the apparent perspective appears too steep and, if viewed too close, it appears too flat – quite the reverse of effects in the camera.

From the above, it is obvious that perspective is important to images and photography, but it is to be found only in these representations of objects – not in reality.

SHADOWS AND TEXTURE

The average photograph will contain a number of *monocular* ('one-eye') cues to depth perception other than linear perspective. These cues require neither binocular vision nor stereoscopy. They rely entirely on the quality of the objects themselves and are to be found from such things as shadows, texture, aerial perspective and interposition (one thing hiding behind another).

Shadows give shape and form to objects and the art of studio photography relies heavily on lighting technique if the object or portrait is to look natural. Shadows also indicate both the direction of light and its quality, and reveal the surface of a subject by emphasising its texture.

Textural perspective appears when surface texture becomes more dense with distance. Thus if we photograph a field of wheat, we find that in the foreground each stand is recorded in detail, but as distance increases there is a gradation towards the horizon where detail blurs into a high density of tone or colour.

Depth illusions due to shadow

There are certain types of photograph that require special consideration with regard to shadows cast. Among these we may include astronomical photographs of the moon where, for example, viewing a print upside down can easily result in mountains becoming valleys and vice versa. Indeed, even the photograph of a coin can result in ambiguous figures if lighting or presentation are incorrect. Relief and depth appear reversed if the light comes from below (contrary to natural experience). Further examples can be found in vertical aerial photographs, where it is essential to view such images with shadows falling towards the observer if the hill/valley ambiguity is to be avoided. (See Fig. 2.22.)

Fig. 2.22 Hill/valley ambiguity: aerial photograph of china clay works, 1,500 feet, f = 35 mm, Kodak 2415 film. Photo: Ron Graham.

STUDENT ASSIGNMENTS

1 Select an object situated at the far end of a room and, with outstretched hand and both eyes open, position your thumb so that it is lined up with the object.
 (a) First close one eye, then the other. The displacement of your thumb (with respect to the object) is due to binocular parallax.
 (b) From this experiment, determine your 'dominant eye', i.e. that eye with which (with monocular vision) there is no thumb displacement.

2 Select a glossy photographic print illustrating a scene where subjects recede into the distance (in depth). Now make a small rectangular aperture (with sides in the same ratio as your print) in a sheet of black card so that the print may be viewed with one eye only – without seeing its outer limits.
 You are now viewing the print in 'aperture mode' and should be able to perceive the scene with greater reality since *constancies* have been set more to the appearance of the real scene.

3

How Photography Works

'I know few things in the range of science more surprising than the gradual appearance of the picture on the blank sheet.'

(William Henry Fox Talbot, 1800–1877)

Photo: Virginia Bolton

In Chapter 2 we dealt briefly with the subject of optics and the process of human vision. In particular, we pointed out that human vision depends upon only a small portion of the electromagnetic spectrum, the region extending from 380 nm to 760 nm, with short wavelengths exciting the sensation of blue and long wavelengths providing us with the sensation of red. We were also careful to emphasise that the rays themselves were not coloured – colour being a human sensation and a function of the brain.

The photographic process can be explained by the laws of science, mainly those of photochemistry. Two of the most important laws are:

(i) **The Grotthus–Draper Law**: 'Chemical change can be produced only by light which is absorbed.'

(ii) **The Bunsen–Roscoe Law**: 'The amount of chemical change is proportional to light-intensity multiplied by time of illumination (exposure).'

These laws are concerned with light and its effect on light-sensitive materials. But first we shall consider the sources of the light we use in photography.

LIGHT SOURCES

DAYLIGHT

Natural daylight has two principal elements: **direct sunlight** and **skylight**. On a clear and cloudless day, sunlight will provide us with direct shadow-forming illumination, supported by diffuse skylight – which will vary in strength and colour according to the atmosphere at any given point on the Earth's surface. Fig. 3.1 shows how both sunlight and skylight increase in intensity from dawn to midday then decline towards dusk and nightfall. On average we can expect the scattered skylight to amount to something like 15% of that due to sunlight at noon.

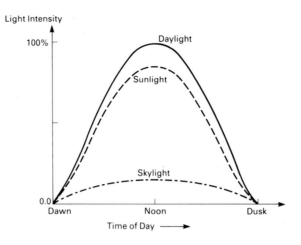

Fig. 3.1

But we can see that in the early morning and late evening skylight can, for a short time, be the equal of sunlight!

It is impossible to be precise about either the quality or the quantity of daylight, because of the atmosphere. Even though the air may be perfectly clear at ground level there could be a hazy sun giving very soft shadows and reducing the lighting ratio

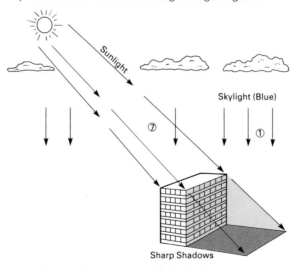

Fig. 3.2 For a white building under a clear sun, the lighting ratio could be something like 7:1 (i.e. direct sunlight 7× stronger than skylight). But the *contrast ratio* between the sunlit side of the building and the shadow side will be 8:1.

between sunlight and skylight. Thus if on a clear day the ratio between sunlight and skylight is 7:1, a white building would be illuminated to a **contrast ratio** of 8:1 (the sunlit side having both direct sunlight *and* diffuse skylight), as shown in Fig. 3.2. But the lighting ratio could be reduced to only 4:1 with a hazy sun, resulting in a subject contrast of only 5:1 (see Fig. 3.3).

It is this ever-changing quality of natural light that gives interest to outdoor scenes, and the observant photographer always takes advantage of this in order to capture mood and atmosphere in landscape work. With colour photography, for example, it is usually best to avoid harsh contrast ratios if correct colour rendering is important. The average colour film (particularly colour transparencies) can handle only a limited scene-brightness range and still give good colour balance.

Atmosphere controls the colour of daylight, as we know. The beauty of sunsets, rainbows, even the haze itself – particularly in mountainous areas – gives a colour quality to natural light that can be used not only in colour photography but also in monochrome (black and white) photography as well.

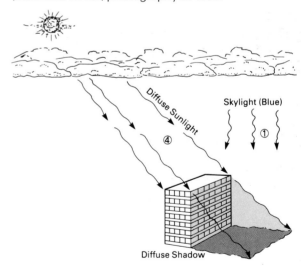

Fig. 3.3 For the same building, now illuminated with a diffuse sun, the lighting ratio could be only 4:1, resulting in a contrast ratio of 5:1.

THE SPECTRAL QUALITY OF LIGHT

We have mentioned that the visible spectrum is only a small part of the whole spectrum of electromagnetic radiation (EMR) and, as shown by Fig. 2.13, comprises wavelengths running from 380 nm to 760 nm. The human eye responds to each wavelength (λ) of light to a different degree, resulting in what is known as the **visual luminosity** curve – see Fig. 2.13(b). Known as the Vλ curve, Fig. 2.13(b) indicates that the eye has its greatest daylight sensitivity with green light at a wavelength of 555 nm. It also shows that eye sensitivity drops away on either side of the green maximum until it no longer 'sees' at all below 380 nm (ultraviolet) and beyond 760 nm (infrared) wavelengths.

Similarly, every source of light, from a candle to the sun itself, has a range of wavelengths over which it will radiate at different levels of energy. The sun, our natural source of EMR, radiates as shown in Fig. 3.4, where it can be seen that there is more energy at the ultraviolet end of the spectrum than there is at the infrared.

The actual colour of light given out by a light source (its **spectral quality**) depends on the distribution of energy emitted at each wavelength within its spectrum. Although most sources, such as the sun,

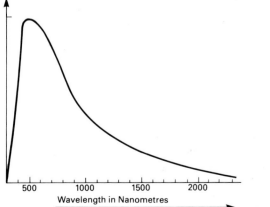

Fig. 3.4 Spectral distribution of solar radiation at Earth's surface (midday).

candles, fire, tungsten filament lamp, etc. are considered as 'white light' sources, they differ greatly when carefully compared one with the other.

Here again is another example of psychological *constancy*. In this case it is *colour constancy*, where differences in the colour of 'white light' are hardly noticed in visual perception. But in photography even small differences in colour can be recorded, and in colour photography the quality of a light source is highly important.

When drawing the spectral energy distribution curve for the sun, shown in Fig. 3.4, we usually include only that range of wavelengths that we find important to light sources, i.e. from about 300 to 1000 nm. We can then more easily compare the relative spectral energy distributions of various light sources. As an example, the curves shown in Fig. 3.5 illustrate the relative spectral energy distributions for four of the main types of light sources used in photography. (Although on a common graph, these curves are relative to each other only with respect to the wavelength axis. The peak energy of each source will vary according to type and circumstances.)

The curve for daylight in Fig. 3.5 has to be treated with care since it represents an ideal case. We know from experience that daylight can vary from a summer sky to that of a drab winter's day. But the one shown here is representative of a nice summer's day, at noon, with a few small white

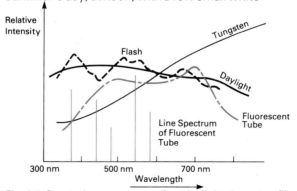

Fig. 3.5 Spectral energy curves for: daylight, tungsten filament lamp, electronic flash and fluorescent tube. (Note: fluorescent tubes also exhibit 'line-spectra' of strong emissions in narrow bands of wavelength.)

clouds and blue sky. The term 'spectral *energy* distribution' is a bit of a cheat, really! For although the curve for each type of light source shown in Fig. 3.5 indicates the energy emitted at each wavelength, most of the blue in daylight is due to atmospheric scattering and strictly speaking is not from a hot-bodied source – as it is with a tungsten filament lamp, for example. As a consequence, we must accept that 'daylight' can vary in quality a great deal, mainly through atmospheric conditions.

TUNGSTEN FILAMENT LAMPS

We are all familiar with the domestic light bulb or, more technically, the tungsten filament lamp. In this lamp, an electric current is passed through a thin (coiled) filament of tungsten wire, with a melting point as high as about 2500°C. Electrical energy is converted into light (and heat) energy. The glass envelope of the bulb is filled with a mixture of argon and nitrogen gases. This prevents the filament from reacting with air and being corroded, and makes it possible to run these lamps for about 1000 hours.

COLOUR TEMPERATURE

The tungsten filament lamp acts very much like the sun in providing us with light. Both give off energy, most of it in the form of heat. If we heat a metal rod in a fire, eventually it gives off a dull red glow and we have light. But just before it becomes incandescent (visible), the energy is in the form of heat, long-wave infrared radiation and what is known as near infrared radiation. If we heat the rod still further, it can become white hot – giving off EMR of wavelengths that are now even more energetic as they run towards the blue end of the spectrum.

We may define the quality of light from an incandescent source by what is known as its **colour temperature**. To be exact, any light source whose spectral distribution of radiation depends entirely on

temperature is known as a 'black body' radiator. It will have a colour temperature equal to its temperature as measured on the Kelvin scale (K). The Kelvin scale of temperature starts at −273.15°C, which is called **absolute zero**. So our tungsten lamp running at 2500°C has a colour temperature of 2773 K. (*Note*: We do not use the degree sign with the Kelvin scale.)

The colour temperature (CT) of artificial light sources can, within limits, be controlled by the manufacturer, but that of natural daylight (which is an everchanging mixture of sunlight, with true CT, and skylight, which is not due to heat and is given only a 'correlated colour temperature' value, CCT) will vary as we have seen. The list given in Table 3.1 gives some typical examples useful to photography.

Table 3.1
Colour temperature of typical photographic light sources

Light source	CT (approx.)	
Sunlight at dawn	2000 K	
Domestic tungsten lamp	2770 K–3000 K	(depending on wattage)
Photographic lamp (500 W)	3200 K	
Photoflood lamp	3400 K	('over-run', limited life)
Clear flashbulb	3800 K	(for monochrome flash)
'Daylight' fluorescent tube	4500 K	
'Mean noon sunlight'	5400 K	(a standard for sunlight)
Blue flashbulb	6000 K	
Electronic flash	6000 K	
Average daylight	6500 K	(sunlight + skylight)
Blue sky (Correlated CT)	10 000–18 000 K	(CCT)

PHOTOGRAPHIC LAMPS

Photographic light sources for the studio come in various forms.

(i) Special 500 W lamps with a life of about 100 hours (if used carefully and not jolted when hot). These lamps are designed for photographic studios and have a colour temperature of 3200 K.

(ii) Photofloods. These lamps come as: No. 1 (275 W) with a life of two to three hours, and No. 2 (500 W) with a life of six to ten hours. They are 'over-run' lamps, which means they give more light and a higher CT than their power rating (wattage) would suggest, but their life is limited as a consequence.

(iii) Finally, we have the tungsten–halogen types, which are tungsten lamps with a trace of a halogen (such as iodine) added to the gas so that the lamp can be operated at higher temperatures. The advantages of this include greater light output (with smaller bulb size), slightly longer life (about 200 hours), and a more constant colour temperature (in the range 2700–3400 K) due to the fact that the bulb does not blacken with age.

FLUORESCENT LAMPS

Fluorescent lamps, or tubes, are usually found in large buildings, workplaces and shops, but are also to be found in domestic areas. These lamps produce light by passing electricity through mercury vapour at low pressure. This produces short-wavelength EMR. The glass tube is coated inside with a fluorescent powder which has the property of converting the short-wavelength (including ultraviolet) radiation into longer wavelengths. These lamps are cool in operation and very cheap to run, but they emit what is known as **line spectra**, seen as the (broadened) bands of radiation in the fluorescent source curve shown in Fig. 3.5. Although they *look* like a source of continuous white light, a colour photograph would record the line spectra as a heavy green overcast. They are therefore unsuitable for colour photography.

Nevertheless, as strip-lamps they provide very soft (almost shadowless) lighting and can be most useful for many forms of interior black-and-white photography. They are particularly useful in the 'cold-light illuminators' (light boxes) used for examining medical X-ray photographs and colour

transparencies (diapositives). Photographic applications of these sources are discussed further in Chapter 4.

ELECTRONIC FLASH

An electronic flash lamp consists of a glass tube containing the rare gas xenon at reduced pressure. When the flash is fired, an electrical discharge circuit allows a pulse of high voltage (usually between 500 and 1000 volts) to ionise the gas to the accompaniment of a short flash of intense light. Within seconds of firing, the capacitor of the flash gun will recharge, ready to trigger the next flash.

The main advantages of this source over the expendable (and much less used) flashbulb are:

(i) cheaper operation;

(ii) a correlated colour temperature (CCT) almost identical with daylight, and therefore highly suitable for colour photography;

(iii) short 'flash' duration (usually between 1/500 and 1/1000 second);

(iv) convenient and cool in operation.

Chapter 5 deals with this form of illumination in greater detail.

BASIC PHOTOMETRY

Regardless of the type of light source, it is important in photography to understand some of the basics about the measurement of light (photometry).

At the beginning of this chapter we mentioned the Bunsen–Roscoe law, which is fundamental to the understanding of photographic exposure. Although lighting measurements are rarely accurate, we are fortunate in that photographic sensitive materials (films) are usually very tolerant.

We must remember that we cannot see light – but we see by it. As a consequence, certain concepts must be understood if we are to use light in a practical fashion. The main quantities measured in photometry are as follows:

		Symbol	Unit
(i)	**Luminous intensity**	I	candela (cd)
(ii)	**Illumination**	E	lux (or metre candle)
(iii)	**Reflectance**	R	—
(iv)	**Luminance**	L	candelas/sq. metre (cd/m^2)

The original unit of luminous intensity was a candle, now internationally standardised as the candela. And if such a source is placed one metre away from a surface, then that surface is said to receive one *lumen per square metre*. This is the basic quantity of illumination with a unit of one lux. The lux is also known as a metre candle (mc), and is often referred to as this in advanced books on photography.

If we look at Fig. 3.6, we can see how light from a source of intensity (*I*) illuminates surface (a) more strongly than surface (b). This is obvious, of course, but the mathematical relationships are not. Yet they affect all calculations in photographic exposure according to a general relationship known as the **inverse square law**.

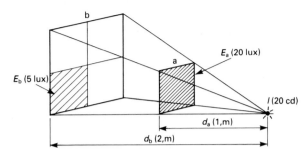

Fig. 3.6

The inverse square law

Consider Fig. 3.6 again. The source has an intensity of 20 candela, and surface (a) is at a distance *d* (in this case, 1 metre) from the source. The illumination of surface (a) is given as:

$$E_a = I/d_a^2 \qquad \text{Eq. 3.1}$$

Example 1
If the source is of intensity 20 cd, and the surface (a) is one metre from it, then, from Eq. 3.1:

$$E_a = 20\ \text{cd}/1^2 = 20\ \text{lux}$$

Furthermore, if we now wish to calculate the illumination falling on a second surface (b) when we only know the value of E_a, then we may use:

$$E_b/E_a = (d_a/d_b)^2 \qquad \text{Eq. 3.2}$$

Example 2

$$E_b = E_a(d_a/d_b)^2$$

Substituting:

$$E_b = 20.\ (1/2)^2 = 20.\ (1/4) = 5\ \text{lux}$$

So much for *calculating* illumination. But in practice we can measure only *luminance*, i.e. the light reflected from a surface – remember we cannot *see* light, only the surface! So when our camera exposure meter measures light, it is luminance that is actually being measured.

Luminance and reflection-factor

In Fig. 3.7, a surface of diffuse reflection-factor *R* is illuminated with illumination *E* to provide luminance *L*, according to:

$$L = E.R/\pi \qquad \text{Eq. 3.3}$$

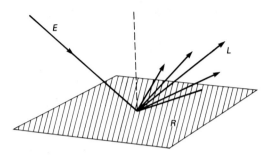

Fig. 3.7

Example 3
If an illumination (*E*) of 628 lux falls on a grey card of 50% reflection-factor (*R* = 0.5), the luminance (*L*) coming from that surface is:

$$L = \frac{628 \times 0.5}{3.14} = 100\ \text{cd/m}^2$$

This value could be measured on some types of exposure meters.

STUDENT ASSIGNMENTS

1 Classify the sources listed below into those which have a true CT, those that may be described only by their CCT rating, and those that are a mixture of the two (CT and CCT).

 (i) Sun
 (ii) Daylight
 (iii) Fluorescent tube
 (iv) Blue skylight
 (v) Tungsten filament lamp
 (vi) Electronic flash
(vii) Clear flashbulb

Remember, if the source does not get its energy directly through heat, but via such agencies as 'scattering' (skylight), 'fluorescence' (fluorescent tubes) or 'ionisation' of gases (electronic flash) then, although it could be roughly matched against the colour temperature of a hot body, it should correctly be described as having a Correlated Colour Temperature.

2 If, for a given film, lens aperture and photo-lamp placed four metres away, the correct exposure of a studio subject is 1/30 second, how far away from the subject should the lamp be placed in order to employ a shutter speed of 1/125 second?

Note: Although Eq. 3.2 is strictly accurate only for 'point light sources', it is sufficiently accurate for use with photographic lamps, complete with small reflectors.

THE CAMERA

Although most modern cameras are highly sophisticated instruments incorporating many helpful facilities, they are also complex, expensive and very different from each other. Most of these differences involve camera operation and it would be most unwise for anyone, no matter how experienced, to assume that a new camera can be operated just like the one he or she had been using previously.

But for all that, and despite the various electronic systems now incorporated in popular 35 mm SLR (single-lens reflex) cameras, they all share a common purpose – to record images on light-sensitive materials, and to do so with the least amount of difficulty.

In this section we shall not even attempt to catalogue the range of modern SLR cameras available, each with its own unique set of facilities and controls. Instead we concentrate on providing an outline of the basic types: SLR (35 mm and 6 cm × 6 cm), TLR (twin-lens reflex) and medium-format (5 inch × 4 inch) studio cameras (also known as 'technical' or 'stand' cameras depending upon their application).

We shall start with the simplest of all cameras, one that can even be manufactured at home in minutes, yet, with a little care, is still able to produce decent photographs.

THE PINHOLE CAMERA

The most simple camera imaginable can be made by anyone with the aid of a small cardboard box and a pin! Yet, despite its basic simplicity, the image produced by a **pinhole camera** is quite good and, in certain areas of work, is still useful for practical photography.

Image formation by a pinhole relies on the fact that light may be considered to travel in straight lines (the **rectilinear theory of light**) as shown in Fig. 3.8. Provided that the pinhole is not too large, the image can be reasonably good, to the point of being useful! However, the pinhole should also not be too small since light can bend around the corners of very small apertures (a property of the wave-theory of light known as **diffraction**). For the best possible results, there will be an ideal pinhole diameter (see Box 3.1).

BOX 3.1

Calculating pinhole diameter

Whether formed by a pinhole, positive lens or concave mirror, **real images** have two things in common: they are inverted and laterally reversed (as viewed from behind the screen).

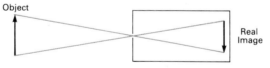

Fig. 3.8 Pinhole camera.

The best possible pinhole images are formed from pinholes that are neither too small nor too large in diameter. Optimum pinhole diameter, d, is given by:

$$d = \sqrt{2\lambda f} \qquad \text{Eq. 3.4}$$

where λ is the wavelength of light employed and f is the distance between the pinhole and the film. (Usually we would say 'focal length', but since we are not using a lens this is not strictly correct.)

Human eye (daytime) sensitivity peaks in the green region at a wavelength of 555 nm. This wavelength is in the middle of the visible spectrum. As a result, our choice for λ in Eq. 3.4 may conveniently be set at, say, 500 nm. And if you have completed assignment 2 on p. 37 successfully, you will know that 500 nm is the same thing as 0.0005 nm, and the value 2λ now becomes 0.001 mm, or one micrometre.

Example

A pinhole camera is to be made from a box with a length of 100 mm and we may assume that the average wavelength of white light is 500 nm. What is the best diameter for the pinhole?

$$d = \sqrt{2 \times 0.0005 \times 100}\ \text{mm}$$
$$= \sqrt{0.001 \times 100}\ \text{mm} = \sqrt{0.1}\ \text{mm}$$
$$\therefore d = 0.33\ \text{mm diameter}$$

In practice, suitable pinholes can be made by punching a pin, or needle, through ordinary cooking foil. It pays to ensure that the pinhole is clean, and rough protruding edges should be ground flat with a fine abrasive cloth. The diameter (d) may then be measured under a magnifying glass against an accurate steel rule with divisions as fine as 0.5 mm.

BOX 3.2

Real and virtual images

A positive lens (see p. 51) produces what is called a real image. This means that the light rays are brought to a focus at the image. If a screen is placed at this point, the image will appear on it (Fig. 3.9(a)).

A negative lens (p. 51) produces a virtual image (Fig. 3.9(b)).

The eye sees an image that appears to be behind the lens. But although the light rays appear to come from the virtual image, they do not in fact, as can be seen from the diagram. A screen placed where the image appears to be would not show the image.

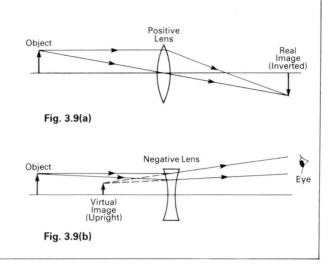

Fig. 3.9(a)

Fig. 3.9(b)

It is important to note that all photographic images, such as that shown in Fig. 3.8, are **real** images, i.e. they can be captured on a screen (such as a sheet of ground glass). They should not be confused with **true or virtual** images (like those seen in a plane mirror) which cannot.

THE SIMPLE LENS CAMERA

If the pinhole in our former camera is now replaced with a simple (thin) positive lens (with its diameter restricted by a small aperture), we may then have a somewhat better camera – one capable of taking pictures in far weaker light than that required for pinhole photography. Such was the primitive 'box camera' which, complete with single-speed shutter and simple optical viewfinder, remained the most common type of camera available to the casual user for many years.

Simple though it was, the box camera was capable of satisfying most people's demand for holiday 'snaps'. With a restricted aperture, its simple lens gave reasonable definition over an image size of

56 mm × 80 mm. Everything was (almost) in focus – even if not very sharp. The simple 'box' enjoyed considerable success as an early form of 'point-and-shoot' camera.

It is important to understand that the basic simplicity of the box camera was mainly due to the fact that it did not require focusing. Every part of the scene was more or less equally sharp in depth simply because the camera operated at its focal length with a very small aperture.

FOCAL LENGTH

The focal length of a simple (positive) lens is shown in Fig. 3.10. Parallel rays of light come to a point of

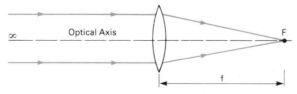

Fig. 3.10 Focal length (*f*) of a simple positive lens. (Note: infinity is always shown thus : ∞ and the point of focus as F.)

focus at a distance *f* from the optical centre of the lens.

The distance *f* is known as the **focal length**, and is always the same for a given lens. By definition, parallel rays of light imply that they come from an infinite distance. But in practice we can relax this definition and assume that infinity will not vary much from a finite distance of perhaps 20 metres or more, depending on the focal length in question. Thus for example, if we focus a lens of 50 mm focal length on a scene some 20 metres away, that scene will be as much in focus as one 100 metres distant – or at infinity, for that matter. ('Infinity' has no measure, of course, but in practical terms it will become closer as the focal length gets smaller.)

RELATIVE APERTURE (f/No.)

We have mentioned the use of a restricting aperture placed behind the simple lens of a box camera. In photographic jargon this is known as a '**stop**'. If we look at Fig. 3.11, we see that this aperture, of diameter *d*, is placed as close to the lens as possible.

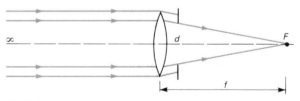

Fig. 3.11

The ratio of the aperture diameter to the focal length of the lens, *f/d*, is called the relative aperture. It is usually referred to as the f-number or f/No.

$$f/No. = f/d \qquad \text{Eq. 3.5}$$

The relative aperture of a camera lens is one of the most important factors in photography, since it controls not only image definition but, in partnership with the shutter, exposure of the film as well.

In our 'box' camera example, the aperture is a single hole cut out of thin metal. With a focal length

of about 150 mm, and a hole of about 12 mm, the ratio f/d is 12.5. In fact, the average box camera had an f/No. somewhere in the region of f/11 to f/14.

In most cameras, however, the f/No. is variable, usually ranging from f/2 (the widest aperture) to f/22 (the smallest aperture), for the majority of 35 mm cameras available today. This is achieved by using an iris diaphragm which is manufactured from very light metal and consists of about five blades which can open up to give an aperture of varying size. When the 'aperture ring' on the outside of the camera lens is set to the f/No. value required, the blades will open to provide the appropriate relative aperture.

LENSES

We have seen that it is perfectly possible to manufacture a camera using a simple lens. But the simple lens is not adequate for high-quality photography since it suffers from various optical errors that can only be corrected by a number of lenses combined to form what is known as a **compound lens**. For modern cameras, the compound lens must also be capable of forming an image in poor light, which requires large apertures, commonly in the region of f/2, with a few lenses close to the practical maximum at about f/1.2.

Simple lenses

There are two different types of simple lens: **positive** (or converging) and **negative** (or diverging). Each can be made in any of three different forms, as shown in Fig. 3.12.

No matter what form they take, all positive lenses have thin edges compared to their centre section, whereas negative types have edges that are thicker than their centres. On their own these simple lenses are generally employed for correcting eyesight, and are usually made of **crown glass** with a refractive index of 1.52.

In photography we require a positive lens in order to form a real image. But, as we shall discuss later,

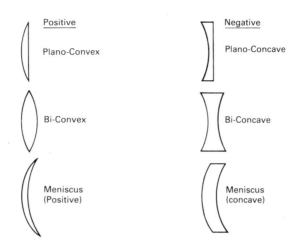

Fig. 3.12 Simple lens types.

modern photographic lenses are far from being simple. A number of 'simple lenses' (**optical elements**) of different types, form and refractive index, are combined to produce a compound lens of high quality.

Apart from their role as part of compound lenses, simple lenses are useful for close-up (macro) photography since they can be fitted to the front of a standard camera lens to allow the camera to focus on very near objects.

Compound (camera) lenses

A simple lens plus a small aperture can produce reasonably good images close to the optical axis. However, the quality of the image near the edges will still be rather poor. So lens manufacturers have had to make continuous efforts to improve their products. They aim for perfection in overall definition, and also for 'faster' lenses. By 'faster' we mean lenses with larger apertures which will let more light through. These improvements have not been achieved easily because of the problems of **lens aberrations** (see below).

Typically, the modern high-aperture camera lens may consist of any number of elements as shown in Fig. 3.13. The number of elements, their type, form, refractive index and spacing are calculated by

computer to produce a compound lens of the type desired: wide angle, normal, long focus, telephoto, etc.

Some of the elements will be formed from two thin lenses cemented together. One typical combination is the **achromatic-pair** made up from crown glass (RI = 1.52) and flint glass (RI = 1.67), so that correct colour definition can be achieved.

Fig. 3.13 A compound camera lens.

The elements of a compound lens usually have a special optical coating to reduce reflection of light between the lens surfaces.

Within the space of all these elements there has to be somewhere to put the iris-diaphragm. Ideally, this will be at a place within the lens where the light rays start to converge towards the image. This is known as the **node-of-exit** (Ne), as illustrated in Fig. 3.13. The approximate position of this node can be found by looking for the aperture-control ring on the lens barrel. Some of the older types of camera have **inter-lens shutters** and these too have to be fitted into the same space as the iris-diaphragm.

LENS ABERRATIONS

By **lens aberration** we mean the inability of a lens (simple or compound) to provide a perfect image point. There are two general types of aberrations:

1 Total field errors: spherical aberration and axial chromatic aberration.
2 Oblique errors: astigmatism, coma, curvature-of-field, lateral chromatic and distortion.

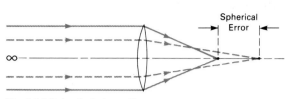

Fig. 3.14 Spherical aberration.

Fig. 3.15 Axial chromatic aberration.

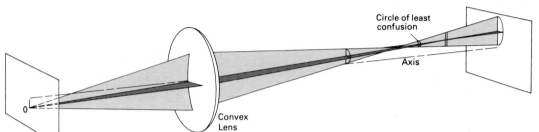

Fig. 3.16 Astigmatism.

1(a) Spherical aberration

A hypothetically 'perfect' lens would form a single (sharp) image point from all zones of its surface, as shown in Fig. 3.10. In practice the rays from the zone close to the optical axis are brought to focus further away from the lens than those from the outer zones (Fig. 3.14). This is known as spherical aberration.

The inexpensive 'box' camera of 50 years ago employed a simple lens with a small aperture. This meant that only axial rays reached the film, so the effects of aberration were limited. However, the fixed aperture generally available (about f/12) restricted the use of the camera to bright sunshine. More advanced cameras were fitted with lenses of wider maximum aperture (f/5.6 or f/3.5), and spherical aberration in these lenses had to be corrected. Manufacturers called these superior lenses *aplanats*. This term is no longer much used, since nearly all lenses are corrected well against this aberration today.

1(b) Axial chromatic aberration

Since the refractive index of glass varies with wavelength (see Fig. 2.13) it is natural to expect that shorter wavelengths, such as blue light, will be brought to a focus before the longer wavelengths (red) . This condition is known as **axial chromatic aberration** and is shown in Fig. 3.15.

As 'total field' errors, both spherical and axial chromatic aberrations affect the entire image space and, for photography, they cannot be allowed to go uncorrected. Fortunately, it is possible to correct both of these errors in a compound lens by combining a positive lens of crown glass with a negative lens of flint glass. The two form what is known as an **achromatic element**. Depending on the quality of the lens, correction for two colours (usually blue and yellow) is provided by an **achromat,** whereas correction for three colours (red, green and blue) is given by the more expensive **apochromat.**

2(a) Astigmatism

In this aberration, we find that we fail to get a single sharp point with the off-axis rays from an uncorrected lens. As shown by Fig. 3.16, instead of getting a single image point from an object point, we get two short image lines at different foci. The lines are at right-angles to each other, with the only approximation to a point being known as a **circle of least confusion**.

Astigmatism becomes less as the lens aperture gets smaller, but all good-quality photographic lenses are now reasonably well corrected against this aberration.

2(b) Coma

Rather like spherical aberration, coma is a lens error due to different zones of the lens providing different points of focus. However, with coma the effect is confined to oblique rays only. If uncorrected, off-axis image points appear comet-shaped as shown in Fig. 3.17. With simple lenses, coma may be reduced by employing a small aperture (stop). Compound lenses can be more efficiently corrected by arranging the elements symmetrically.

2(c) Curvature of field

The natural image field of a lens is not flat, but saucer shaped. To reduce this curvature of field, it is necessary to design compound lenses so that 'field flattening' is accompanied by corrections for astigmatism. If uncorrected, a curved image field would produce very poor definition at the edges of a photograph – see Fig. 3.18.

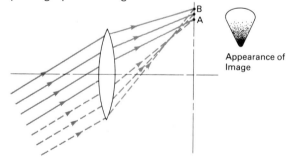

Fig. 3.17 Coma.

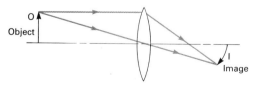

Fig. 3.18 Curvature of field.

2(d) Lateral chromatic aberration

Lateral chromatic aberration is an oblique error that causes differences in chromatic (colour) magnification. It may cause coloured fringes at the edges of the image. This aberration is quite difficult to correct and is particularly prominent with very long-focus lenses.

2(e) Distortion

The magnification of an image varies with its distance from the optical axis, and this gives rise to the defect known as distortion. Two kinds of distortion exist, **barrel distortion** and **pincushion distortion**, as shown in Fig. 3.19. In the case of barrel distortion, magnification decreases with distance from the axis, whereas with pincushion it increases.

 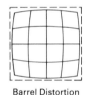 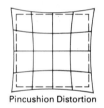

| Subject | Barrel Distortion | Pincushion Distortion |

Fig. 3.19

Although we can ignore the small amounts of distortion common to most photographic lenses, those employed for photogrammetry and aerial survey must be distortion-free in order to provide the geometric accuracy required for map making.

IMAGE FORMATION WITH A SIMPLE POSITIVE LENS

In Fig. 3.20 we see the formation of an image I of an object O by a lens of focal length f. The size relationship between image and object is called the **magnification** of the optical system – regardless of whether the image is the same size, smaller than, or larger than the object.

Magnification (M) is given by:

$$M = I/O = v/u \qquad \text{Eq. 3.6}$$

where v and u are the distances between image and lens, and object and lens respectively.

The distances v and u are uniquely related to each other via the focal length. As the object distance (u) decreases, the image distance (v) increases and vice versa. We call them **conjugate distances**. We have already mentioned that if the object distance is infinite (∞), then the conjugate distance v is equal to f. But as the object gets closer to the lens (u decreases), then the distance between the film and the lens (v) must be increased so that the image is in focus.

For any given camera lens (with the exception of zoom lenses), focal length is a constant, and the conjugate distances u and v can be calculated from Newton's formula:

$$\frac{1}{f} = \frac{1}{u} + \frac{1}{v} \qquad \text{Eq. 3.7}$$

Example

A lens of 100 mm focal length is focused on an object 500 mm away. What is the distance between lens and image?

We have: $f = 100$ mm and $u = 500$ mm. By rearranging equation 3.7 we get

$$\frac{1}{v} = \frac{1}{f} - \frac{1}{u}$$

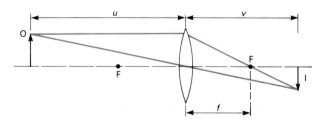

Fig. 3.20 Image formation with a simple lens.

Substituting, we have:

$$\frac{1}{v} = \frac{1}{100} - \frac{1}{500}$$
$$= \frac{5}{500} - \frac{1}{500}$$
$$= \frac{4}{500}$$
$$\therefore v = \frac{500}{4}$$
$$= 125 \text{ mm}$$

Sometimes it is more convenient to use Eq. 3.7 in terms of image magnification. Since $M = v/u$, we can multiply through by v as:

$$\frac{v}{f} = \frac{v}{u} + \frac{v}{v} = M + 1$$
$$\therefore v = f(M + 1) \qquad \text{Eq. 3.8}$$

Similarly,

$$u = f(1/M + 1) \qquad \text{Eq. 3.9}$$

Example

We wish to photograph a small object at unit magnification (i.e. life-size) with a lens of 50 mm focal length. How far away should the subject be placed?

From Eq. 3.9, we can say:

$$u = 50(1/1 + 1) = 50(1 + 1) = 100 \text{ mm}$$

So the subject should be 100 mm from the lens.

IMAGE FORMATION WITH A COMPOUND (CAMERA) LENS

Unlike simple (single element) lenses, those employed in cameras are made up from a number of elements, as shown in Fig. 3.12. In order to make lens calculations we must now be more precise and take all our measurements from the node-of-exit of the lens.

With compound lenses we assume that parallel rays of light (from infinity) will converge to the point of focus from the node-of-exit of that lens. This node will be unique to each design and is the plane from which the focal length of all the component lenses is measured, as shown by Fig. 3.21.

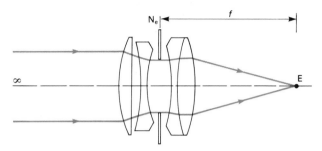

Fig. 3.21

MAGNIFICATION OF THE IMAGE

As $M = v/u$, we can increase the magnification (M) of the image by decreasing the distance of the object from the lens (u) and increasing the distance of the image from the lens (v). However, there is a limit to the distance possible between the lens and the film and if the object is brought too close to the lens, the image will be out of focus on the film. For most 35 mm SLR cameras, the closest focusing allowed, with a standard (50 mm) lens, is in the region of 45 cm.

Example
Find the maximum degree of magnification possible with a 50 mm lens limited to an object distance of 45 cm.

By re-arranging Eq. 3.9, we can find the maximum value for M as:

$$u = \frac{f}{M} + f$$

Therefore, $$\frac{f}{M} = u - f$$

and $$M = \frac{f}{(u - f)}$$

$$= \frac{50 \text{ mm}}{(450 \text{ mm} - 50 \text{ mm})}$$

$$= \frac{50}{400 \text{ mm}}$$

$$= 0.125 \text{ mm}$$

i.e. the largest image size we can record will be one-eighth object size.

Extension tubes and bellows

If we wish to provide for greater magnifications, where very small objects are to be photographed, for example, then we can extend the v conjugate by fitting **extension tubes** (or bellows) between camera-body and lens, as shown in Fig. 3.22.

Fig. 3.22

Example
With the aid of extension tubes fitted to its 50 mm lens, a 35 mm SLR camera has a 'v' distance equal to 200 mm. What magnification is now possible?

From Eq. 3.8:

$$M = (v/f) - 1 = (200/50) - 1 = 4 - 1 = 3\times$$

Supplementary lenses

As an alternative to the use of bulky extension fittings, it is possible to fit simple lenses to the front of a standard camera lens. These supplementary lenses may then be used for close-up photography. They are generally known as **close-up** attachments.

These simple lenses are usually optically coated (as are all the elements of a camera lens) to avoid excessive internal reflections between lens surfaces. They are also threaded to fit the internal threads of the camera lens, according to its diameter.

Supplementary lenses are generally marked according to their **optical power**, in dioptres (D). The power of a lens, P, is given as:

$$P(\text{dioptres}) = 1/f \text{ (where } f \text{ is given in metres) Eq. 3.10}$$

A simple lens of focal length 25 cm will therefore have a power of $P = 1/0.25$ metres $= 4$ dioptres. The power of a 50 mm camera lens is 1/0.05, or 20 dioptres.

Most suppliers provide a range of close-up lenses of values 1 D, 2 D, 3 D and 4 D, and it is quite remarkable to find that even with all four fitted onto the camera lens (a total of 10 D), the image quality is still very good.

Example
A 50 mm camera lens is fitted with 5 D of supplementary lenses. Calculate the degree of magnification likely when the camera lens is set at infinity.

The total power of the camera lens plus supplementaries is 25 D, and the associated focal length is 1000/25 = 40 mm.

Since the camera lens has $f = 50$ mm, and since at infinity $f = v$, we can use Eq. 3.8 to calculate:

$$M = (v/f) - 1 = (50/40) - 1 = 1.25 - 1 = 0.25$$

Close-up lenses are most useful and allow the photographer to take photographs of all manner of small objects, or to bring out fine detail, simply by adding lenses as required. For example, with the full extent of standard lens focusing and 10 D of

supplementary lenses, it is possible to fill the frame of a 35 mm camera when photographing the adult human eye!

COVERING POWER OF A LENS

Every camera lens is designed so that it will be able to project a disc of light that will be larger than the format of the film employed, so that the whole of the negative is exposed. Since it is natural for all lenses to give their best definition on the optical axis, we must accept that image quality will be best at the centre of the image but fall off towards the edges. However, for a camera lens to be successful it must provide acceptable **covering power**, which means reasonable definition over the entire image format, as shown in Fig. 3.23. In order to do this, it is essential to reduce lens aberrations to a minimum. Even then, covering power can still be elusive, particularly with extreme wide-angle lenses.

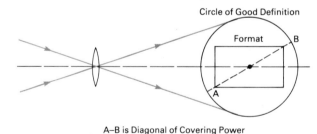

Circle of Good Definition

Format

A–B is Diagonal of Covering Power

Fig. 3.23

ANGLE OF VIEW

For a given format size, the angle of view of a camera lens is controlled by its focal length. Angle of view (θ) is illustrated by Fig. 3.24 and defined as the angle subtended by the diagonal of the film format when the lens is set at infinity.

A few examples of the relationship between θ and f are listed in Table 3.2 for typical 35 mm camera lenses working with a format diagonal of 43 mm.

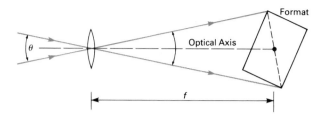

Format

Optical Axis

θ

f

Fig. 3.24 Angle of view, θ.

Table 3.2

Type of lens	Focal length (mm)	θ
Wide angle	28	75°
'' ''	35	66°
Standard	50	48°
Long-focus	85	28°
'' ''	135	19°
'' ''	200	12°

IMAGE DEFINITION

What is the size of a point? There can be no sure answer to this question since it depends very much on the resolution of the human eye. With a very sharp pencil, make two points on white paper so that they are as close together as you can get them. Hold the paper in front of your eyes and gradually move it away from you. You should find that the two dots fuse into one. For the average person with normal eyesight the dots will usually be **resolved** into two separate points at a distance of about 25 cm – the so-called **least distance of distinct vision (LDDV)**.

Naturally, this simple experiment will depend on how much contrast there is between pencil point and paper. If grey paper were used, for example, or a very soft pencil, the poor contrast would disguise the resolution very effectively. For an average contrast it has been found that the distance between two such points, viewed at 25 cm, will be in the region of 0.25 mm. As a result, we may say that the average

human eye can resolve two points separated by a distance 1/1000 the LDDV.

If we now consider a photographic print, viewed at the LDDV of 25 cm, then we may assume that a 'point' on the image may still be considered as a point, provided that its diameter does not exceed a disc (known as a **circle of confusion**) of 0.25 mm diameter.

The circle of confusion allows us a certain amount of latitude in image definition since, for normal viewing, the eye will accept a disc of up to 0.25 mm as a sharp image point. As a matter of fact, most people with good eyesight can see detail as small as 0.1 mm with the naked eye – provided they take a very close look, of course!

CAMERA LENS DEFINITION

Since photographs are viewed by observers, all questions dealing with their definition are subjective, i.e. subject to human conditions, as we have discussed above. But when we deal with the definition provided by lenses and film, we can be strictly objective and place our findings on much firmer ground.

Lens resolution

The term **definition** covers such things as **contrast** and **resolution** (the measurement of separation between points) and the two are very much related in camera optics. As a matter of fact, when a lens is hard put to it to resolve fine detail, it usually shows as a fall in contrast as the detail gets finer, to the limit where detail simply fades away.

A very simple test of a lens's ability to resolve detail is provided by what are known as lens-testing charts. Basically, these are no more than a series of white bars set on a black (or grey) ground, according to the contrast required for the test. The white bars are usually three times as long as they are wide, and are separated by their own width. Known as **three-bar targets** they can be photographed to gain a

◄ **Fig. 3.25 Three-bar targets for testing camera resolution. Low contrast. High contrast.**

comprehensive resolution for the lens and film combined. Two examples used for testing aerial camera/film systems are shown in Fig. 3.25.

Lens manufacturers quote the performance of their lenses in terms of **resolving power** (RP), expressed as **line-pairs per millimetre** (lp/mm). One line-pair is the distance between the centres of two adjacent white bars, as shown in Fig. 3.25.

For example, an exceptionally good lens may be quoted to have an RP of, say, 200 lp/mm at f/4, on the optical axis. Which means that it is capable of resolving two points that are 0.005 mm apart. This is high definition indeed! And if the film could also resolve this detail, then, on the basis of our circle of confusion (0.25 mm) we could enlarge the negative 50 times (0.25/0.005) and still retain image definition – provided that the enlarger had sufficient resolving power, of course. We can see, therefore, that image definition depends on a number of stages: camera lens, film, enlarger and human eye. Yet, as we shall see, we must also include other factors too, involving image movement and the recording of scenes in depth.

DEPTH OF FIELD

In the majority of scenes we wish to photograph, there are a number of subjects extending in depth away from the camera lens. Yet, according to Eq. 3.7, we may only focus our camera lens on one plane. Fortunately, the so-called sharp image is tempered by the tolerance of the circle of confusion which provides the photograph with what is known as **depth of field**.

Depth of field may be defined as the distance between the nearest and farthest parts of a scene (surrounding the point focused upon) that can be accepted as being sharply imaged at the same time.

In general, depth of field is not distributed equally. With most scenes there is about twice as much in focus behind the plane focused on as there is in front of it. However, as the lens gets closer to its subject, depth of field becomes more equally distributed.

Most cameras indicate depth of field on the lens barrel. It can be read off against the aperture in use,

and increases as the f/No. gets higher, i.e. as the aperture gets smaller. But in order to calculate depth of field we have to find the **hyperfocal distance** (hd) – the distance between the lens and the nearest object that is acceptably sharp when the lens is set at infinity. A suitable formula for hyperfocal distance is:

$$hd = 1000f/(f/No.) \qquad \text{Eq. 3.11}$$

Thus for a 50 mm lens working at f/2, the hd is 25 metres, whereas at f/4 it will be 12.5 metres.

The total depth of field, between the nearest point at distance N and the farthest point at distance F, may now be calculated:

$$N = (hd \times u)/(hd + u) \qquad \text{Eq. 3.12}$$

$$F = (hd \times u)/(hd - u) \qquad \text{Eq. 3.13}$$

where u is the object distance focused on. The total depth of field, T, is given by:

$$T = (F - N)$$

Example

A 50 mm lens operating at f/4 is focused at a distance of 10 metres. Find the total depth of field.

$hd = 1000 \times 50 \text{ mm}/4 = 12.5 \text{ metres}$
$N = (12.5 \text{ m} \times 10 \text{ m})/(12.5 \text{ m} + 10 \text{ m}) = 5.5 \text{ metres}$
$F = (12.5 \text{ m} \times 10 \text{ m})/(12.5 \text{ m} - 10 \text{ m}) = 50 \text{ metres}$
$T = F - N = 44.5 \text{ metres}$

From inspection of the above equations, we can see that depth of field is governed by four different working conditions:

(i) focal length of lens (f);
(ii) distance focused on (u);
(iii) relative aperture (f/No.);
(iv) circle of confusion.

To summarise, depth of field is greater where: (i) focal length is short, (ii) the distance focused on (u) is long, (iii) the f/No. is large (smaller aperture), and (iv) the circle of confusion is allowed to be larger than 0.25 mm.

TYPES OF CAMERA LENS

We have mentioned the three main types of camera lens with regard to their angle of view and focal length. But there are a few others which should also be mentioned.

Telephoto lenses

Often confused with the ordinary long-focus lens, the telephoto is more expensive but provides the same focal length. By design, the telephoto lens is physically shorter than its long-focus counterpart so as to remove some of the bulk and weight common to the latter. It is a lens where the focal length is longer than its physical length. This is made possible by extending the node-of-exit to a position in front of that normally found in lenses.

Zoom lenses

Whereas the term 'zoom' is appropriate in cinematography or television, in still photography the zoom lens finds its place mainly as a vari-focal lens. For dynamic filming, as in ciné, video or TV, the 'zoom' takes place over a period of time and has an effect that can only be partly simulated in still photography, i.e. by changing image size (in steps) during exposure.

Although it is very useful to have a number of different focal length lenses to hand, long-focus, wide-angle, etc., it is not always sensible to change lenses during a busy photographic session. The shot you really want may well have disappeared in the time taken to change lenses! The zoom lens allows the photographer to change focal length very rapidly, simply by twisting the vari-focal barrel on the lens mount, and also provides for a continuum of focal lengths from, say, 35 mm to 70 mm, or 70 mm to 150 mm, etc. Apart from this facility is the unquestioned convenience of having less equipment to carry around.

Macro-lenses

Earlier, we discussed supplementary lenses and the use of extension tubes as means for taking close-up (macro) pictures, and mentioned the limits to which the average lens could be extended (*v* distance) before a serious loss of image quality occurred. The macro-lens is designed to allow for this, however, and has its aberrations specially corrected for close-up conditions. Such lenses usually have an aperture range extending to f/32 or f/45, and should give results superior to standard lenses employed with extension tubes.

Macro zoom lenses

Many zoom lenses which extend down to lower focal lengths also allow for a macro facility. By special design, some of the internal lens elements are relocated so as to provide better 'corrections' for close-up work. Typically, they can provide for magnification up to about 4×, often with the front lens element almost touching the object.

Fish-eye lenses

So called because of its all-round angle of view, the fish-eye has developed considerably since the first 'all sky' camera for meteorology was devised in 1924. Modern fish-eye lenses for 35 mm cameras typically have a focal length as short as 8 mm and an angle of view in excess of 180°. They produce circular pictures of 23 mm diameter and are mainly used for scientific purposes. Fish-eye lenses are

designed on the **retrofocus** system, also known as inverted telephoto. This design allows for the extra space required to fit a very short focal length within a mirror-reflex (SLR) camera.

Mirror lenses

Mirror lenses have been used in astronomy for many years but their use in photography, as alternatives to conventional (refracting) lenses, has been restricted mainly by their limitations, but also by cost. Based on the image-producing concave mirror, these 'catoptric' lenses are not yet generally useful for photography since they cannot provide a sufficiently flat image field. Nevertheless, a number of long-focus **catadioptric** lenses, with both reflecting and refracting components, have been manufactured for cameras in recent years. A typical mirror–lens system is shown in Fig. 3.26, from which various advantages and disadvantages can be made clear.

Chief among the advantages is the fact that mirrors do not create chromatic aberration. The system is also very compact and light in weight. Although catadioptrics suffer severely from off-axis errors, they are excellent as extra-long focus lenses on 35 mm cameras, and a number have been produced with focal lengths ranging from 500 mm to 2000 mm. Since normal apertures cannot be fitted, mirror lenses have to use neutral density filters to control image light (see p. 75) – but depth of field cannot be controlled at all. A further disadvantage is that out-of-focus highlights are recorded as doughnut-shaped rings, rather than as discs of light.

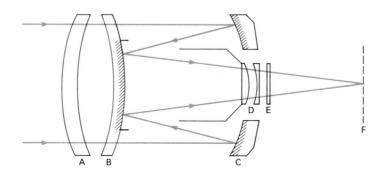

A = Meniscus Lens
B = Mangin Mirror (Reflecting Surface Behind a Concave Meniscus Lens)
C = Primary Mirror
D = Correcting Lenses
E = Neutral Density Filter
F = Focal Plane

Fig. 3.26 Catadioptric lens.

CAMERA SHUTTERS

Two different kinds of camera shutter are generally available today, the **focal-plane** and **inter-lens** types. However, nearly all of the popular 35 mm cameras incorporate the former type since it is more efficient and appropriate to modern camera technology.

Regardless of type, all camera shutters serve a dual purpose, each essential to capturing a photographic image.

1 The shutter arrests image motion

All object motion, such as that of people, traffic, wind-blown trees, etc. – and also the motion given to the camera by the photographer's hand – will have an associated 'image motion'. To avoid a blurred photograph, the image should scarcely move while the film is exposed. The image motion is proportional to the scale of the image. For example, the image of a man running 50 metres away will be small and move very slowly. If the running man is only 5 metres away, the image will be much larger and will move much faster. Similarly, the longer the focal length of the camera lens, the greater the scale of the image and the degree of image motion.

To 'freeze' the motion of a fast-moving image, the shutter must remain open for a very short time. The average focal-plane shutter has a range of shutter speeds, starting with the 'brief' (B) open-shutter position. This opens the shutter for as long as the shutter-release button is depressed. There is then a series of 'timed' shutter periods of 1, 1/2, 1/4, 1/8, 1/15, 1/30, 1/60, 1/125, 1/250, 1/500 1/1000, 1/2000 seconds. The actual shutter periods (t) may not be perfectly accurate, particularly at the shorter times (higher speeds), but this is not as important as the relationship between them. Each successive time is half the preceding one.

Selecting the 'correct' shutter speed often puzzles the beginner, particularly since the photographer never knows the true image motion. But in practice one soon learns to 'play safe' and select the fastest shutter speed one can if the object is moving fast. It is generally accepted that the average person can hold the camera steady at 1/30 second, and this serves as a useful guide. But it still pays to employ as fast a shutter speed as other factors allow since camera shake is a common source of blurred photographs.

2 The shutter makes an exposure

The exposure of light-sensitive material (film) depends on both the strength of the light reaching it and the time for which it is exposed to the light.

$$H = E.t \qquad \text{Eq. 3.14}$$

where H is the exposure in metre candle seconds (mcs), E the image illumination (mc), and t the exposure time (seconds).

We can see, therefore, that the shutter has an important bearing on how much light actually reaches the film. Image illumination (controlled by the f/No.) and exposure time (shutter) work together.

The relationship shown by Eq. 3.14 is a reciprocal one, i.e. if E is doubled, then t must be halved to get the same exposure, and vice versa.

Inter-lens shutters

An inter-lens shutter is usually positioned close to the node-of-exit within a camera lens. It consists of several thin opaque blades which are normally closed. When the shutter-release button is pressed they spring back to pass the light-beam for a set period before closing again. The usual range of speeds is from 1 second to 1/500 second, plus B and, in some cases, T (time exposure, which allows the operator to keep the shutter open without having to keep a finger on the release mechanism). Inter-lens shutters have the advantage of affecting the entire image field at the same time, and are easy to synchronise with both flashbulbs and electronic flash. For electronic flash, these shutters should be set to 'X' synchronisation. This allows the mechanism to automatically complete the flash-

trigger circuit as soon as the blades are in the fully open position. Regardless of the shutter speed selected, the electronic flash (typically 1/500–1/1000 second duration) will be completed before the shutter closes again. For flashbulbs, the 'M' position should be selected. This allows a mechanical delay of 22 milliseconds before the shutter acts. This is necessary since it takes about this time for the flash material to ignite to about one-third of its peak intensity – by which time the shutter is open.

Focal-plane shutters

The main difference between inter-lens and focal-plane shutters is that whereas the former exposes the entire image field simultaneously, the F-P shutter does this in a series of continuous strips, as shown in Fig. 3.27. Most F-P shutters consist of two roll-up

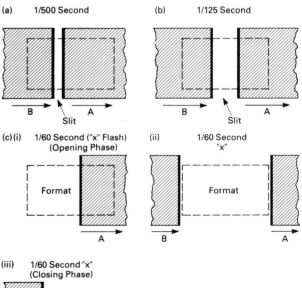

Fig. 3.27

blinds (made of cloth) located just in front of the film plane. As the shutter button is depressed, the first blind, marked A in Fig. 3.27, starts its path across the image format. It is followed a fraction of a second later by the second blind, B. For the shortest exposures, the two blinds appear as a fixed slit travelling together across the format (a), but with slower speeds it is possible to see that the two blinds move independently to create a travelling slit. At some low speeds (usually 1/60 second), there is a point where the first blind has reached the far side of the format before the second blind has started moving. This provides a clear frame suitable for an electronic flash to expose the film evenly.

After each exposure, the blinds are overlapped (to prevent light getting through and fogging the film) and drawn back with the same lever-wind action that advances the next film frame ready for the next photograph.

Many modern 35 mm cameras use a slightly different type of F-P shutter. This has two or three metal blades which slide vertically to open and close the format. By such means it has been possible to extend the shutter speed range as far as 1/2000 second and even higher. Traditionally, all shutter speeds have been timed by purely mechanical methods, but modern SLR cameras now use electronic systems, with small capacitors and 'chips' to control and display shutter speeds with much greater accuracy.

STUDENT ASSIGNMENTS

1 Construct a pinhole camera, using Eq. 3.4 to calculate the pinhole diameter. The angle of view should be 75°. When completed, load the camera with a sheet cut from a 120 size black and white film. A medium speed film (125 ASA) should be used and your first exposure should be tried out of doors on a bright day. As a suggestion, start with an exposure of about two seconds.

2 Construct a series of black and white three-bar resolution groups by mounting white 'bars' on a black card. Each bar should be separated from its neighbour by its own width to form a three-bar group. Make at least four such groups, each having bars exactly half the width (but the same height) of those in the previous group. At a suitable distance, photograph the test target to determine the resolution of your pinhole camera, or your personal 35 mm camera, with the particular film used. Take care to note the magnification employed at each stage. Measure the resolution by projecting the negative on to an enlarger baseboard.

CAMERA TYPES AND THEIR APPLICATIONS

It would be a mistake to equate image quality with camera sophistication. Indeed, many popular 35 mm cameras of today have electronic aids for exposure and focusing which, although designed to help the raw amateur, can sometimes militate against good photography, simply because they no longer allow the discriminating photographer to have full control of his or her camera.

THE PINHOLE CAMERA AT WORK

We have mentioned the simplest of all image-making devices – the pinhole camera – but it would be a mistake to dismiss it just because it is simple! Over the years, it has been used for many scientific purposes, from photographing the interior walls of the human stomach to identifying sources of radioactive contamination in nuclear power stations. The photograph shown in Fig. 3.29, illustrates its use in a less exacting role as a wide-angle (120°) camera providing a good image via a pinhole of 0.25 mm, with a green filter ($\lambda = 0.5$ μm) and pinhole-to-film distance (f) of 63 mm.

Many industrial pipe interiors, and similar cavities, are too small for conventional cameras to operate within. A suitable pinhole device can provide perfectly adequate records with an almost infinite depth of field, large angle of view, freedom from distortion and no need for focusing! One such camera, devised by Colin Abel for metallurgical research work, incorporates an electronic ring-flash surrounding the pinhole, and uses colour film. In Fig. 3.28 we see a colour photograph taken with this camera to record rust deposits on the inner wall of a control valve.

Fig. 3.28

DIRECT VISION VIEWFINDER CAMERAS

Regardless of cost, the classic design for most hand-held cameras comprises a barrel-mounted lens fitted to a body which, apart from storing the film and transporting it across the picture format, must also incorporate a suitable **viewfinder** for composing the photograph.

Fig. 3.29

In the cheaper range of cameras, the optical viewfinder is often placed on top of the camera body and is of the 'Albada' (suspended frame) type. This shows the scene as a small (virtual) image, framed within a white rectangle (see Fig. 3.30). (The white frame lines inside the eyepiece are reflected by the semi-silvered side of the lens and appear superimposed on the image.)

More advanced cameras usually employ the same type of viewfinder housed within the upper part of the camera body. They may also incorporate a **rangefinder**, coupled to the camera focusing barrel. With this, the operator can compose the picture and focus the lens within the same optical frame.

The rangefinder (Fig. 3.31) has two mirrors, M_1 and M_2. M_1 is fixed at an angle of 45° and is semi-silvered so that light can pass through it. M_2 can rotate. The eye sees two images: one formed by light passing through M_1, and one formed by light reflected from M_2 and then from M_1. When M_2 is at the same 45° angle as M_1, the two images of a distant object will coincide. However, to reflect light from a nearer object (broken line) so that the images coincide, M_2 must be rotated as shown. The rotating mirror is coupled to the rotation of the lens focusing barrel so that when the two rangefinder images

coincide the lens is correctly focused on the object viewed. The eyepiece shows either the top part of one image and the bottom of the other ('split field') or two overlapping images. With overlapping (coincident) rangefinder images, it is usual to fit pale filters of different colours over each window to make it easier to distinguish the two images.

With these types of camera, either focal-plane or inter-lens shutters can be used, but the former type is more usual these days. The focal-plane shutter has numerous advantages, of course, chief among them

Rays from scene

Semi-Silvered

White frame lines on inside of eyepiece

Virtual Image

Negative Lens

Fig. 3.30

being its cheaper cost of manufacture, longer mechanical life (efficiency), and faster shutter speeds. Fast shutter speeds are particularly important, now that highly sensitive films are available to the photographer. Yet another highly important point in their favour is that manufacturers can provide a cheaper range of interchangeable lenses for a given camera, since there is no need to incorporate a shutter in each lens.

TWIN-LENS REFLEX CAMERAS (TLR)

Although no longer a very popular amateur camera, the twin-lens reflex is still an important tool for the professional photographer. Designed to give accurate focusing on a fine ground-glass screen, the TLR camera employs two identical focal length lenses – one for focusing and viewfinding, and the other for photography. The upper lens has no iris-diaphragm or shutter, and images the scene (via a metal mirror fixed at 45°) on to the focusing or viewing screen. Since the two lenses are seated on a common focusing panel, and since the total length of the path followed by the light to the viewed image is identical with that to the image projected on to the film, an accurately focused screen image ensures that a similarly sharp one will be recorded.

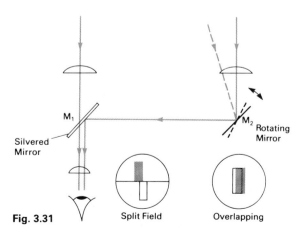

M_1

Silvered Mirror

M_2 Rotating Mirror

Split Field

Overlapping

Fig. 3.31

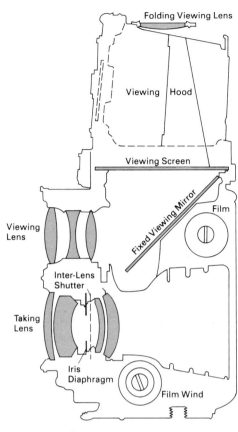

Fig. 3.32 The twin-lens reflex camera.

The general design of a TLR camera is shown in Fig. 3.32. The viewing screen is shielded from light by a folding hood, which also provides a small magnifier for viewing the screen. Although the two lenses have a common focal length and angle-of-view, they also have two or three centimetres of parallax error between their optical centres. As a result, it is always possible to have some degree of parallax error between the 'viewed' and 'recorded' images of objects close to the camera. This usually causes problems only with objects closer than a couple of metres or so (such as tops of heads chopped off in portraits) and is common to viewfinder cameras also. Although some provision is made to offset this error with most TLRs, it pays to be cautious when working at close distances.

Most TLR cameras offer a 6 cm × 6 cm format on 120 size roll film (12 pictures) with some providing an option for greater capacity using 220 size film (24 exposures). Compared to 35 mm size format (36 mm × 24 mm), the square 6 cm × 6 cm frame allows for more critical photography and is a good professional option for those who do not wish to use the larger-sized cameras (5 inch × 4 inch) for commercial work such as advertising, portrait or industrial photography. The TLR has the advantage of allowing the photographer to see his or her image up to, and during, the instant of exposure (important in advertising work with models, for example), but suffers from a number of disadvantages which have mainly been answered by the single-lens reflex camera.

For those who find the TLR an advantage in their work, there can be no doubt about its efficiency. The 6 cm × 6 cm negative is large enough to allow for retouching and may be enlarged to give excellent image quality. But for most photographers it remains a bulky, rather old-fashioned instrument with a number of important limitations such as the following:

(i) Interchangeable lenses are available but expensive since a panel consisting of two lenses is required. Even so, there are physical limitations that prevent the use of very wide-angle lenses.

(ii) It is not possible (as with an SLR) to check the depth of field provided by the 'taking' lens.

(iii) Parallax error can be a problem.

(iv) The TLR offers an 'open viewfinder' (no lenses – just a simple frame) facility for eye-level operation, but the waist-level position is usually adopted since focusing is accomplished this way. This leads to constant use of a single viewpoint, which after a time becomes boring!

(v) The use of a square format often leads the photographer into some difficulties with composition. It often results in only part of the format being used to create a rectangular shaped print.

(vi) The camera is not suitable for action photography, sport, etc., when using the viewing screen. The screen image is laterally reversed; thus any action going from, say, left to right, will be imaged in the reverse direction. As a result, the following of image motion (panning) is not possible unless the 'open viewfinder' is employed.

Two well-known examples of twin-lens reflex camera are the Rolleiflex and the Mamiya C330.

SINGLE-LENS REFLEX CAMERAS (SLR)

Considered the most representative of all camera designs, the SLR is mostly found in 35 mm format. Complete with **pentaprism**, to provide eye-level viewing (see below), and **through-the-lens metering (TTL)** to give correct exposure, it satisfies most demands for a complete camera – suitable for both professional and amateur alike. Typical examples include the Nikon, Pentax, Canon, Exacta, Minolta, etc., in all their various forms.

There are a few well-known examples in the larger 6 cm × 6 cm format size, too. Although more expensive, these are highly regarded for commercial and technical work. Typical are the Hasselblad, Bronica and Rolleiflex 6006, but in these the 6 cm × 6 cm SLR usually does without the pentaprism and relies on viewing modes similar to those used with the twin-lens types.

Typical pentaprism SLR cameras have a basic design that follows the diagram shown in Fig. 3.33, where a single lens now serves for both viewing and recording. While viewing and focusing the camera, image light is directed upwards via the mirror on to a viewing screen at the top of the camera body. From here, thanks to the pentaprism, the photographer has an eye-level view of a corrected image which, unlike the TLR, does not suffer from lateral reversal.

As the shutter release is operated, the hinged mirror behind the lens flips up, exposing the image to

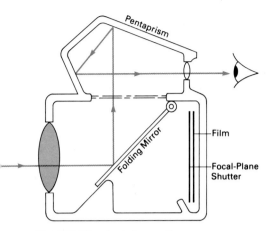

Fig. 3.33 The single-lens reflex camera.

the film-plane. It comes to rest against the underside of the screen where it prevents light reaching the film via the viewing system. Finally, as the mirror reaches the screen, it completes its task by firing the focal-plane shutter positioned just in front of the film.

SLR advantages

Obviously, the main advantages can be seen by comparison with the TLR camera, but there are some others as well. Many of these are due to the TTL metering system common to modern SLR cameras. The SLR allows for a much more economic range of extras, with interchangeable lenses running from very wide-angle to extra-long focal length. All of these come without shutters and can replace the standard (50 mm) lens within seconds.

The SLR can be simple to use, depending on its degree of sophistication, and most models have a facility to allow the operator to check depth of field at any selected aperture. The shutter speed range can reach 1/2000 second or more and, thanks to the pentaprism, critical focusing is possible for almost any type of subject, regardless of its nature. This is of particular interest to those who have to take extreme close-ups (macro-photography) where correct focus and depth of field are of the greatest importance. Furthermore, since TTL metering systems measure

image illumination directly, there are no problems with exposure calculations when using either extension tubes or bellows. It is for this reason that the 35 mm SLR is favoured for scientific work.

Pentaprism viewfinder

The pentaprism (a five-sided glass block) makes all the difference to SLR technology. Although too heavy for larger format cameras, it has allowed numerous advantages to attend 35 mm camera technology.

The pentaprism reflects image light according to the laws of **total internal reflection** which can be explained as follows. When a ray of light passes from a denser to an optically less dense medium (such as from glass to air), it is bent away from the normal-to-the-surface. As the angle of incidence (i) increases, the angle of refraction (r) also increases. At a limiting value of i, C, the refracted ray is parallel to the edge of the glass. At angles greater than C, the ray is reflected back through the glass. This is total internal reflection. Fig. 3.34 shows the situation for a conventional three-sided 45° prism made of glass with refractive index (n') equal to 1.52. Total internal reflection is governed by:

$$\sin C = n/n' \qquad \text{Eq. 3.15}$$

Fig. 3.34 Total internal reflection.

Thus where n is the refractive index of air, $\sin C = 1/1.52$ and angle C is about 42°. As angle i in Fig. 3.34 is greater than C, the ray is totally internally reflected. The pentaprism works on this principle.

Viewfinder information display

Most modern 35 mm cameras employ the viewfinder for displaying camera-control information. Typically, these data relate to shutter speed and aperture selection, battery condition, exposure readiness, operating mode (manual, automatic, shutter-priority or aperture-priority), film-end warning, flash, etc. This information is usually displayed by an array of tiny light-emitting diodes (LEDs), the actual data available depending on the camera concerned.

VIEW CAMERAS

Under this heading we include all cameras described as **stand, field, studio, technical** and **monorail**. Over the years, their manufacture has progressed from wood and brass to all-metal constructions, but for the most part they have all retained a similar type of design. Usually of large format (9 cm × 12 cm, 5 inch × 4 inch, etc.), with a direct viewing screen, lengthy bellows extensions, comprehensive 'camera movements' and considerable bulk, these cameras are the very essence of professional photography.

View cameras are designed for studio, laboratory or external (field) work and are intended to be used with a tripod. Although they are far from convenient compared to 35 mm cameras, for example, they do allow the photographer to gain exactly what he or she wants – regardless of the technical difficulties involved. With view cameras, the image is seen and manipulated by what are known as **camera movements**, which allow the photographer to control every part of the image rather than the entire image as a whole. As a result, images may be recorded with various degrees of perspective distortion, and depth of field can be controlled regardless of the lens aperture employed. Such provisions are of great importance for architectural photography and for photographing complex studio subjects – particularly in the fields of advertising,

Fig. 3.35

scientific and industrial work. A typical 5 inch × 4 inch monorail view camera (the Sinar) is shown in Fig. 3.35. Cameras such as this can accommodate a normal range of lenses, wide-angle, standard (150 mm) and long focus, but in professional work it is their bellows extension and flexibility of 'movements' that makes them so useful.

TECHNICAL CAMERAS

The technical camera is often no more than a view camera dedicated to a specific task – photomicrography for example. In Fig. 3.36, the camera (which has a shutter but no lens) is seen mounted over a free-standing microscope so that the operator can record the specimen at a screen magnification calculated as:

$$M_{(screen)} = M_{(objective)} \times M_{(eyepiece)} \times v/25$$

Eq. 3.16

In this application the camera doesn't need a lens, since all the optics are provided by the microscope; i.e. primary magnification selected from an **objective** mounted on the turret, and secondary magnification according to the chosen eyepiece. Total magnification, as shown on the camera screen, is then controlled by bellows length (v) measured in

Fig. 3.36

centimetres from eyepiece to viewing screen.

Alternatively, if the microscope is removed and one of its low-power (×5 or ×10) objectives is fitted to the camera, the system shown in Fig. 3.36 can be used for macro-photography. Magnification is now calculated according to Eq. 3.8.

In many scientific and medical laboratories, routine macro-photography requires a wide range of films – monochrome, colour, infrared, diapositive, Polaroid, etc. – that are only available in different film sizes. To solve this problem, one manufacturer (Zeiss) has produced a sturdily mounted macro-head, complete with a turret of macro-lenses and focusing eyepiece, that can support a variety of camera bodies. Fig. 3.37 shows four different types of camera available for this rig. From left to right we have: (i) a Polaroid (instant-picture) camera, (ii) a roll film, or plate camera, (iii) Hasselblad (120 or 220 size roll films), and (iv) a simple 35 mm viewfinder camera mounted on the macro-head. Note the exposure meter connected to the eyepiece for reading the required exposure.

Fig. 3.37

SOPHISTICATION: AUTOMATION AND ELECTRONICS

Many of the cameras marketed today, such as the compact and disc types, are totally dedicated to the casual amateur, and although ideal for their purpose, have limitations that put them outside the major interests of this book. Therefore, we shall concentrate our attention on the modern small-format cameras designed for both advanced amateurs and professionals alike.

Whereas today's popular 35 mm cameras are almost entirely electronic, they still require fine mechanical parts for such things as film wind-on and shutters. The first camera to incorporate electronics was the Contax III (1936) with a Selenium (Se) cell exposure meter built into the body. Although not connected to either aperture or shutter, this was a useful innovation at the time, since the Se cell generated its own current (by converting light energy into electrical energy) and provided a convenient in-camera exposure meter.

By the 1960s, Se cells had given way to the much more sensitive cadmium sulphide (CdS) cell. Easily a thousand times more sensitive and much smaller, this device requires only a small 1.5 V battery and is ideal for low-light exposure readings. The CdS cell was small enough to be secreted within a pentaprism viewfinder, and was the mainspring of TTL metering – until the advent of silicon or gallium arsenide phosphide cells. These, like selenium cells, can generate current, which is now amplified by miniscule electronic components within the camera.

In 1978 two new cameras, the Canon A-1 and the Konica FS-1, made camera technology almost completely electronic. Between them they introduced such things as automated exposure control as well as automatic film loading and frame advance. Nowadays, modern camera technology uses integrated circuits to control most of the camera's functions via a central processing unit (CPU). Commands from the CPU send signals through printed circuits and wires to motors that activate shutters and diaphragms. Shutter timings are now controlled by digital clocks and even the process of focusing has become fully automated in certain (auto-focus) cameras.

Typically, modern cameras have their exposure metering systems coupled to the camera's exposure controls. Some automate only the aperture, some only the shutter; others automate both controls with options known as **modes**.

As with all exposure calculations, manual or automatic, film sensitivity must be taken into account. Every film has a film-speed rating, called an ISO number (see p. 70). This must be dialled into the camera at the time of loading. Increasingly, modern cameras are **DX coded**, that is they can *read* what is called a DX code printed on the film cassette. This code, like the bar code used on goods in a supermarket, ensures that the film speed is correctly entered into the camera's central processing unit.

Aperture-priority mode

In this mode the photographer simply fixes the aperture to a given (priority) aperture, leaving the automated exposure system to adjust to the correct shutter speed. The shutter speed is usually indicated by LEDs in the viewfinder display.

Aperture-priority is useful when the photographer needs to use a certain aperture for his or her pictures, mainly to control depth of field.

Shutter-priority mode

In this mode, the photographer pre-selects a certain shutter speed, letting the auto-system control exposure by varying the lens aperture. This mode is useful when photographing subjects in motion, where a limiting shutter speed has to be maintained.

Programmed (fully automatic) modes

Depending very much on the camera, these modes allow the camera to alter both aperture and shutter through an 'intelligent' program of exposure settings. As light decreases, to the point where the lens's largest aperture is reached (f/2 for example), the shutter time increases up to 1/30 second, when a 'camera shake' LED lights up. Although useful when built into simple compact cameras, programmed modes tend to vary greatly among the different types of SLR – and can be confusing.

Manual mode

As the name suggests, manual mode is the most basic setting. Exposure controls are adjusted in the usual way, and LED signals appear in the viewfinder when combinations of aperture and shutter provide correct exposure. Most LED signals are combinations of letters and flashing (coloured) lights, indicating over-, correct or under-exposure.

Auto-focus cameras

To most keen photographers, automatic focusing has never been a priority. And even where it has been demonstrated to be an accurate method for getting a sharp image, there is little enthusiasm for it from those experienced with manual focusing. In particular, auto-systems do not allow the photographer freedom to differentiate focus as he or she sees fit.

Its main appeal, however, is for the casual user – the occasional photographer who always has a problem with getting the focus correct. In this respect, the auto-focus compact camera has proved to be quite successful. However, it must be admitted that many of these cameras employ very short focal length lenses which, with their increased depth of field, hardly require auto-focus technology anyway.

Automatic focusing became a practical reality in 1977 and has advanced considerably since then. Most compact cameras employ a scanning infrared beam transmitted from a rangefinder window (much like the one shown in Fig. 3.31) which, on return from the subject, is detected by a sensor placed behind the other window of the rangefinder. A small motor focuses the camera lens as the infrared beam is

scanned across the subject. As soon as a strong return signal is detected, both lens and scanning-beam are halted, as the lens is brought to focus on the object.

Other auto-focus mechanisms use either sonar (like the infrared system, but using a beam of ultrasonic pulses), or a passive electronic system to detect image sharpness. In the latter method, elements of the central picture area are directed on to a charge-coupled device (CCD) sensor, which can provide either fully or semi-automatic focusing.

We shall no doubt see an all-electronic camera before too long, with electro-optic shutter (having no moving parts) and film replaced by electronic elements. Indeed, such things have been possible for a number of years now. But unless there is a significant increase in their image quality we are not likely to see a dramatic change to completely electronic systems for a few years yet.

The solid state still camera

The world's first real attempt to make a popular camera that didn't use film was introduced, and demonstrated, by the Sony Corporation in 1981. Called the Mavica (Magnetic Video Camera) the camera image is received on a CCD chip of 4.8 mm × 6 mm dimensions, then converted into a digital data stream which is recorded on a spinning magnetic disc. The disc stores up to 50 pictures with a facility to erase unwanted frames.

Charge-coupled devices work by manipulating small packets of electrical charge across a silicon chip. Image light falling on the silicon is absorbed, creating an electrical charge which is stored locally under metal electrodes. The amount of stored charge is proportional to the image light at that point and can be 'clocked out' of the charged area into a circuit for subsequent video display or, optionally, to a hard-copy printer. Associated with the Mavica, the Sony Mavigraph produces hard copies in colour via a 512-element thermal head. The resulting prints are quite acceptable but not up to the standard of conventional colour prints.

The Mavica is somewhat larger and heavier than the average 35 mm camera, but as solid state image technology advances we can expect the size and weight to be reduced in time. Further developments proposed by Sony include image transmission over a conventional telephone as well as an auto-viewer which would work rather like a slide projector.

There can be no doubt that solid state imagery will be marketed at some future date, or that it will prove useful – particularly for scientific recording. But like the 'instant picture process' (Polaroid), it is more likely that it will supplement conventional photography rather than replace it, certainly in its early years.

LIGHT-SENSITIVE MATERIALS

The term **light-sensitive materials** includes photographic films, plates and printing papers, both in monochrome (black and white) and colour.

BASIC COMPOSITION OF LIGHT-SENSITIVE MATERIALS

The two main ingredients of a photographic **emulsion** are gelatin and silver halides. These are coated on to glass plates, or clear polyacetate base, in thin, even layers to make negatives and diapositives (transparencies), or coated on to paper to provide photographic prints.

Gelatin

Photographic gelatin is made from chippings of calf hide, pigskin and even bone, and has many properties that make it an ideal 'binder' for the silver halides suspended in it. (Strictly speaking, we should really talk about a photographic *suspension*, but the term *emulsion* has been used for too long for it to be changed now.)

First of all, gelatin is highly transparent and colourless. It also suspends the silver halide grains evenly throughout its volume, preventing them coalescing into a curdy mass. Typically, the shape and size of grains in a medium-speed film emulsion will look like those shown in Fig. 3.39, with a distribution of grain sizes from about 0.1 to 3 μm. Just as important, it allows processing chemicals to reach all the grains, act upon them without disturbing their position, and then, when their task is over, be rinsed away by washing. But for all its 'sponge-like' properties, gelatin can be hardened sufficiently to provide a reasonably tough 'binder' for the light-sensitive grains. Indeed, a specially hardened gelatin 'supercoat' is applied to most photographic emulsions as a protective cover for the emulsion.

As well as its obvious role, gelatin also imparts a certain amount of photosensitivity to silver halide grains, and plays an active role in the formation of the **latent image**, i.e. the invisible, yet-to-be-developed, weak image formed by the action of light alone.

Silver halides (AgX)

Silver bromide (chemical formula AgBr), silver iodide (AgI) and silver chloride (AgCl), are collectively known as silver halides (generally referred to as AgX). They form fine crystals (grains) which make up about 40% of the total weight of a photographic emulsion. They are all sensitive to light. Photographic emulsions of low sensitivity, such as those used for printing papers, usually employ AgBr and AgCl; but most high-sensitivity emulsions, such as those made for camera films, contain AgBr with small amounts of AgI added.

Silver bromide and silver chloride crystals can be formed by mixing a solution of silver nitrate (AgNO$_3$) with a solution of potassium bromide (KBr) or potassium chloride (KCl). The reaction can be represented in chemical symbols as:

$$AgNO_3 + KBr \rightarrow AgBr + KNO_3$$

silver nitrate potassium bromide silver bromide potassium nitrate

Eq. 3.17

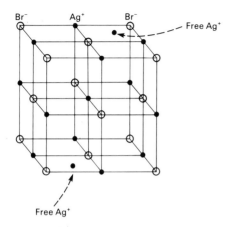

Fig. 3.38 Crystal structure of silver bromide, AgBr. AgCl has the same structure.

The potassium nitrate stays dissolved, but the silver halides forms as small crystals.

The crystal structure of silver bromide is shown in Fig. 3.38. The bromine atoms have gained an electron each to become large negative bromide ions (Br^-). The silver atoms have each lost an electron to become small positive ions (Ag^+). These ions are arranged in a regular pattern called a cubic lattice. Some of the smaller Ag^+ ions occupy free-state positions within the crystal. These free ions are highly important to the creation of the latent image.

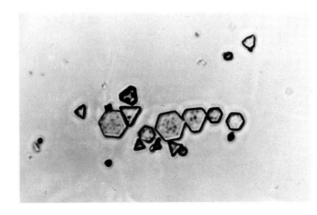

Fig. 3.39

CREATING THE LATENT IMAGE

The action of light on AgX grains is illustrated in Fig. 3.40.

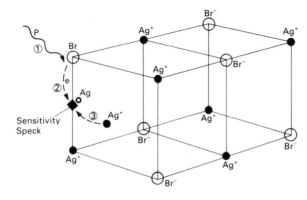

Fig. 3.40

(1) A **photon** (an energy particle of electromagnetic radiation) (p) releases an electron (e^-) from a bromide ion (Br^-), leaving a bromine atom (Br):

$$Br^- + p \rightarrow Br + e^- \qquad Eq. 3.18$$

(2) The released electron is then trapped at a **sensitivity speck**, usually an imperfection in the crystal lattice, where:

(3) it may combine with a free Ag^+ ion to form a silver atom (Ag):

$$Ag^+ + e^- \rightarrow Ag \qquad Eq. 3.19$$

When a few such silver atoms are formed within the crystal (grain), they constitute a **latent image**, which may be subsequently developed. Developers act by donating many more electrons, amplifying the reaction shown in Eq. 3.18 by thousands or millions of times. In Fig. 3.41, a very large AgBr grain is shown at various times in its development, from its latent form to almost complete development. Later stages of growth (depending on the type and

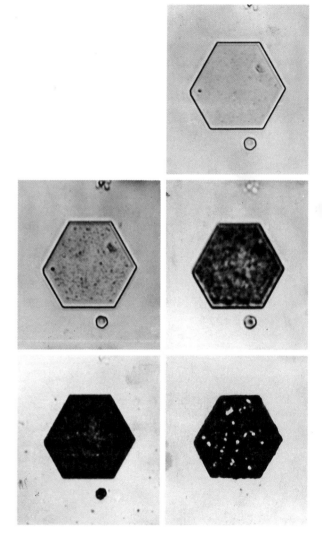

Fig. 3.41

strength of the developer) will break up the grain's shape, leaving a black coke-like particle of pure silver that will be totally opaque to light. Grains that have received a lot of light when the film was exposed will be converted almost totally to silver, giving a black image. Grains that received less light will be only partly converted to silver, giving a grey image at that point on the film.

FILMS AND PAPERS

Film

The structure of a typical film is shown in Fig. 3.42. It consists of:

(i) a thin gelatin supercoat which helps to protect the emulsion from scratches;

(ii) the light-sensitive emulsion (about 7–10 μm thick);

(iii) a 'subbing' layer (gelatin and cellulose ester) to 'stick' the emulsion to the base (ester being a modern polyester material of high dimensional stability);

(iv) tri-acetate film base (70–100 μm thick);

(v) subbing layer for sticking the anti-curl backing to the base;

(vi) gelatin anti-curl backing – if this layer were not present, the edges of the film would tend to curl up. This backing usually contains an anti-halation dye to absorb any strong image light that might be reflected back from the base–air interface, thus preventing 'halos' from appearing around highlight areas.

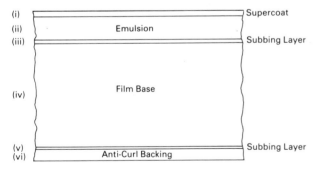

Fig. 3.42 Structure of a typical film.

Paper

Photographic printing paper is somewhat different from film, mainly because its image has to be reflected rather than transmitted. Two main types of construction are employed:

(a) Fibre-based paper

The traditional form of printing paper is shown in Fig. 3.43. It is somewhat similar to that of film, except that beneath the emulsion layer there is a **baryta** coating on top of the paper base. This layer of baryta (barium sulphate) is extremely white and it reflects print highlights as white as possible. This provides the maximum print brightness range (from black to white).

Fibre-based papers are mainly used by professionals, since they are easier to retouch and, with correct processing, have a longer display life. They are usually available in either single or double weight, the latter being specially useful for large exhibition prints.

(b) Resin-coated (RC) paper

Resin-coated papers have a different construction to the (older) fibre-based types, and have the distinct advantage of taking up only a quarter of the processing time. As shown in Fig. 3.44, RC paper has its fibre-base sealed (top and bottom) with a waterproof resin. This resin coat ensures that the paper base cannot absorb solutions, except at the edges, which allows washing and drying times to be very short.

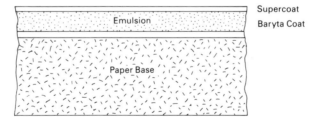

Fig. 3.43 Structure of a fibre-based paper.

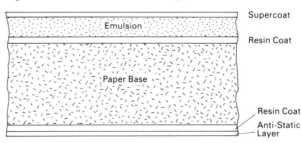

Fig. 3.44 Structure of a resin-coated paper.

Paper surface

Printing papers can be finished with a variety of surfaces, ranging from matt, semi-matt, lustre, pearl, etc. to glossy. The most favoured surface is glossy, mainly because glossy blacks tend to increase print contrast and so enhance image quality, particularly when the photograph is slightly unsharp or otherwise less than perfect. With fibre-based papers, a full matt surface is often useful for exhibition photographs, portraits and landscapes, for example. Resin-coated papers have a limited range of surfaces. The glossy type dries with a natural shiny finish without the need for any special drying or glazing equipment. This is yet another advantage of RC papers.

SPECTRAL SENSITIVITY OF FILMS AND PAPERS

Although monochromatic materials can only represent colours in terms of grey tones, it is nevertheless important that they should do this in a representative manner. Ideally, they should have the same spectral sensitivity as the human eye, so that the photograph gives the same relative brightness as the original scene, though without the sensation of colour.

In Eqs 3.18 and 3.19, the basic mechanism of the reaction of light-sensitive materials with light was explained using AgBr as the silver halide and p to represent incident photon energy. These simple explanations suitably represent what is known as an **ordinary** emulsion – one that has a spectral sensitivity determined only by the nature of the silver halide employed. In general, we can say that all emulsions are sensitive to the ultraviolet, down to 250 nm in fact, but in practice the camera lens will absorb wavelengths shorter than about 320 nm. (The human eye can only see as far down as 380 nm, which is the upper end of ultraviolet radiation.) Ordinary emulsions will have a spectral sensitivity range from about 250 nm to about 450 nm or more, depending on the halides used.

However, an emulsion that is only sensitive to blue light can only represent a bright yellow object, say, as black! In fact, any colour of longer wavelength than blue will be represented as black on the photographic print.

In 1873, Vogel discovered that when certain coloured dyes were *absorbed* on the surface of silver halide grains, they made them sensitive to light of longer wavelengths. This is the theory behind dye-sensitising of emulsions.

Ordinary emulsions

In practice (where glass lenses are used), silver bromide or silver chloride emulsions (or their combinations) are sensitive only to the near ultraviolet and blue radiation. It is for this reason that monochrome printing papers can be used in yellow or red safelights.

The practical range for AgCl emulsions is 340 nm to 420 nm: these emulsions are not very common today, but were once popular for contact printing papers. Silver chloride emulsions have small grains, which makes them rather contrasty and insensitive – but this lack of sensitivity also has the advantage of allowing them to be used in bright yellow safelights.

A more common variety is the combination known as chlorobromide (AgCl + AgBr) which produces a warm-toned image when employed for printing papers with a spectral range of 340 to 450 nm.

Pure AgBr emulsions are found both in papers and in films, and have a spectral range extending from 340 to 470 nm. They provide a neutral black image colour, and a wide range of tones for both prints and films.

Ordinary emulsion film is extremely useful for making transparency prints (slides), and for intermediate negatives and diapositives necessary for various image modification techniques.

Orthochromatic emulsions

The term **orthochromatic** is really incorrect, since it suggests that such emulsions will respond to *all* colours, recording them as grey tones. It was first used in 1884, when the dye erythrosin was used to extend colour sensitivity slightly beyond the green. It is now used to cover all emulsions that are sensitised as far as the green part of the spectrum – but red objects will still appear black! Although monochrome ortho-films are still used for specialised work, ortho-emulsions find their main use as the green-sensitive layer of colour films.

Panchromatic emulsions

Materials sensitive to the entire spectrum are called panchromatic. These are the normal type of monochrome film used in cameras. Generally, the red sensitivity reaches as far as 700–720 nm and allows panchromatic emulsions to render all object colours as grey tones. But as we see from Fig. 3.45, the spectral response curve for a human eye peaks in the central green region, whereas that for a typical panchromatic film is relatively flat. However, if a suitable filter is fitted to the camera lens it is possible to record colours (as grey tones) more or less as we see them. The relative response curves for ordinary, ortho and panchromatic emulsions are shown in Fig. 3.46.

FILM SIZES

The most popular and economic film size in use today is 35 mm. By this we mean that the film has a total width of 35 mm, including the sprocketed

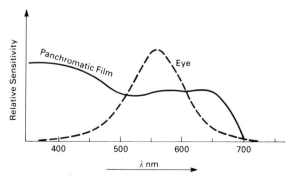

Fig. 3.45 Spectral response curves.

edges by which the film is transported through the camera. Most modern cameras use 35 mm film, both in monochrome and colour, and have a common format of 36 mm × 24 mm. Although available in bulk quantities, in rolls of up to 30 metres' length, they are mainly sold in **cassettes** holding 12, 20, 24 or 36 frames, ready for daylight loading into the camera.

The larger, but less popular, 6 cm × 6 cm format is typical of TLR cameras, and a few SLRs such as the Rollei 6006, Bronica and Hasselblad. These cameras take 120 or 220 size roll films, each film being wrapped within a light-tight wrapping paper. They provide 12 or 24 frames respectively.

Roll films are traditionally associated with many of the older types of camera, some using 46 mm wide 127 roll film, others using 120 size with either 8, 12 or even 16 frames available according to the camera format.

FILM SENSITOMETRY

In order to understand fully the relationships between light, film and development, it is convenient to display their characteristics in the form of a graph. This is known as **sensitometry** and before we go any further it is important that we understand the terms involved.

If we expose a sheet of film to a source of light, so that we gain a series of exposure steps, each

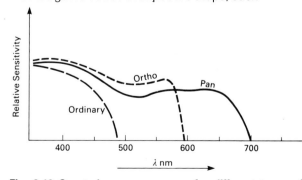

Fig. 3.46 Spectral response curves for different types of monochrome film.

Fig. 3.47

increasing by a known amount (×2, for example), we can then process the film to provide a **step-tablet** like that of Fig. 3.47. Each step will have an **opacity** (*O*) which is associated with the amount of light it transmits *(T)* and may be calculated as:

$$O = I/T \qquad \text{Eq. 3.20}$$

where *I* is the incident light intensity.

Sensitometry usually only requires relative values, so we consider the incident light, *I*, as being 100%. Then, if the transmitted light coming through part of the film is 50%, $O = 100/50 = 2$, and, if only 10% gets through, $O = 100/10 = 10$.

Opacity is the light-stopping power of exposed film, and every photographic negative can be considered as an image made up of many different opacities. It is an interesting fact that the eye sees constant brightness differences, like those shown in Fig. 3.47, between exposures that follow a geometrical progression, i.e. increase by a constant ratio, such as ×2 or, as for the steps in Fig. 3.47, by a factor of √2 (1.41). Exposures that progress geometrically do so very fast, soon reaching large numbers, e.g. 2, 4, 8, 16, 32, 64, 128, 256, 512, 1024, etc. As a result, it is convenient to express such progressions logarithmically, as shown in Table 3.3.

Density

We can see from Table 3.3 that a very large range of opacities going from, say, one to ten thousand, can be represented on a logarithmic scale (common logarithms – to the base ten) from 0 to 4. As a result, it is more convenient to express opacities in terms of their log-values. The log-value is called the **density** (*D*). Thus:

$$D = \log_{10}O = \log_{10}I/T \qquad \text{Eq. 3.21}$$

Exposure

When light-sensitive materials, film or paper, are exposed to light they receive illumination (*E*), which is made up of many wavelengths (λ), for a given period of time (*t*) usually given in seconds or fractions of a second. Exposure is the product of $E \times t$ and, by international agreement, **exposure** is given the symbol *H*. So,

$$H = E.t \qquad \text{Eq. 3.22}$$

In practice, we control image illumination (*E*) in the camera by use of relative aperture, i.e. the f/No. (Eq. 3.5), and the exposure time (*t*) by the shutter.

The characteristic curve

In order to see how a particular film, or paper, responds to both light and development, we make a step-tablet (like that shown in Fig. 3.47) and, with the aid of a simple instrument known as a densitometer, plot the density of each step against the relative logarithm of its known exposure. The resulting plot is known as a **characteristic curve**, and can be made for any given emulsion to indicate the changes that take place when the film is developed in different conditions. (*Note*: In the absence of a densitometer it is still possible, but less convenient, to measure density using an exposure meter and Eq. 3.21.) A typical *D*–log *H* curve is shown in Fig. 3.48, from which we may understand the important characteristics of a negative image.

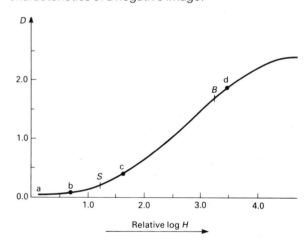

Fig. 3.48 A typical film *D*-log *H* curve.

We can see that the region a → b on the *D*–log *H* curve is almost flat. Despite increase in exposure (as we move to the right on the curve), there is no increase in density. This is the region of total *under-exposure*. With increased exposure we have the **toe** region, b → c, which is highly important since it is here that the so-called film speed (ISO rating) is calculated and where all the shadow detail is found.

As we use longer exposures, there is now a region that is almost a straight line (c → d) where most of

Table 3.3

No.	Log.	No.	Log.	No.	Log.	No.	Log.	No.	Log.	No.	Log.
1	0	2	0.30	4	0.60	8	0.90	10	1.00	16	1.20
20	1.30	32	1.50	40	1.60	64	1.80	100	2.00	128	2.10
200	2.30	256	2.40	400	2.60	512	2.71	1000	3.00	1024	3.01
2000	3.30	4000	3.60	8000	3.90	10000	4.00	20000	4.30	40000	4.60

the subject detail will be recorded and where the contrast of the film is calculated. The region of *over-exposure* lies above the point d, and continues to the point where more exposure does not give more density.

If the darkest (shadow) parts of an object are recorded at point S on the curve and the brightest parts (highlights) at B, we can see that they cover an image brightness range of 2 log units (100:1). Since point S is within the toe region, we can say that the exposure is correct and this leads us to the well-known maxim 'expose for the shadows and let the highlights take care of themselves'. On the other hand, this same image brightness range (2 log units) could be shifted anywhere along the log H axis, from putting the shadow at a point on the curve corresponding to 1.0, or the highlight at a point corresponding to 4.0 on the relative log H axis. Since the image brightness range is 100.1, and the overall (useful) log H scale is 10 000:1 (four log units), we can say that for this particular scene there is an exposure *latitude* equal to 10 000/100 = 100. This latitude provides for a degree of tolerance when calculating exposure, but it is still best to try to get the shadow detail at some point close to S on the D–log H curve. But if the camera controls are incorrect for the same scene, leading to under-exposure, dark objects have their image intensities shifted to the left of point b (i.e. point S will now lie between a and b) and the film will fail to record small brightness differences since the curve is flat in this region.

Film speeds

A film's sensitivity to light is indicated by its ISO (International Standards Organisation) speed rating. There have been a number of such rating systems in the past, such as ASA (American), which is an arithmetical scale, and DIN (European), which is expressed on a logarithmic basis.

The current ISO system uses both types of scale. For example, if a film is rated as ISO 125/22°, the first figure indicates film sensitivity on an arithmetic basis (a film of 125 is half as sensitive as one of 250), and

the second figure, with the degree sign, is logarithmic (22° being half as sensitive as one of 25°, each 3° added meaning twice the sensitivity).

Obviously, there is an advantage to loading cameras with film of the highest possible speed rating, since this allows photographers to take pictures in very dim lighting conditions. But there is a price to pay for such advantages – and this is manifested by increased **granularity**.

Granularity and graininess

Inspection of Fig. 3.41 shows that as AgX grains develop, their structure turns to complete silver. But with extra exposure and/or development, the grains soon lose their neat form and clump into larger silver filaments. This increase in grain size tends to break up the fine micro-image structure, resulting in the random pattern (when enlarged) we know as **graininess**. It is important to note that the measured differences between grain micro-densities is called **granularity**, whereas the irregular pattern we see in the enlarged image is known as **graininess**.

One of the major reasons for avoiding high densities in 35 mm photography is to reduce graininess. This is of particular importance to the highlight regions, where graininess tends to spoil subtle tone relationships.

IMAGE DEFINITION

From the moment of exposure to the point where an image is seen as a print, a number of factors contribute to the final image quality.

Starting with the camera lens, the image is as good as it ever can be in terms of resolution, which we can measure with targets such as those shown in Fig. 3.25. But this quality will then be reduced to some extent, according to the resolution capability of the film employed. The resolution of a 'fast' film of, say, 400 ISO will be lower than that of, say, a 50 ISO (slow) film. Thus if the lens is capable of resolving 100 line-pairs per millimetre (lp/mm), and the film is

80 lp/mm, the resultant resolution (in the negative) can be approximated as:

$$1/R_{(neg)} = 1/R_{(lens)} + 1/R_{(film)} \qquad \text{Eq. 3.23}$$

and for the example quoted above, we have:

$$1/R_{(neg)} = 1/100 + 1/80 = \frac{4+5}{400}$$

and so

$$R_{(neg)} = \frac{400}{9} = 44 \, \text{lp/mm (approx.)}$$

However, this result would be a fair approximation only if the film were to be correctly exposed and developed.

For small negatives, which need to be enlarged, the same process is involved for the resolution of both enlarger lens and printing material, but here we have another problem – granularity! After a certain degree of enlargement the negative will demonstrate 'graininess' (according to the type of film and its processing), which will lower the final definition of the image still further.

Image definition is therefore not an easy concept, for not only must we consider the optical qualities of lens and materials, but the processing as well. Were it only as simple as this! In fact, matters are made even more complex due to the nature of the subject, and the contrast (grade) and surface of the printing paper. Indeed, if the subject itself has high contrast and strong lines, then the final image will have great strength, and may appear quite sharp (particularly when viewed at some distance) despite poor lens resolution. Similarly, an unsharp negative can be made to appear much sharper by printing on to a contrasty grade of printing paper.

We can see, therefore, that image definition is not a simple matter, nor is it possible to express it fully by objective testing, i.e. by calculating resolution figures, as defined in Eq. 3.23. Image definition is very subjective and relies on such things as edge sharpness, simultaneous contrast and the surface of the print, as well as resolution. It is sometimes a useful ploy to use matt surfaced printing paper when printing an unsharp negative, simply because it tends to hide the poor definition that would otherwise be very evident on a glossy surface.

TYPICAL 35 mm MONOCHROME FILM TYPES AND THEIR CHARACTERISTICS

There are many different types of monochrome films available, but we shall look only at a representative sample, covering those types that are essential for a full range of photographic techniques.

In Table 3.4, various films are listed with their major characteristics, i.e. film speed, contrast, granularity (grain), and their general purpose. Over the years, manufacturers tend to change these characteristics, and with them the names of their products. But many of the films listed here, such as Kodak Tri-X and Ilford FP4, have retained their names, characteristics and popularity for a number of decades now.

Most of the films in Table 3.4 are available in 35 mm and roll film sizes, but Kodak Gravure is usually sold in boxes of sheet film (18 cm × 24 cm). However, since this film can be safely handled in yellow printing light, it is quite convenient to make diapositives as enlargements, processed in a similar manner to printing papers.

GAMMA: THE MEASURE OF CONTRAST IN A NEGATIVE

Inspection of Fig. 3.49 indicates that for a given film and its development there will be a density range (ΔD) associated with the log-exposure range ($\Delta \log H$) recorded for any given scene. Furthermore, if we develop a film for different periods of time, we find that the slope of the characteristic curve gets steeper the longer we develop the film. This results in greater values of ΔD for a given exposure range ($\Delta \log H$).

The slope of the straight-line section of the $D-\log H$ curve can be assigned a value, known as gamma (γ), which is useful for expressing the contrast of a negative.

Table 3.4

Film	Speed (ISO)	Contrast	Development (20°C)	Remarks
Kodak Gravure Positive 4135	8/10°	medium	DK-50 2–5 min	Blue sensitive film for diapositives
Kodalith Ortho type 3	6/9°	high	Kodalith 2–4 min	Suitable for line work and tone-separation
Kodak Panatomic-X	32/16°	medium	D-76 (1 + 1) 7 min	General purpose, good for high enlargements
Kodak Technical Pan Film (2415)	32/16°	low	LC Dev 18 min	Capable of very high (×50) enlargements
	By trial & error	high	D-19 4 min	D-19: high contrast with coarse grain
Ilford Pan-F	50/18°	low	ID-11 (1 + 1) 8 min	General purpose, with fine grain
	80/20°	medium	12 min	Fine–medium grain
Kodak Plus-X	125/22°	medium	Microdol-X 7 min	Moderate enlargement, fine grain
Ilford FP4	125/22°	medium	ID-11 (1 + 1) $9\frac{1}{2}$ min	Moderate enlargement, fine grain
Ilford HP5	400/27°	medium	ID-11 (1 + 1) 12–14 min	Moderate enlargement, medium grain
Kodak Tri-X	400/27°	medium	D-76 (1 + 1) 10 min	Moderate enlargement medium grain
Ilford XP1	Variable 100-800 (150)	Variable low-medium	See film instructions: C41 chromogenic	Dye image using C41 colour developer
Kodak Royal-X Pan	1250/32°	medium	DK-50 12 min	Very high speed and coarse grain
Kodak T-max	Various up to 3200 (ISO)	medium	T-max developer	Flat shaped grains giving high-speed with enhanced definition
Kodak High-Speed Infrared film	50/18° No. 87 filter	medium	D-76 12 min	Coarse grain, speed depends on filter used (No. 87 filter passes IR only)

Gamma is calculated as the ratio:

$$\gamma = \Delta D / \Delta \log H \qquad \text{Eq. 3.24}$$

and is illustrated in Fig. 3.49, for different degrees of development. An even more precise definition, known as **contrast index**, includes other parameters but is very similar to gamma.

The curves shown in Fig. 3.49 illustrate what happens with increasing development. For the 18-minute curve, ΔD is 1.5 which, over a $\Delta \log H$ range of 1.0, gives a value of 1.5 for gamma.

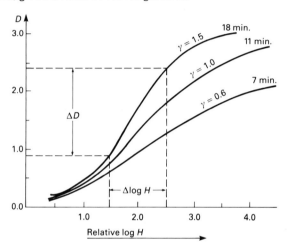

Fig. 3.49

PRINT CONTRAST AND ITS CONTROL: PAPER GRADES

Unlike films, prints are developed for a constant time to gain the best quality that can be produced, i.e. with the maximum black and clearest white possible. With most papers, full development is set for two minutes at 20°C. Different manufacturers make different grades of paper, but essentially they all produce three basic grades: **soft**, **normal** and **contrasty**. In addition, there are **extra-soft** and **ultra-hard** grades, but these are not made by all manufacturers.

Although it is possible to gain some extra contrast

from a print, either by extending the development time or using concentrated developer, there is always the danger of staining the print if this is overdone. As a result, these measures are usually reserved for negatives that have been grossly under-developed and where the maximum grade of printing paper no longer gives sufficient contrast.

A typical range of printing paper D–$\log H$ curves (Kodak) is shown in Fig. 3.50. It will be noticed that

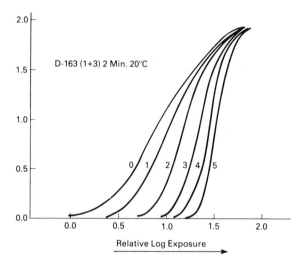

Fig. 3.50 D-log H curves for glossy printing papers.

the curves increase in slope as the grade number increases, all being developed to a constant time and at a constant temperature. The maximum density, $D_{(max)}$, is shown to be in the region of 1.8 to 1.9, which is typical for glossy bromide paper. For matt papers $D_{(max)}$ would be reduced to about 1.4. (*Note*: The curves shown in Fig. 3.50 suggest that the harder grades are less light-sensitive, since they are shifted to the right along the $\log H$ axis, in the direction of greater exposure. In practice, this is nearly always the case.)

The photographer usually selects his or her printing grade from inspection of the negative image. This process takes a little experience to get right and will be discussed further in Chapter 4, but in theory the correct grade of paper will have an exposure scale ($\Delta \log H$) equal to the density range of the

negative (ΔD). The exposure scale for each of the papers shown in Fig. 3.50 is given in Table 3.5.

Table 3.5

Kodak Kodabrome II RC Paper	Description (Grade)	$\Delta \log H$ (paper) (to match ΔD of negative)
0	Extra Soft	1.5
1	Soft	1.3
2	Normal	1.0
3	Hard (contrasty)	0.7
4	Extra Hard	0.5
5	Ultra Hard	0.4

The values given in Table 3.5 are those for a particular range of Kodak papers, representing the widest possible choice in paper grades.

Multigrade papers

Yet another method for matching the paper exposure scale ($\Delta \log H$) to the negative is to have a printing paper with a variable grade. This system, known as **multigrade**, uses photographic paper that changes its grade according to the colour of the printing light source. The colour is varied by means of 'multigrade printing filters' held in front of the enlarger lens.

Multigrade papers afford an economic alternative to keeping a stock of different grades at each required size. It is a convenient solution for those who need a less expensive system. These papers incorporate two emulsions, a contrasty blue-sensitive one, plus a softer one sensitised into the green end of the spectrum.

A range of about ten filters, extending from a deep yellow (grade 0) through to deep purple (grade 5) allows multigrade paper to be used in much the same way as the range of papers shown in Table 3.5. When using these papers, care should be taken to ensure that the correct type of safelight is installed in the printing room.

STUDENT ASSIGNMENTS

1 Take a spare piece of film (Ilford FP4 or Kodak Plus-X, for example) and expose (fog) it to very low-intensity light, such as that found in the printing room. Process the film in the normal way and, when dry, find its density. (*Note*: A camera TTL meter could be used for this purpose. For example, suppose the camera film is exposed to a sheet of white paper for 1/125 second at f/5.6. When the 'fogged film' is placed in front of the camera lens, the meter reads only 1/30 second at f/5.6. The light intensity must have been reduced by a factor of four. The film therefore has an opacity of 4, and $D = \log 4 = 0.6$.)

2 Use an enlarger (no negative required) to make three step-tablets (as in Fig. 3.47) by successive exposures on soft, normal and hard grades of printing paper. Adjust your exposures to ensure that each step-tablet exhibits its full range of densities, i.e. from best possible white to maximum black, when developed fully.

Compare the finished step-tablets with respect to their contrast and exposure range.

FILTERS

We should start by saying that in photography the term *filter* means an *optical filter*, and refers to the selective wavelength transmission of light. Very often we see certain optical attachments, such as soft-focus, multi-image, starburst, etc., being referred to as 'effects filters', but strictly speaking these are not filters at all, and will be discussed elsewhere in this book.

We know that light consists of a spectrum of electromagnetic radiation extending from 380 nm to 760 nm, to which the average human eye responds as shown in Fig. 3.45. But if we were to place a yellow tinted glass in front of the eye (or camera lens) then, broadly speaking, only those wavelengths close to pure yellow would be transmitted.

It is very important to understand that filters *absorb* all wavelengths other than those they transmit. Since yellow is complementary to blue, i.e.

$$\updownarrow\ \begin{array}{lll} \text{red} & \text{green} & \text{blue} \quad \text{(primaries)} \\ \text{cyan} & \text{magenta} & \text{yellow} \quad \text{(complementaries)} \end{array}$$

then, by definition, a yellow filter will transmit the remaining two primaries, i.e. red and green (which together make yellow) and absorb the blue. Similarly, a green filter will hold back (absorb) red and blue wavelengths (magenta), and transmit green.

WAVELENGTH BAND-PASS

There are no definite cut-off points in filters; *all* wavelengths are transmitted as a percentage of the incident light. Nevertheless, it is convenient to talk about the wavelength **band-pass** as starting and finishing at a particular percentage level. Thus a deep yellow-green filter (such as the Kodak No. 61) may allow 10% of incident light to pass at 495 nm, rise to a maximum transmission of 40% at 520 nm and drop down to 10% again at 570 nm, the total band-pass being 75 nm. A lighter yellow-green filter would have a broader band-pass. The Kodak No. 59, for example, transmits from 470 nm to 600 nm and has a maximum transmission of 70% at 520 nm.

FILTER FACTORS

Since filters absorb some of the incident light, it can be expected that when they are placed over a camera lens, extra exposure will be required to compensate. Before TTL metering was invented it was essential to apply a **filter factor** (FF) for the film/filter combination employed. Typically, a medium yellow filter, such as a Kodak No. 8, would require an FF of ×2, whereas that for the narrow-cut yellow-green (Kodak No. 61) would require something like ×12, depending on the wavelength sensitivity of the film that was being used.

Fortunately, with TTL metering now common to most SLR cameras, exposures are read via the filter and filter factors are almost a thing of the past. But if an independent exposure meter is used, take care to use the appropriate filter factor in your final calculation. For example, if an exposure of, say, 1/60 at f/8 is measured (off the camera) and a filter with an FF of ×2 is to be used, the correct exposure will now be 1/60 at f/5.6.

TYPES OF FILTERS AND THEIR APPLICATIONS

Filters are extremely useful in photography and, for convenience, may be divided into different groups. Naturally, these groups are not mutually exclusive and it is quite common to find some filters being used in a number of groups, depending on the work involved.

Filters used for monochrome (b/w) photography

Perhaps the best-known use for filters is in monochrome photography, particularly as **contrast** or **effects** filters. A yellow filter is the most common – used to reduce the light intensity from a blue sky (monochrome films are over-sensitive in the blue, as shown in Fig. 3.46), thus rendering better contrast to fluffy white clouds in landscape scenes. An even better filter is the yellow-green, which provides lighter tones to the landscape as well as giving contrast to the sky.

In all matters relating to choice of filters it is useful to remember the old maxim: 'like colours lighten and complementary colours darken'.

Red filters are useful for creating dramatic effects, particularly since they darken the blue sky considerably, and also green areas to some extent.

Filters used for colour photography

Apart from the so-called 'skylight' or 'haze' filter, which is virtually colourless, filters designed for use with colour films are intended to modify the colour temperature of the image light. Thus if daylight colour film is in the camera, and a photograph is taken indoors with photoflood illumination (3400 K), the filter required over the lens is a pale-blue Kodak (Wratten) 80B. Similarly, if artificial-light colour film is in the camera, and a shot is needed outdoors, the appropriate **conversion filter** is an amber-coloured Kodak (Wratten) 85.

All colour films have three light-sensitive emulsions. From the top, there is a blue-sensitive layer, a green-sensitive layer and a red-sensitive layer. All the emulsions are highly sensitive to ultraviolet radiation – but to different degrees. So in order to avoid unwanted colour casts it is important to filter out excessive UV with a colourless 'haze' filter, such as the Kodak 1A. This filter is extremely useful since it may be kept on the camera at all times, thus affording a measure of physical protection to the lens.

Polarising filters

Obviously, we cannot use a coloured filter when using colour film, except for colour-temperature conversion purposes. We are therefore unable to use a yellow filter for bringing out clouds, as we would with monochrome film. However, the blue of the sky is a result of scattering of blue wavelengths, and since this phenomenon is accompanied by partial polarisation of the scattered light (see p. 35), we can use a polarising filter to exclude the scattered short-wavelength light and thus darken the sky.

The action of a polarising filter was described in Chapter 2 (p. 35). Camera polarising filters come supplied with the usual threaded mount, but the filter itself can be rotated through 360°. All the photographer need do is rotate the filter until the sky appears darker, or a reflection is reduced, depending on the application.

It is important to understand that the entire sky will

Fig. 3.51

not be polarised to the same degree. As a result, the effect of a polarising filter will depend largely on camera viewpoint. Scattered skylight is mainly polarised in directions at right-angles to the line of sight of the sun, and the effect of a polarising filter is greatest when viewing scenes that include sky in the region of the shaded area of Fig. 3.51.

The scene shown in Fig. 3.52 was taken at right-angles to the direction of the sun, but without a polariser. That in Fig. 3.53 was made with a polarising filter rotated to give maximum effect (as indicated by the strength of the clouds). Changing the camera viewpoint more into the sun meant the polarising filter had less effect, as shown by Fig. 3.54.

Yet another use for polarising filters is to reduce unwanted specular reflections coming from glass or water surfaces. It is quite common to find specular (mirror-like) reflections in a photograph. They do not generally worry the photographer until such time as he or she wants to see into a shop window, under the surface of a clear pool of water, or avoid their disturbing effects when photographing glassware.

Reflections that come from transparent media, such as glass or water, can be reduced considerably by using a polarising filter rotated to the point where they are subdued to the maximum degree. But, as with photographing the sky, there are certain rules that should be recognised.

According to **Brewster's law**, specular reflections are polarised at an angle given by:

$$\tan\theta = n \qquad\qquad \text{Eq. 3.25}$$

Fig. 3.52 Without polariser, at right-angles to sun.

Fig. 3.53 With polariser, at right-angles to sun.

Fig. 3.54 With polariser, into sun.

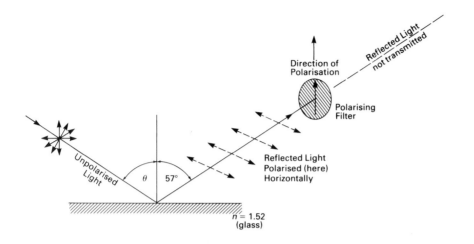

Fig. 3.55

forgeries and the like. It has also been used to detect hidden portraits, particularly where, say, an impoverished painter has overpainted a canvas containing previous work, as seen in Fig. 3.57.

In a similar fashion, filters are available that pass only ultraviolet radiation. These are useful in medical photography.

Neutral density (ND) filters are non-selective in terms of wavelength – they reduce the intensity of all wavelengths of light. They are useful for laboratory work where it is impracticable to reduce camera illumination by way of apertures. These ND filters can be purchased in glass or gelatin, like coloured filters. Typically, they are made as ND = 0.3 (50% transmission), ND = 1.0 (10% transmission) and ND = 2.0 (1% transmission).

where angle θ is the angle shown in Fig. 3.55, and n is the refractive index of the reflecting medium (1.52 for glass, 1.33 for water).

Thus for glass ($n = 1.52$), the angle whose tangent is 1.52 is close to 57°. If the camera is positioned at this angle with respect to the normal-to-the-glass, the reflected light entering the lens will be polarised and the polarising filter can be rotated to reduce reflections with maximum effect. With water ($n = 1.33$), the corresponding angle is 53°.

Special filters for scientific and technical use

Although all the filters mentioned so far also come into this category, there are a few filters which are designed especially for scientific and technical work. In this group we must include those filters employed for use with special emulsions, such as infrared-sensitive films. Filters such as the Kodak 87, though opaque to the eye, will pass infrared radiation but not visible light. A landscape example, taken with Kodak infrared film and an 87 filter, is shown in Fig. 3.56, where the almost moonlight effect of this type of photograph can be seen. The white areas of the landscape are due to the high infrared reflectance of natural foliage.

Infrared photography is also very useful in forensic science, where it may be employed to detect

Fig. 3.56

Fig. 3.57 Turn upside down to find overprinted face. Photo: Ron Graham.

Filters used for colour printing

Filters intended for colour printing, such as the Kodak CP filter range, filter out either red (cyan filter), green (magenta filter) or blue (yellow filter) light. They are used in the colour enlarger either as filter inserts, placed in a special holder below the light source (and above the colour negative) or are selected from a range of filters incorporated in the enlarger 'colour head'. Their purpose is to control the amount of red, green and blue light falling on the colour paper. This controls the respective amounts of the cyan, magenta and yellow dyes formed in the exposed layers of emulsion in the colour paper in conjunction with the colour developer.

Multigrade filters for monochrome printing

Multigrade filters were fully explained in the previous section. But we can mention here that if a colour enlarger is used, it will already have colour filters incorporated that can be used for printing on multigrade papers.

Darkroom filters (safelights)

Although each manufacturer of photographic materials will insist that their own type of 'safelight' should be employed with their own light-sensitive materials, it is reasonable to say that most materials can be used with most safelights, regardless of make – provided that the sensitive material is not exposed too long or too close to the safelight. Indeed, a 'safelight' is only safe provided that films or papers are not exposed to it for too long, and it is well worth while testing the safelights of a printing darkroom by placing a coin on the surface of a paper, leaving it for a minute or two, then processing it to see if there is any difference between the exposed and unexposed parts of the paper.

It is rare to employ a safelight for processing films these days because daylight developing tanks are used. Slow panchromatic films, which are sensitive to all colours, can be processed in a very weak green safelight, but there is no reason to do so, unless there are special loading or processing conditions to be considered. Ordinary films can safely be handled with red or conventional (yellow or orange) print-room safelighting, but special care should be taken when using multigrade printing papers, since these require their own safelights.

STUDENT ASSIGNMENTS

1 Check your printing darkroom for safelighting. Take care to ensure that light bulbs do not exceed the specified wattage, and establish safe lighting conditions consistent with ease of viewing.

2 Imagine you are going to carry out the following projects in monochrome photography using panchromatic film.
 (a) An old, yellow-stained document has to be photographed. What filter (if any) would you use?
 (b) You intend to photograph a rough stone wall under a clear blue sky. Which filter would give you the best contrast?
 (*Note*: Remember the maxim: 'like colours lighten, complementary colours darken'.)

4

Operating Techniques

'Look and think before opening the shutter. The heart and mind are the true lens of the camera.'
(Yousuf Karsh, b. 1908)

Photo: Virginia Bolton

HANDLING THE CAMERA AND ITS CONTROLS

It is perfectly possible to instruct a novice on the handling of a modern camera within the space of about twenty minutes. Indeed, many modern cameras (of the pocket-sized 16 mm-110 film cartridge-loading type) have been specifically designed to accommodate those who wish to get good photographs without any form of training or study in photography, people who are not really amateur photographers in the accepted sense, but who still wish to have good-quality records of events, places and people. With these cameras, twenty minutes' training may well be excessive! However, although many of these highly sophisticated (and often expensive) sub-miniature, or 'compact', cameras are capable of producing first-class photographs and can be very useful to the serious amateur and professional alike, they are generally unsuited to all-round photographic work. They will have 'auto-focus' systems, fully automatic exposure operation, automatic film wind-on (and return) and other features designed to replace the 'photographer' with an 'operator'. They remain items of convenience, essentially, rather than a means of serious photography.

Our concern here is for cameras intended for serious and extended employment, rather than for those designed for holiday snapshots and occasional use. As such, our 'model camera' is a 35 mm single lens reflex (SLR), with through-the-lens (TTL) metering and manual focusing. A large number of popular models of this kind is available, each with its unique controls, lenses and attachments.

There are many different systems of camera control, some of which are almost entirely electronic, and it would be fruitless even to attempt to describe them in detail. Nevertheless, we may consider most SLR cameras to have at least two things in common: their dependence on electrical power (in the form of small disc-shaped 1.35 or 1.5

volt batteries in the base of the camera), and the following basic controls – many of which may be semi-automated from a **Central Processing Unit** (CPU) provided by a tiny microchip:

1 Viewfinder
2 Lens focusing (with a depth-of-field scale)
3 Lens aperture (f/No.) selection
4 Shutter-speed selection (including open-shutter 'B' setting)
5 Through-the-lens (TTL) exposure metering
6 Film-speed selection
7 Film advance (wind-on)
8 Film rewind
9 Film-frame counter
10 Shutter-release button (with provision for cable-release)
11 Flash-synchronisation socket (or 'hot shoe')
12 Interchangeable lenses (bayonet fitting)

Additional functions, not common to all SLR cameras, include:

13 Delay-action timer (usually in the region of 8 seconds)
14 Double-exposure option
15 Exposure-compensation dial
16 Depth of field *preview* facility
17 A selection of exposure-setting *modes*
18 Auto-exposure lock

Let's assume that our camera is a typical 35 mm SLR camera with all the usual controls (1–12 above) and start by taking a look through the viewfinder.

1 VIEWFINDER

The natural handling of a typical SLR camera is with the thumb and forefinger of the left hand holding the lens barrel, and the right hand cupped around the camera body – as shown in Fig. 4.1. The forefinger on the right hand should now be placed over the shutter-release button, with the thumb available to flick the film-advance lever for the next shot.

Fig. 4.1 Photo: Ron Graham.

In this way, the essential controls are to hand as the eye scans the scene through the viewfinder, ready to make an exposure.

Most SLRs incorporate exposure information within the viewfinder, either as a centre-needle system, or with apertures and/or shutter speeds indicated by light-emitting diodes (LEDs) as well as the focused image. As a result, you have three tasks to perform before pressing the shutter-release button:

(a) compose the subject(s) within the frame;
(b) focus on the principal subject;
(c) adjust the correct exposure, by control of aperture and/or shutter-speed, using the TTL-metered information within the viewfinder.

2 LENS FOCUSING

It is impossible to focus critically on any part of a scene when the aperture is less than maximum, and for this reason all SLRs have lenses which operate at preset maximum aperture, regardless of the aperture set for the exposure. This means that the subject can be composed and focused with the image at maximum brightness and sharpness. Just before the shutter is operated, the aperture will flick to the required exposure-setting, and then return to the present position immediately after the photograph has been taken.

Focusing is not difficult and, with practice, you will be able to focus within a second or two, as the focused image becomes sharp within the pentaprism. Many viewfinders have a split-field rangefinder in the centre of field – to be used or ignored at will, depending on the method you used to focus.

3 LENS APERTURE (f/No.) SELECTION

For the standard focal-length lens on a 35 mm camera (50 mm), the average range of f numbers is from a maximum aperture in the region of f/2, to a minimum at f/22. When the shutter is released, image light is exposed to the film according to the rule: $E \times t$, where E (image illuminance) is controlled by the lens aperture for a period of time, 't'.

The lens aperture is not only important in terms of control of light intensity, however, for it also has a unique role to play in dictating the depth of field allowed in the image.

We saw in Chapter 3 that depth of field can be calculated from a knowledge of the hyperfocal distance, but it would be highly impracticable to do so in most circumstances. As a result, all lenses incorporate a depth-of-field scale adjacent to the lens-focusing barrel, as shown in Fig. 4.2.

If you intend to isolate an important feature within

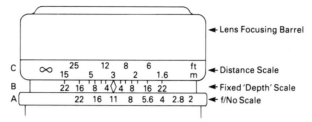

Fig. 4.2 For a given aperture (A), depth-of-field is read off scale C against aperture shown on fixed scale B. For example, at f/11 (scale A) when focused on object 3 metres distant (scale C), we read 'depth' from scale C against f/11 shown on scale B, i.e. 2 metres to 5 metres.

a complex field of detail, then you should use **differential focusing**, i.e. focus the lens on the most important feature and use the widest possible aperture (such as f/2, or f/2.8) which is consistent with the minimum depth of field necessary. See Fig. 4.18, for example.

In this respect, it is useful if the camera has an **aperture preview** facility (16) which overrides the *preset* function mentioned above and allows you to have a preview of the depth of field available at the aperture setting used for exposure, rather than at the preset maximum f/No.

Alternatively, for scenes such as those shown in Fig. 4.22, the aperture will need to be as small as possible, in order to gain the maximum depth of field.

4 SHUTTER-SPEED SELECTION

Most photographs are captured within a short period of time: the exceptions are those taken of objects in very low illumination, which require a long 'time-exposure'. Some cameras have shutters that function with speeds ranging from a few seconds to 1/4000 second, but the range of the majority is from 1 second to 1/2000 second plus 'B'. The 'B' setting (brief) allows the shutter to be held open for as long as the shutter-release button is depressed. Shutter speeds are reasonably accurate and are provided in a sequence of halved periods as: 1, 1/2, 1/4, 1/8, 1/15, 1/30, 1/60, 1/125, 1/500, 1/1000, 1/2000, etc.

Camera shake occurs when you fail to hold the camera steady: the result is a blurred picture. Most people are capable of holding a small camera steady for about 1/30 second, but, if in doubt, it always pays to use the highest possible shutter speed, in order to avoid camera shake.

It is difficult to hold an exposure longer than 1/30 second, including 'B', without camera shake. For these exposures, the camera should be placed on a tripod or, failing this, a stable surface and a cable-release employed so that the camera is not disturbed by your finger releasing the shutter.

The shutter-speed dial usually includes a speed marked 'x', which on most cameras is 1/60 second, and is the speed that must be employed when using electronic flash.

Like the aperture, shutter speeds can be varied in order to give different exposures to the film. But you should always consider the objects being recorded when selecting the shutter speed: short exposures, for example, are essential to freeze motion, particularly where moving objects are close to the camera.

5 THROUGH-THE-LENS (TTL) EXPOSURE METERING

All the different TTL metering displays used in SLR cameras employ an internal exposure meter which monitors the same image light that reaches the film.

On most cameras, the meter system is switched 'on' with a small pressure on the shutter-release button (take care not to push too hard or you will release the shutter!), and will switch itself off after a short period of about ten to fifteen seconds. Some cameras, however, have a separate meter switch.

The exposure sensor is usually a small silicon photocell, which is coupled to either a delicate meter or to an LED (light-emitting diode) display observed within the pentaprism viewfinder.

Incoming image light is received by the photocell, transformed into electrical current (proportional to

the light) and sent to a Central Processing Unit (CPU) which takes the form of a tiny microchip. Additional exposure information, such as f/No. (3), shutter speed (4), film speed (6) and exposure compensation (15) are further inputs to the CPU, which instantly computes all the data and then transmits appropriate signals to the aperture and/or shutter, as well as displaying exposure settings inside the viewfinder or elsewhere on the camera. (Further sophistication involving the CPU is included in those cameras which offer various exposure-setting *modes* (17) and (18).)

6 FILM-SPEED SELECTION

When using cameras with TTL metering, it is vital to set the correct film speed as soon as the film has been loaded into the camera. The film-speed selection dial is usually wrapped around the film-rewind knob (8) and may be easily found since it will show figures under the heading of ISO.

Many cameras, particularly those intended for casual use, do not have a film-speed selection dial but rely instead upon the DX coding printed on most 35 mm film cassettes. This bar code (a series of lines of varying thickness as found on supermarket packaging) is 'read' by sensors within the film-feed cavity, which then send film-speed data as well as the number of frames in the cassette to the CPU. In the event that a cassette is used which does not have a DX code, the system will automatically select a nominal film speed of 100 (ISO).

7 FILM ADVANCE (WIND-ON)

Nearly all SLRs employ a film advance that is coupled to the 'cocking' action of the shutter, usually in the form of a lever-wind mechanism, actuated by a quick flick of the thumb on the right hand. As the film is advanced, the shutter is reset for the next photograph.

Some cameras have an integrated motor-drive,

allowing a rapid series of photographs to be taken for as long as the release button is depressed. Many other cameras offer this facility as an optional extra. These battery-powered drives allow for rapid film sequences of up to about five frames per second, and are extremely useful for sport and fashion photography.

8 FILM REWIND

After the last frame has been used, it is necessary to return the exposed film into its cassette. This is usually done by depressing a small button on the base of the camera which releases the film-wind mechanism. Keeping the button depressed, you then turn the rewind knob on the left-hand side of the camera in the direction indicated.

It is possible to rewind the film completely into the cassette, of course – not a bad idea when using colour film that has to be sent off for processing, and to avoid any confusion about which film has or has not been used! But if you are processing your own monochrome films it is best to rewind only as far as the shaped leader, since this allows you to cut a clean edge to the film, and makes it easier to load the film into its developing tank. You can always tell when the film has just left the take-up spool by listening for a definite 'click' towards the end of the rewind.

9 FILM-FRAME COUNTER

Film-frame counters are usually located within small windows next to the film advance: they indicate frame numbers from 0 to 36. Advance freshly loaded film to the zero position by operating the lever wind and shutter release.

10 SHUTTER-RELEASE BUTTON

Shutter-release buttons are conveniently positioned

next to the film advance and have a threaded interior to accommodate a cable-release. Many of them also have a safety lock to avoid accidental firing.

11 FLASH-SYNCHRONISATION SOCKET (OR 'HOT SHOE')

The traditional flash-synchronisation socket is usually found on the front face of the camera body, close to the lens. But most of today's SLRs will also incorporate a 'hot shoe' contact, located on top of the pentaprism, and fitted with electrical contacts to synchronise a flash gun with the shutter. As a result, it is always possible to synchronise two flash guns with the same exposure.

12 INTERCHANGEABLE LENSES (BAYONET FITTING)

Although this facility can hardly be called a 'control' in the accepted sense of the word, the ability to change to a different focal-length of lens does offer the photographer control of image scale. This can also be done with a zoom lens, of course, but even that has its limitations and will not cover every contingency.

The following functions may or may not be included in your own camera and should be considered as useful, rather then essential, extras.

13 DELAY-ACTION TIMER

This facility is quite common on 35 mm cameras, though it is rarely used. Essentially, it acts as a shutter release, but with a delayed action of about 8–10 seconds. It is, therefore, useful for self-portraits. It may also be useful if the camera is being used on slow speeds, in the range of 1/15 second to

1 second, particularly when there is no cable-release handy, or even a tripod! If you place the camera on a firm support, and aim it at the subject and set the delay action, the camera will have stopped shaking by the time the shutter is released.

14 DOUBLE-EXPOSURE OPTION

We have mentioned that when the film is advanced, the shutter is automatically 'cocked' ready for the following exposure. There are, however, occasions when you may wish to take two exposures (or even more) on one frame. This is only possible if the film-wind/shutter interlock can be uncoupled. Some cameras do, however, allow for this by providing an interlock release.

In studio work, it is possible to take double or triple exposures by placing the camera on a tripod and taking multiple flash exposures with the shutter 'open' and the lights out.

15 EXPOSURE–COMPENSATION DIAL

There are times when you would like to modify the image by giving more, or less, exposure than that calculated by the meter system. You may want either to (a) over-expose in order to accommodate some very dark regions of a scene which the meter has not allowed for (Fig. 4.3) (and compensating with slightly less development) or (b) under-expose a scene and give extra development, to create more contrast to the image.

Naturally, you could always alter the film-speed rating (6), increasing it from, say, 100 ISO to 200 ISO to give it half the normal exposure. But this could prove to be confusing if you did not put the rating back to normal as soon as possible. Many cameras now have a compensating dial which can override the set film speed by increasing the exposure by factors of 2, 4, or decreasing it by 1/2, 1/4, etc.

Fig. 4.3 When photographing against the light, take care with the exposure found by the camera meter. By using a ×2 factor on the 'Exposure Compensation Dial', the shadow areas in this exterior portrait have been correctly exposed. (Note: the camera exposure meter was mainly influenced by the strong skylight.) Photo: Ron Graham.

16 DEPTH OF FIELD PREVIEW FACILITY

As mentioned in (3) above, some SLRs allow you to override the preset maximum aperture so that you can view the scene at the aperture to be used for exposing the photograph. In this way, you can preview the depth of field that will be recorded. However, if the preview aperture is small (say, f/11 or smaller), then it will be difficult to see the rather dim image in the viewfinder.

17 EXPOSURE-SETTING MODES

The most basic **mode** of exposure setting on a camera is manual, that is to say without assistance from a CPU. In many respects, this is the most reliable, but it is arguably not the swiftest and certainly not the most convenient. A variety of modes is available: some cameras offer all of them, others only one or two, while a few offer only an **automatic mode.**

Each mode has its own advantage for a particular field of work and it is up to you to select the appropriate mode according to the task in hand.

Manual mode

In the manual mode, you are free to select any combination of aperture and shutter speed until the exposure meter indicates a correct reading. This 'correct' indication may take the form of a needle, situated to one side of the viewfinder frame, or of a (coloured) LED.

As an example, let us take the case where the shutter has been set at 1/250 second, and our photographer looks at a scene through the viewfinder – all the time changing the lens aperture. At some particular f/No., the needle, or LED, signals 'correct' exposure – and on inspection this turns out to be f/2.8. However, if the photographer believes the scene requires some depth of field, he or she would then drop the shutter speed to, say, 1/30 second, to find the meter now confirming a correct exposure at f/8.

The manual mode offers great flexibility and accuracy, but requires more time to operate than any of the other modes, since both the shutter speed and the aperture have to be set.

Aperture-priority mode (Av)

As this mode suggests, priority is given to the aperture, which the photographer sets. The CPU then takes over and will operate the camera at

whatever shutter speed is needed to gain a correct exposure. Naturally, the photographer should always check what this shutter speed is: this is usually given as a display within the viewfinder. Thus if you have selected an aperture of, say, f/11, and a speed of 1/60 second is displayed, you can always change the aperture (without taking your eye from the viewfinder) to gain a higher speed, say 1/1000 second, should the subject start to move rapidly. In this case, you would not need to calculate the new aperture, but a quick check would show it to be f/2.8.

A common mistake, made by many who use this mode for the first time, is to ignore the shutter speed – it could easily be lower than 1/30 second, and this could result in camera shake and blurred photographs!

Aperture priority is nevertheless very convenient, and is perhaps the most common of all the exposure-setting modes. It is particularly useful in conditions where you have to maintain sufficient depth of field in all your shots: you can set a given aperture which will be maintained, the exposure being controlled by the shutter.

Shutter-priority mode (Tv)

Working with shutter priority is just the opposite to Av mode. Here, the shutter speed is pre-selected and the camera exposure system decides what f/No. the lens aperture will close to just before the picture is taken.

Fewer cameras incorporate Tv mode, mainly because it is a more expensive system – and the Av mode is usually sufficient for most people. However, the Tv mode is highly regarded by professional photographers (who employ it for sports work) and by those who need to operate their camera from a remote location, with shutter speeds held constant, for example, in some applications of aerial photography.

Programmed modes

Even greater sophistication is available with programmed modes that can do almost all the thinking for the operator. Programs are available in some cameras, such as fully automated compact types, which will run through both shutter and aperture options in order to gain a correct exposure. This is only limited if there is insufficient light, at which point LEDs will flash to warn of the risk of camera shake due to low shutter speeds and even, in some models, bring in a flash unit to assist.

18 AUTO-EXPOSURE LOCK

With the camera set on the auto-exposure (AE), it is sometimes possible to under-expose parts of the scene in deep shadow.

To correct for this, move close to that part of the scene and find the correct exposure required. Now press the AE lock button and hold it down while taking the picture. The exposure will now be retained for that region of the scene.

SUPPORTING EQUIPMENT

Today's cameras require very little supporting equipment, but for those who wish to extend the range of their work, the following can be recommended:

(a) A sturdy tripod, that is to say a tripod that even though it may be portable and light will at least keep the camera steady (and safe).

(b) A (soft) cable-release. Avoid the metal-sheathed types which are too stiff and counterproductive in keeping the camera free from 'shake'.

(c) A range of filters. Colour filters for controlling tones in monochrome photography include: medium yellow, yellow-green, and red. A good polarising filter should be included for colour work.

(d) A set of 'supplementary lenses', e.g. 1,2, and 4 dioptres, for close-up photography.

(e) A suitable lens-hood.

(f) Either a zoom lens or a wide-angle (e.g. 28 mm) and long-focus lens (100 mm to 135 mm).

(g) A small flash gun, ideally one with a flexible flash-head that allows the unit to direct its flash in various directions.

(h) An appropriate camera bag.

(i) A 'changing bag'. This 'shirt-like' black bag is fitted with a zip fastener at one end and tightly enclosed sleeves. Changing bags are extremely useful for those conditions where access to a darkroom is impossible, and can be used for loading film into processing tanks, removing films that are stuck in the camera, etc.

Note

All lens attachments, filters, hoods, supplementary lenses, etc. are threaded for fitting into the front of the lens. When ordering these items take care to purchase the correct diameter fitting. The most common diameter is 49 mm, which fits most 50 mm focal length lenses, but if you are using a number of different types of lens, you may find that they each have a different diameter.

STUDENT ASSIGNMENTS

1 Examine any available SLR camera and identify each of its controls against the list 1–18 provided in this chapter.

Check each of the controls and familiarise yourself with their operation, paying particular attention to:

(a) focusing
(b) pre-set aperture
(c) exposure-setting modes
(d) film-loading.

Load the camera with monochrome film and set the correct film speed on the appropriate dial.

2 To test 'depth of field', select a suitable scene

that has a line of objects running from the camera position. Make two (correct) exposures with:

(a) the lens set at maximum aperture
(b) the lens set at minimum aperture.

In each case, focus the camera on a point about one-third the distance into the line of objects.

3 To check your own ability to hold a camera on slow shutter speeds, photograph the front page of a newspaper at 1/30, 1/15, 1/8, 1/4 and 1/2 second. Make sure that the page is held firmly at a constant distance from the camera. Check the resulting negatives for their sharpness with the aid of a magnifying glass.

PHOTOGRAPHY AS AN EXPRESSIVE MEDIUM

INTRODUCTION

When we start a photographic course we have to learn a completely new science and master an electro-mechanical instrument – the camera. At times, these may seem barriers between ourselves and the production of good photographic results, but we should look upon them as vehicles for individual expression through the creation of images.

Photography is not purely a language of metering and f/stops. Everyone is a potential image-maker, and each of us sees the world through different eyes. The great photographers of the past established photography as an art form and it is primarily in terms of creativity and aesthetics that we should now see it.

In this section, we will be looking at the effects these great photographers achieve by use of shutter speed, depth of field (or lack of it), lighting, framing, viewpoint and type of film.

THE PHOTOGRAPHER AND SEEING

Our first instinct in photography may be to peer through the viewfinder of our camera, and then to press the shutter, but we would do well at first to put the camera aside and just look at the world with discriminating eyes. The art of photography is a visual one, one in which the act of seeing is more acute than in everyday life.

Great photographers of the past were able to express their meaning of a subject by looking more critically at the everyday. Like them, we must educate our eyes to be aware of visual information such as shape, form, texture, colour and tone.

Shape

An object's shape is its two-dimensional outline and one of the strongest ways by which it can be identified. A change in viewpoint, lighting and lens selection can emphasise or alter shape; the use of shadow or silhouette (an object's essential shape) can create interest in a photograph. Similarly, as objects overlap or come together, we see more than one shape.

Examine the items around you – what shape are they? Are their outlines harsh or soft? Do shapes overlap? Does backlighting from a window emphasise outlines? Do these shapes have visual interest? See Fig. 4.4.

Texture

Texture is an object's surface characteristics, its roughness or smoothness. In everyday life we are generally unaware of texture unless we pick up an object, to touch it or eat it. In photography, a sense of an object's texture can add interest and give a tactile quality to a two-dimensional image, thereby creating a sense of depth.

Oblique lighting (light which skims across the surface of an object, creating shadows) is best for bringing out texture (see Fig. 4.5) – the harsher the light source, the greater the sense of texture. Soft or

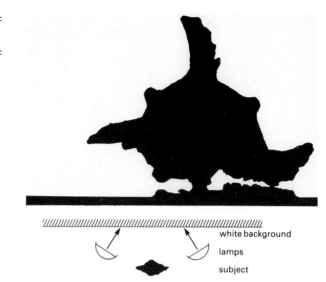

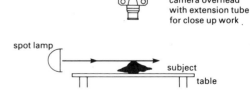

Fig. 4.4 Studio lighting to create shape. Photo: James Wilkinson.

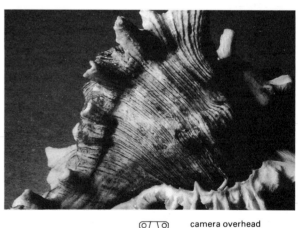

Fig. 4.5. Studio lighting to create texture. Photo: James Wilkinson.

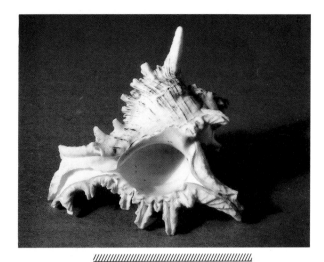

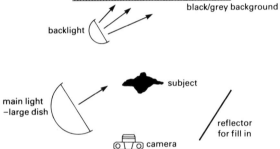

Fig. 4.6(a) Studio lighting to create form. Photo: James Wilkinson.

overhead lighting, on the other hand, subdues texture. Observe the way in which the texture of things outdoors changes as the sun moves through the day. When are the shadows at their longest and texture most emphasised? When are there little or no shadows?

Form

An object's form is its three-dimensional quality – its volume. In photography, the sense of an object's three dimensions is usually created through variations of tone, from shadows to highlights with a broad range of greys in between. In monochrome (black and white) photography, tones are simply variations of lightness – from black-through-grey-to-white; the same principle applies to colour photography except that here, variations in lightness will vary the lightness or value of a colour – as indicated in the Munsell diagram of Fig. 2.18.

With careful attention to lighting, exposure and printing, we can interpret form and create depth in our photographs (Fig. 4.6(a)). If you study Nick Haines' photograph (Fig. 4.6(b)), you will notice how real the subject looks. The lighting and tonal range in printing have given this flower a feeling of depth and realism – you can almost pick it from the page!

Colour and tone

Colour and tone do much to create the mood of a photograph. A black and white photograph which has mainly dark tones and makes use of heavy shadow has a sombre, dramatic or mysterious feeling. On the other hand, a photograph of mostly light tones (a high key situation) has an air of softness, space and delicacy. Filters can change the

Fig. 4.6(b) Photo: Nick Haine.

mood of a photograph, for example by darkening skies and increasing contrast on monochrome as shown in Fig. 4.7. Blue skies can be made to look darker by using a yellow, orange or red filter, just as foliage can be made to look lighter by using a green filter. (The rule with filters is that like colours lighten and complementary colours darken.)

When you use colour film, you can create a feeling of harmony or discordance either by looking for colours which are close together in the spectrum (see Fig. 2.13) and which therefore blend, or by looking for those which are at opposite ends of the spectrum and so contrast with each other. The most pleasing colour photographs are those where hues are subtle rather than gaudy, but the choice depends upon the mood required. These features are likely to change considerably as the light changes throughout the day, and as weather conditions change: both of these make significant changes of mood. How does your own home town or village appear in early-morning sunlight? How does it look in a cold grey mist? Does the mood of the place change as these light and weather conditions change?

The subject and meaning

If you are to produce an image which communicates meaning to the viewer rather than just a photographic record, you must not only be visually aware of the environment but also able to respond to it emotionally and bring all the elements together within the viewfinder. When taking a photograph it may be a good idea to ask the question 'What do I want this image to say?' If you know what you wish it to communicate and why you are taking it, then you will be able to create an image of interest, rhythm, balance, depth and realism in your photograph.

So how do you go about 'designing' a photograph? This involves creative decision-making. Which shutter speed? How much depth of field? What composition and emphasis? Which viewpoint? What film type? Which lens? Your answers to these questions applied together will make your photograph what it is – so what do *you* want it to say?

Fig. 4.7 Ansel Adams: *Sierra Nevada from Lone Pine,* **1969.**

However, if you look at examples of such images (perhaps family 'snaps'), they tend to be very boring. The reason for this is that the eye goes straight to the central area of the image and leaves it at that! However, if you place a subject off-centre and use other elements, lines, shapes or patterns for secondary interest within the frame (such as distant objects or converging lines leading away), then the eye has a path to follow and the whole visual effect is far more interesting.

Similarly, photographs composed in two halves – land and sky – tend to be boring because the relative 'weight' of each element is equal and the eye darts from one half of the picture to the other. What you should be aiming for is to lead the eye through the picture along a path of interest, or to concentrate on one main area. These basic rules make up part of the 'theory of thirds', which is also known as the Golden Mean. If you divide an image area into thirds, vertically and horizontally, and place the main picture elements on one of the intersecting lines or within one or two of the thirds, you will end up with a stronger and altogether more interesting composition. Try to imagine the grid, shown in Fig. 4.8, in your mind's eye as you look through the viewfinder – can you place the main subject on one intersection? Does your eye lead to a secondary subject on another intersection? Does your landscape have land and sky divided in thirds or halves? Which is more visually pleasing?

CREATIVE DECISIONS

Structure and composition

Let us first consider compositional guidelines and decisions. When we pick up a camera and bring it to our eye, we do not have to shoot the first thing we see. There are infinite ways in which we can compose and there is obviously no right way or wrong way to do so, since we all see things differently and develop our individual photographic style. However, there are helpful guidelines to bear in mind when you start taking photographs.

The film format of a 35 mm camera is that of a rectangle. This can be used either horizontally (landscape) or vertically (portrait style), depending on the nature of the subject and your own preference, but in either case the ratio of the length of the sides of the negative remains the same, 3:2. It may seem sensible to place any main subject in the centre of the frame – to avoid losing any vital information.

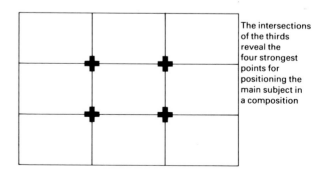

The intersections of the thirds reveal the four strongest points for positioning the main subject in a composition

Fig. 4.8 The theory of thirds.

Some other grids to follow when composing are those shown in Fig. 4.9. These can be used to create interest and a strong visual path through an image.

Discuss some of your work with friends. Which compositions do they prefer? Do any of these follow the theory of thirds or some other strong compositional shape? Does your eye follow smoothly through the picture?

Perspective and lens selection

As soon as we use a camera we create perspective in our image: distant objects seem small while those close-to seem larger. This change in apparent size and scale gives a sense of perspective and reality to the image and it is something we can control or apply consciously to create interest in our photographs. If, when photographing a person, we use a wide-angle lens such as a 28 mm and hold it close to someone's hands, we can alter the perspective to make them appear unnaturally large in relation to the rest of the body, as shown in Fig. 4.10(a). Conversely, using a long focal length, such as a 100 mm lens, can give a greater sense of compression to an image: Andreas Feininger's photograph of a New York street scene (Fig. 4.11), where the traffic seems so jammed together it is almost stationary and the crowd is quite claustrophobic, is an example of this effect.

Fig. 4.9 Strong compositional shapes.

Fig. 4.10(a) Maximum depth of field f/16. Photo: Edward Miles.

Fig. 4.10(b) Minimum depth of field f/2.8. Photo: Edward Miles.

We can also use linear or aerial perspective to emphasise depth in a photograph. If we look at Bill Brandt's photograph of Halifax (Fig. 4.12) our eye is drawn from the foreground to the background by the strong converging lines of the railway track and path stretching away into the distance. This is called linear perspective. The feeling of scale and distance is further enhanced by the atmospheric smog or haze which reduces the contrast of the far chimneys and highlights the distance between them. This is called aerial perspective.

Viewpoint

We should never limit ourselves to photographing the world at our eye level only, or from a set distance, when it is possible for us to change our viewpoint and in so doing alter the appearance of the subject. By moving around the subject it is possible to change the background we record; by moving closer or further away we can emphasise detail or include other visual information. Looking down upon a subject we can subordinate it, or, by looking up, make it seem more dominant. How you wish to portray the subject or scene as a whole will determine the viewpoint you take on it.

André Kertész made this decision when he photographed the Eiffel Tower. Instead of using the conventional ground-level viewpoint, he selected a high one within the structure. From this viewpoint he

Fig. 4.11 Andreas Feininger: *Fifth Avenue, New York.* **Using a long lens, Feininger has created a feeling of compression and captured the atmosphere of the crowded city.**

Fig. 4.12 Bill Brandt: *Halifax,* **1936. Strong converging lines and atmospheric haze or smog do much to create a sense of depth in this image, while the minute children in the bottom left of the picture bring life to the sombre scene at the same time as giving a scale of reference by which we may appreciate the immensity of the tall chimney stacks.**

produced a visually arresting image of tiny people dwarfed by the immense but delicate shadow of the tower. This is an image of endless fascination – its shapes, patterns, lines and minute human detail invite the eye to explore its intricacies. The strength of vision and the creative decisions about light, viewpoint, camera angle and timing have resulted in a memorable photograph rather than just another postcard snap of this all too familiar Parisian landmark.

Lighting

Light is to photography what ink is to paper; it is the medium of photography, all important and essential. Despite the fact that we see by light but cannot

ourselves see it (as was mentioned in Chapter 2), it is convenient to talk of the quality of light as though it were a tangible thing rather than the property of the atmosphere and of objects reflecting its radiation into the eye. Light is a subjective matter, and depends on an eye for its detection and a brain for its (psychological) perception, as we explained in Chapter 2.

Light is an essential feature of photographic education. You must take a serious look at it and consider how it changes, what it does to affect our perception of the environment, how it alters mood, how it is constantly changing in quality and strength. And just as you have to understand the quality of light in its visual sense, you must also exercise your mind so that you can recognise the 'feeling' you wish to capture and then use a light meter to put it all on film.

The fact that the sun moves throughout the day will not, of course, be new to you, but it takes on a new significance when you look at the difference the sun's movement has on your surroundings. You need to be constantly aware of this, whether or not you have a camera to your eye. The time of day and the type of weather alter both the quality and the relative colour of light, early-morning light being blueish and cold, and evening light reddish and warm. This is obviously important to bear in mind in colour photography, but these changes can affect monochrome tones as well.

The intelligent use of exposure meters

Just as there are many variations in the quality of light, so there are many different techniques in measuring exposure. Simply pointing your camera at the general scene and taking an average exposure reading may be convenient and easy, but it is rarely correct! You need to consider what you are *really* measuring. Where is the important shadow detail? Are you pointing the meter (camera) in the correct direction?

Imagine you are taking someone's portrait in an open landscape – which is the most important 'key' tone? In this instance, surely it is the skin which is

critical and for which you must take an exposure reading. In this case you must use the camera meter (or hand-held meter) close to the subject and take a reading from the face – a **key-tone** reading, in fact. As discussed in the previous section, there are a number of exposure modes available to various cameras and if you use the straightforward **manual mode** you are unlikely to make many mistakes: the example quoted above is typically measured in manual mode. The advantage of this mode is that, when you have found the correct reading (as in the example above) and made the exposure setting accordingly, you can then step back and frame the subject at any distance, and the exposure will remain set and correct for the shadows. But if you use any of the other modes, the exposure reading displayed will refer to the particular position the camera is in at the time of exposure.

If we look at Fig. 4.3 again, we can use either the manual mode or the auto and priority modes. If you use the manual mode, go in close, take a key-tone reading of the shadows and then step back to frame your subject at whatever position you choose. With auto and priority modes, frame the subject as required, and select a ×2 or ×3 factor on the exposure-compensation dial in order to expose for the shadows.

You can, of course, use the exposure-compensation dial on manual mode and you would need to do so, regardless of what mode you were using, if you could not get close to your subject. But it is still important to remember that at all modes other than manual, indicated exposure readings are at the mercy of the camera viewpoint, your only additional control being the exposure-compensation dial. (*Note:* in the absence of a compensation dial, it is always possible to alter the film-speed setting to provide over- or under-exposure, but, like the compensation dial, don't forget to return it to the correct position once your 'compensation' exposure has been made.)

Photographing down a dark alleyway, or in a half-lit room, in which there is a figure illuminated by bright sunlight, poses a different metering problem. If the

Shutter speed and aperture selection

In your photography, you will have to decide what aperture and shutter speed to select in the light of the final image you are seeking. Do you need maximum or minimum depth of field? Do you wish to record movement as a blur, or capture it as a frozen moment? These are decisions you have to make, for it is your image and only you know what it is that you wish to express.

Henri Cartier-Bresson was a master of the 'decisive moment' and a photographer whose anticipation of events was like a sixth sense. His photograph 'Place de l'Europe, Paris, 1932' (Fig. 4.13), shows how an instant has been seized and frozen on film. A man leaps to avoid the water. If the photograph had been taken a moment later (when his foot hit the pavement), the effect would have been lost, since the beauty of the picture lies in its ability to eternalise a small fragment of time. There is a symmetry of composition, the shapes are balanced by their reflection in the still water on the pavement, and even the helpless human figure is echoed by the leaping dancer in the poster at the rear of the scene.

This is a first-rate example of effective shutter-speed selection. The sense of movement is captured by the slight blur and enables us even to anticipate the outcome of the scene – we know that the man will land, and that his attempt to stay dry will have been futile.

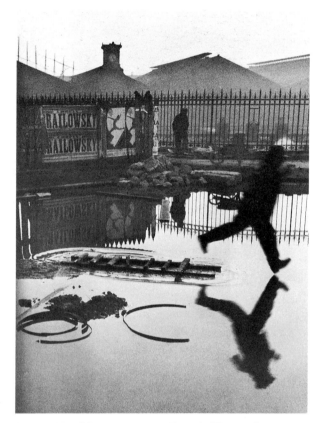

Fig. 4.13 Henri Cartier-Bresson: *Place de l'Europe, Paris*, 1932. The 'decisive moment'. Composition, shutter-speed, depth of field – the photographer's visual language applied with sensitivity.

scene is predominantly dark and you were to take an average reading, the meter would read more dark than light. This would effectively over-expose the highlight area, because the meter will have determined a correct exposure for the more dominant low-light areas, which will, however, be too much for the bright spots. This calls for a 'brightness range' reading, which means taking two separate readings, one from the highlights and one from the shadows, and selecting an intermediate setting on the camera. In this way, both highlight and shadow will fall within the film's 'exposure latitude', i.e. it will be able to retain delicate detail at both ends of the brightness scale.

Fig. 4.14 Philippe Halsman: *Dali Automicus, c.* 1948.

Aperture control can have as remarkable an effect upon the final picture as shutter speed, since it determines the overall depth of field in the image. When a large aperture such as f/2.8 is used, the main subject can be isolated by throwing the background out of focus, creating a soft, non-distracting backdrop to offset the area of sharp focus, as illustrated in Fig. 4.10(b). You can see this clearly in Eamonn McCabe's image of a boxer's hands (Fig. 4.16) in which the fact that the dark chest behind is out of focus concentrates the viewer's gaze on the wealth of tone and texture in the foreground. However, if you require great detail throughout the image, from foreground to background, you would need to select a small aperture such as f/16 or f/22 to give maximum depth of field, as shown in Fig. 4.10(a) absolute sharpness and attention to microscopic detail can be seen in the work of Ansel Adams, the masterly photographer of the magnificent landscapes of the American West.

Fig. 4.16 Eamonn McCabe: *Sylvester Mittee, King's Cross*, 1984. The critical focusing upon the boxer's hands, together with a careful use of limited depth-of-field, emphasises the texture and form of the bandage. Wrapped hands – a simple but compelling image.

Fig. 4.15 Bill Brandt: *Top Withens, West Riding, Yorkshire*, 1945. 'When I have seen – or sensed – the atmosphere of my subject, I try to convey that atmosphere by intensifying the elements that compose it' – Brandt.

The photographer has also selected the aperture to provide sufficient depth of field throughout the image. How important is the depth of field in the picture? And how important the shutter speed?

The idea of the 'decisive moment' is dependent on change. You must decide what it is that you wish to record, position yourself carefully, and watch the scene unfold before you. The picture is made when the visual and emotional elements come together as an expression of the moment. If you fail to capture this, you cannot try again, for the moment will have passed.

Fig. 4.14 provides a wonderful illustration of the suspended animation created by a very high shutter speed. On the other hand, looking at Ernst Haas' famous 'Bullfight' image, we can see how effective the use of a long exposure can be to record movement as a soft blur (Fig. 4.17).

Film choice

There are many different photographic emulsions or film types now on the market, which vary not only in price but also in light-sensitivity (speed), grain size, exposure latitude and contrast; and, of course, there are colour films and monochrome films, negative and reversal (diapositive) films. With so many to choose from, you must be careful to select a film type appropriate to the task in hand.

Generally speaking, a slower film has a smaller grain size, so that while it may not give us a high shutter speed in low light conditions, it is capable of rendering fine detail. This makes it highly suitable for quality still-life objects where the camera can be used on a tripod and there is little subject movement. At the other extreme, fast films can be used to capture mobile subjects at high shutter speeds, which makes them the films generally used by sports photographers. While these fast emulsions have a larger grain size (which is why they can react

to low light levels), the graininess that results is generally accepted within sport or reportage work.

Graininess is not always a problem – it can be exploited to convey strong visual effects in both monochrome and colour. Sarah Moon, a fashion and advertising photographer for *Vogue*, uses high-speed colour transparency film to create grainy impressionistic images which have a romantic feel to them.

You can also eliminate the mid-tone range completely, as Bill Brandt did in his bleak image of 'Top Withens' (see Fig. 4.15). By using a high contrast emulsion, such as Kodalith, as an intermediate stage in printing, all greys are lost and the result is a pure image of stark black and white. Used selectively, this 'tone-drop' technique can be very effective for stark and dramatic images. (See Chapter 4, p. 105, and Chapter 3, pp. 70 and 71.)

Fig. 4.17 Ernst Haas: *Bullfight, Madrid,* **1955. The use of a long shutter speed has created a soft streak of red cape and almost transforms a violent sport into a scene of gentle harmony.**

Additional creative controls

Most of the controls we have looked at so far involve decisions taken at the time of taking the photograph, but you can also alter or enhance the image at a later stage.

You can alter the composition of your photograph by cropping it when you are making the enlargement. However, it is much better if you can achieve the composition you want when you take the actual photograph since this will ensure the maximum use of the available film format, and there will be less demand for enlargement and a subsequent reduction in graininess.

Monochrome prints can be toned to a sepia or blue colour to evoke different moods. Prints may also be hand-coloured with water-colour paints, when printed on fibre-based paper, to create an old-fashioned or surreal image.

Rules of reality and perspective may be altered by use of photo-montage, in which several photographs can be cut up and pasted together for a surreal or dreamlike feel. Man Ray used this effect in a humorous way as shown in his image 'Violin d'Ingres' where, by partial montage, he likens the human form of a woman's back to a violin.

STUDENT ASSIGNMENTS

1 Over the period of a week, make a photographic record of a local landscape scene. Your pictures should show how mood can change with differences in the lighting quality and weather.

2 Create a visually interesting image by means of strong composition, selective focusing and depth of field control (to isolate a subject from its background).

3 Compile a selection of pictures from magazines or postcards which interest you and have a notable 'feel' or strong image. Try to work out what techniques were used to achieve these effects. You could use them as reference material for your own creative photographs.

RECORD PHOTOGRAPHY

We have become so used to good photography – in journals, books, magazines, and advertising – that we rarely bother to question the quality of published images. Yet the high quality we may now expect from professional photographers comes only from technique and training. In this section we shall illustrate some of the more important techniques that will help make good 'record' photographs.

Record photography is simply making images that convey information, and it is conveniently described in the well-known expression 'a good photograph is worth a thousand words'. As our first example of record photography, let's look at the kind of problems you could encounter if you were recording detailed parts of a car engine.

VIEWPOINT

The most obvious consideration in recording anything is **viewpoint**. If you have to record some technical detail of a car, then you will have to select your viewpoint carefully to position the object of interest in the centre of the frame. Unfortunately, the position of other objects may make this impossible, in which case you can wait until the printing process to reposition the main item in the centre and provide a good composition. A careless approach to viewpoint is perhaps the single main factor that reduces a possibly good photograph to a 'snapshot'.

DIFFERENTIAL FOCUS

Occasionally, the main object will not stand out enough because it is surrounded by other objects. In such cases, it is often impossible for the viewer to identify the subject under discussion. A simple way around this problem is to apply differential focus to

the field of view.

At the beginning of this chapter, we learnt about relative aperture (f/no.), and how the aperture controls the depth of field as well as the exposure. So, for a large f/no., such as f/4, there is virtually no depth of field. Using a large aperture like this will make everything else in the picture out of focus, but we have to focus very carefully on the principal object. This is called differential focusing. With it we can highlight items of importance simply by making them the only ones in focus! This is illustrated in Fig. 4.18.

Fig. 4.19 Photo: Joan Graham.

Fig. 4.20 Photo: Joan Graham.

Fig. 4.18 Photo: Ron Graham.

TONE CONTRAST

In a number of situations, the choice of viewpoint will also control the strength of a photograph, particularly in monochrome work where there are only tones to vary contrast within the picture. In Fig. 4.19 the small aircraft is almost hidden, not only by the closeness of the wing to the horizon, but also by the conjunction of tones (where the light-toned wing is compared with the light sky tones). An improved viewpoint is shown in Fig. 4.20 where the wing is now contrasted with the darkness of an open hangar.

Some subjects which have low contrast require treatment if their features are to be shown to advantage. Treatment may vary from a simple coat

of white paint to a chemical coating, so that in suitable lighting the subject may be given enhanced contrast. In Fig. 4.21(a) we have a normal photograph of an ammonite fossil. It has been taken against a clean white (shadowless) background which leaves the fossil low in contrast and interest. By coating the fossil with a very thin white coat of fumed ammonium chloride, the fine structure of the ammonite is accented. This yields the record shown in Fig. 4.21(b) which has been set on a black

background to add contrast to the photograph. Similarly, coloured subjects should be given a complementary background where possible.

In monochrome work, one of the most common mistakes is to record a subject with tones that closely match those of the background. Sometimes this cannot be avoided, and painting may very well be out of the question. In this case, the photographer must use selective lighting to differentiate the subject from its background.

Fig. 4.21(a) Photo: Ron Graham.

Fig. 4.21(b) Photo: Ron Graham.

LIGHTING TECHNIQUES

Lighting is one of the most important features of good photography. In record work a variety of specialised lighting techniques are used. We can divide these techniques into those used for two groups of photographs: large, industrial-type scenes, and table-top photography.

1 INDUSTRIAL SCENES

An industrial-type scene may well be just a simple exterior shot of a factory or shop. It could be a subject of some architectural interest or a building under construction, but lighting will always be of the greatest importance. Most buildings will look better if lit with the sun shining directly upon them, casting shadows to highlight their structure. The photographer should therefore select a good day, and an appropriate time of day, in order to record the building to advantage.

Large to medium-sized interiors vary in their difficulty, according to the quality of lighting. If the photograph is to be in monochrome, then a mixture of natural and artificial lighting is not a problem. However, colour work requires uniform colour temperature, and unless professional lighting and filters are used, it is best to employ electronic flash to balance any daylight that comes into the interior.

Electronic flash

Electronic flash is a simple and convenient form of lighting for any interior record, be it in colour or monochrome. It is always better to use the flash away from the camera in order to avoid 'flat' lighting, i.e. where the shadows cast fall directly behind the subject(s). In order to hold the flash mounted high and to one side of the camera, you will need to buy an extension lead which synchronises the flash with the shutter. Remember, we are used to seeing our

natural lighting coming from above (the sun), and so by placing the flash high, and to one side, we cast shadows that give a natural effect.

Chapter 5 deals in detail with the principles and practice of electronic flash, but in this chapter we will consider some techniques employed. Before you experiment with the following techniques, make sure that you understand fully the flash equipment you are going to use, and refresh your knowledge of the guide number system.

In Fig. 4.22(a) the photographer simply took an exposure reading through the TTL system of the camera from the location of the viewpoint. As may be expected, the TTL metering system (see p. 79) has given a correct exposure for the windows and under-exposure for the figure and the interior of the room. This is a common error. (It can be done deliberately if a silhouette is intended). You can gain the correct exposure for the subject (the girl in this scene) by taking the camera to the subject and pointing the camera at the shadow areas of the figure. Where this is done, the result, Fig. 4.22(b), gives better detail in the figure, but at the expense of 'burnt-out' highlights in the windows (now totally lacking detail), and a hazy effect around the head of the girl. You gain a much better picture if you synchronise the flash (held high and off the camera) to balance the light coming into the room from the windows, as seen in Fig. 4.22(c). (The indicated exposure for Fig. 4.22(a) was 1/60 second at f/16 for 125 ISO film; and so for Fig. 4.22(c), a flash guide number of 200 (125 ISO) was ideal, with the flash placed 12 feet from the subject.)

A small interior, such as that shown in Fig. 4.22(c), can be reasonably well illuminated by a single, synchronised, flash unit. A larger interior requires many such units strategically positioned throughout the area covered by the lens. Covering such large interiors is a professional job requiring professional equipment, and is well outside the scope of this book. A technique you can use for lighting any size of room is known as the 'moving light' technique which requires no more than a single floodlamp, and some control of light coming from windows.

Fig. 4.22(a) Photo: Ron Graham.

Fig. 4.22(b) Photo: Ron Graham.

Fig. 4.22(c) Photo: Ron Graham.

Moving light technique

You should experiment with this technique a number of times before actually taking the photograph. If you can have an assistant as well, so much the better, since it is difficult to use the technique on your own, though not impossible.

First of all, find a suitable room, such as a large classroom, laboratory, or refectory. The room should, ideally, have curtains over windows that are in the field of view, and the floor must be free from vibrations. The first condition cannot always be guaranteed, of course, but since this technique demands a long time exposure (of at least a minute), uncovered windows will be grossly over-exposed. For the same reason, it is essential that the floor is stable enough to prevent the camera from being disturbed by the 'moving light'.

Since the camera should cover as wide a field as possible, you should fit a wide-angle lens to the camera, if you have one available.

At this stage, it is important to calculate the required exposure time. Your assistant should direct the single photoflood lamp at some point midway in the room. It is best to select an area of the room that is neither especially dull nor especially reflective. Then an exposure reading can be taken either with an exposure meter, or with the TTL system of the camera. Let us say, for example, that the indicated exposure reading was 1/15 second at f/2 (film speed 125 ISO) with a 250 watt lamp some 12 feet distant from a chair. This will give a required exposure of 8 seconds at f/22 which is the minimum aperture of most 35 mm cameras. You will need as much time as possible for the exposure – since the photographer has to fill the room with moving light and this takes time!

The camera should now be placed on a tripod and the lens focused on a point about one-third of the way down the length of the room. The lens is then stopped down to the minimum aperture (usually f/22), and the shutter selected at the 'B' position.

In order to compensate for the moving light – which is casting shadows in every direction – it is necessary to multiply the calculated exposure (8 seconds at f/22) by a suitable factor. From experience, we recommend a factor of eight. Thus the 'moving light' exposure is now 8 seconds × factor 8 = 64. A minute will do! We are now ready for the moving light technique to be practised.

All the room lights are turned off, and the curtains drawn. The assistant is looking through the viewfinder of the camera and the photographer holds the photoflood lamp.

When the exposure was first calculated, the lamp was directed at a typical surface from a distance of about 12 feet. Bearing this in mind, you must try to keep the lamp at this distance from all surfaces in the room, i.e. walls, ceilings, furniture, etc. At the same time, the lamp must be rotated in circles of about 2 feet diameter, in order to keep the shadows cast moving. (See Fig. 4.23(a).) As you move about the interior you must keep the lamp moving at all times, and avoid shining the lamp either into the camera lens, or upon yourself. Your assistant, who is looking

Fig. 4.23(b) Photo: Ron Graham.

into the camera viewfinder, will instruct you when the light shines into the camera lens, or when you have cast your own shadow on a wall. In this way, it is possible to get a record with shadowless lighting, and with full exposure in the darkest of shadow regions. (See Fig. 4.23(b).)

Using a similar technique, it is possible to 'paint' an interior scene with multi-flashes from a single flash gun – as in Fig. 4.24, where eight flashes were bounced from the ceiling – to provide diffuse lighting. The problem with this method is that it gives multi-shadows as well.

Fig. 4.23(a).

Fig. 4.24 Photo: Ron Graham.

Ghosted backgrounds

Sometimes backgrounds are ugly, obtrusive, confusing or a mixture of all three. In order to minimise their effect, you can 'ghost' the background by whiting it out to put it into a higher key than that of the principal object(s) in the foreground. An example of this technique is shown in Fig. 4.25, where you can see that the ghosted backdrop includes the figure of a laboratory worker.

Fig. 4.25 Photo: Ron Graham.

Ghosting can be used with a conventional time exposure, but works better as a scene illuminated by the moving light technique. Whatever lighting is used, ghosting is done with a large white sheet (or, for smallish objects, a white card) that is held between the principal subject(s) and the background. The sheet should be constantly moving (two assistants are required for this), and be in place for something like 30–50% of the total exposure time.

2 TABLE-TOP PHOTOGRAPHY

Table-top photography is the term used to describe the photographing of small objects that could conveniently be set on a table top. Machine parts, metal objects, instruments, small animals, biological specimens, ceramics, museum pieces and glassware are examples of suitable subjects for table-top photography. Specialised work may require the use of special rigs, but an all-purpose set, complete with heavy-duty glass sheets for accommodating objects and backgrounds, is normally adequate; an example is shown in Fig. 4.26.

The use of a perspex plate on the lower surface helps to diffuse light, if you are using lamps below the rig. Alternatively, you could use 'cold-light' illuminators (of the type used to display slides) on this surface. A 'cold-light' illuminator is a short fluorescent tube contained in a box with a plastic transparent diffusing plate over the top.

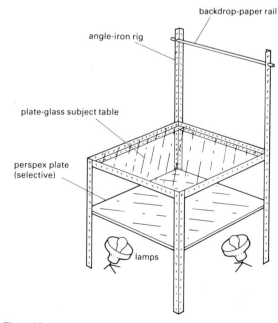

backdrop-paper rail

angle-iron rig

plate-glass subject table

perspex plate
(selective)

lamps

Fig. 4.26

Macro-photography

Many small objects, such as coins, insects, fossils, etc. are recorded at magnifications of up to about 20 times. This is called macro-photography, although it is often better known as 'close-up' photography. Sometimes supplementary lenses are fitted to the front of a normal lens for magnification. However, if fine detail is required , special 'macro-lenses' may have to be used. Macro-photography is usually done with the same kind of rig as that shown in Fig. 4.26, but the type of illuminator involved will be much smaller.

Some small objects are best recorded by projection; the object is mounted on glass and placed in an enlarger like a negative. In this way, subjects like fish scales (Fig. 4.27) may be enlarged directly on to film.

Fig. 4.27 Photo: Ron Graham.

Lighting for macro-photography

The type of lighting required for macro-photography depends upon the form and surface texture of the object. There are, however, a number of standard lighting arrangements that can always be modified as you become more experienced in this work. From the few examples provided here you should be able to practise a number of standard lighting arrangements, and be able to record simple objects in metal and glassware.

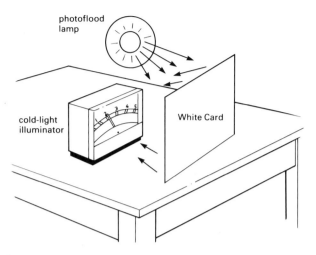

Fig. 4.28

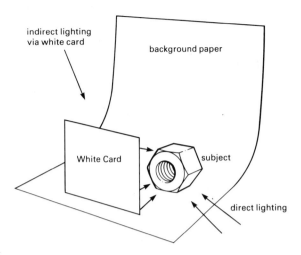

Fig. 4.29

GLASSWARE

Glassware always provides a difficult lighting problem, from the glass face of an instrument that gives off reflections, to complex glass artware. A glass-fronted instrument is easily dealt with, simply by placing the subject on a diffusely illuminated glass plate and indirectly illuminating the face of the instrument via a white card, as illustrated in Fig. 4.28. But if the final result lacks contrast, then the easiest way is to remove the glass face from the instrument and use direct lighting. Direct lighting will always enhance the relief of an object, particularly if the light comes at an angle. The shadows cast will always give rise to good contrast, but if there are deep recesses in the object these will require lighting and the best way of doing this is with a white-card diffuser, as illustrated in Fig. 4.29.

It is quite a simple matter to photograph heavy, cut-glass ornaments, or scientific glassware, provided that the glass walls of the object are reasonably thick. All that is needed is a cold-light illuminator, on which the subject is placed under the camera lens. And if any top-lighting is required, a white card (with a hole for the lens to look through) is

placed over the subject. The two examples of photographic flash tubes shown in Fig. 4.30 were recorded in this fashion.

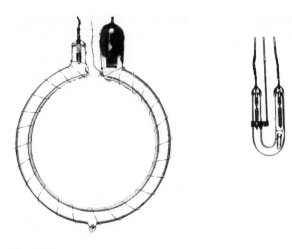

Fig. 4.30

Fine-walled laboratory glassware is a very difficult subject, mainly because the glass walls are easily lost against a white or a black ground. But by placing a contrasting 'mask' next to the glassware, it is possible to reflect the mask into the glass walls, as shown in Fig. 4.31(a) and (b). In (a) we see the

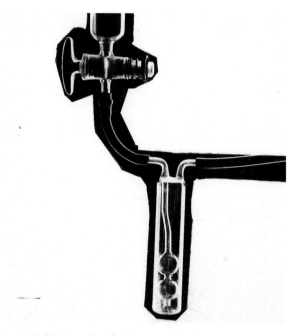

Fig. 4.31(a) Photo: Ron Graham.

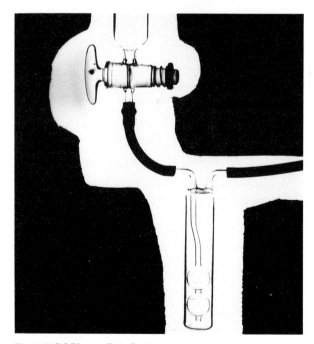

Fig. 4.31(b) Photo: Ron Graham.

glassware against a black ground, but closely masked with a white card to reflect white edges into the glass. After processing, the negative will have a black area representing the white mask, and this will have to be removed with 'Farmers Reducer' (see Appendix D) before we start printing. In (b) we have the opposite, a black mask closely surrounding the glassware set against a white background. After processing, the transparent masked areas of the negative must be 'blocked out' with 'photopaque' before printing. The final result from both of these techniques is shown in Fig. 4.32.

Fig. 4.32 Photo: Ron Graham.

METAL OBJECTS

Metal objects can offer just as many lighting problems as glassware. It would be impossible to suggest a lighting arrangement that would prove suitable for every subject, of course, but two of the main problems are dealt with here, and their solutions should give you ideas for future work.

The highly polished, yet detailed, micrometer shown in Fig. 4.33 was simply recorded on a cold-light illuminator, with a single floodlight placed directly over the tool. But by placing black-card reflectors close to the tool it is possible to reflect dark

edges into the micrometer (Fig. 4.34) to provide the much improved photograph shown in Fig. 4.35. (Fig. 4.33 makes this clear. The black card is reflected into the edge of the metal subject (micrometer).)

Fig. 4.33 Photo: Ron Graham.

Fig. 4.34 Photo: Ron Graham.

Fig. 4.35 Photo: Ron Graham.

Fig. 4.36 Photo: Ron Graham.

Perhaps the most difficult task of all is to record in detail objects that have shiny metal surfaces as well as deep shadow areas, as shown in Fig. 4.36. The main problem is to get light down into the deeply recessed areas directly under the lens axis. At the same time, the light must not provide too many specular (mirror-like) reflections from the shiny surfaces of the object. The answer is to use a home-made conical reflector, made from cutting a sector out of a circle of white card, as shown in Fig. 4.37, and employed as shown in Fig. 4.38.

close

white paper card

Fig. 4.37

conical reflector

subject

Fig. 4.38

STUDENT ASSIGNMENTS

1 Collect a selection of illustrated magazines, such as DIY journals, car, housekeeping and cookery magazines, etc. and examine their photographs.

(a) Divide the photographs into what you consider to be good, fair, or poor examples in terms of their success as aids to the reader's understanding of the text.

(b) In each class of examples, list the good or bad points of each photograph with reasons for your decision.

You should be able to recognise faults due to such things as poor lighting, lack of differential focusing, conjunction of tones in monochrome photographs, incorrect viewpoint, etc.

2 In this exercise, the aim is to balance interior with exterior lighting. Using electronic flash, take a daytime photograph of someone working indoors. It is important that an outside window is shown in the picture and that exterior detail is recorded in the final print. Take care to select the correct camera aperture. Hints: check the flash guide number for a given type of film (film speed), and take an exposure meter reading of the scene viewed through the window.

3 Select two different types of glassware, e.g. a thin-walled wine glass, a thick-walled beer glass.

(a) Using a single studio lamp, photograph the two glasses together against (i) a white background, (ii) a black background.

(b) Print the two photographs to get (i) the best possible white background and (ii) the best possible black background. In each case, try to show the structure and the differences between the types of glassware.

This exercise is devised to give you experience with difficult subjects; the importance of camera exposure control; form and lighting; the relationship of the subject to the background; and their overall effect on print quality. (*Note:* you will probably find that the thin-walled glass will lose the form as you attempt to get a black background in the print. You might like to think why this happens.)

4 Make a conical reflector (as shown in Fig. 4.37) from lightweight white cardboard. As indicated in Fig. 4.38, take a macro-photograph of the interior of a (white) plastic 3-pin plug, showing the interior detail, including fuse, with shadowless lighting. The background should be black.

The aim of this exercise is to provide full detail without the inclusion of confusing shadows. Ideally, the plug should be raised slightly above the black background so that the latter is not in focus.

PHOTOGRAPHIC PROCESSING

Processing is the essential after-treatment necessary to complete the making of a photographic image. You don't need to process the film as soon as it is removed from the camera, but it is sensible to do so as soon as possible, before you forget what's on it!

Today, processing is not a difficult task. Usually it involves transparent negatives and positive paper prints. Other processes include making **diapositives** (print transparencies), and the various image-modification techniques, such as 'tone elimination', 'multiple printing', 'photograms', 'colour toning', etc. It is best to leave these, however, until you have mastered basic processing.

Since all photographic materials (negative or positive) are sensitive to light, they must be handled in a darkroom. Work involved in a darkroom is different from any other, since, in the absence of visual contact, you have to rely heavily on touch and concentration.

The most convenient way to process a film, either 35 mm or 120 size, is to load the film into a **daylight developing tank** (DDT). This is usually made of tough plastic. A typical DDT comprises five major components, as shown in Fig. 4.39. They are: (i) a light-proof tank, (ii) spiral-reel assembly, (iii) light-tight lid, (iv) agitator-rod, and (v) liquid-tight cap.

Fig. 4.39 Daylight developing tank and changing bag. Photo: Ron Graham.

Although the DDT shown here is made for just one roll of 35 mm film, some have a capacity for two, three or even more rolls. Universal types can take either 35 mm or 120 size film, simply by altering the width of the spiral-reel.

LOADING THE FILM INTO A DEVELOPING TANK

If you do not have a proper darkroom you can always load a film into the tank at night. It must be perfectly dark, however, and if you are in doubt, load the film in a light-proof cupboard to be on the safe side. You can

also use a 'changing bag' (shown in Fig. 4.39) which allows you to load film at any time with complete security.

Prior to taking both film and the complete tank unit (except the agitator-rod) into the dark, you should always check the following:

(a) Ensure that the tank assembly is clean and dry.
(b) Check that the spiral-reel assembly is correctly aligned, with the base of the 'centre-column' at the bottom (part of the light-trap). Also check the direction of film entry (normally from the right).
(c) Make sure that a pair of scissors are to hand.

Ideally, you will not have wound the film-leader completely into the 35 mm cassette, so you will be able to cut it neatly. This makes it easier to guide it into the spiral-reel in complete darkness. If not, then this has to be done in the dark, after the cassette has been opened up and the film removed.

Once the leading edge of the film has been entered into the spiral, the film can be wound in with the ball of each thumb exerting a slight pressure to the back of the film, while the arms of the spiral are turned in contra-directions. When the film is completely wound into the spiral, cut it off at the cassette and place the spiral-reel in the tank (with the base of the centre column to the bottom). Put the cone-shaped lid on the top, and turn it slightly to 'lock it safe'. You can do the rest of the process in the light.

Only fit the plastic cap if you intend to agitate the solutions by inverting the tank, rather than by using the agitator-rod.

Now you have the film loaded in the DDT and ready for processing, the first thing you must do is prepare the chemicals. These can be bought either in powdered form (in which case you have to mix them from their packets according to the instructions provided), or from bottled chemicals that only require dilution with water. But whatever their composition they must be prepared from **stock solution** to **working solution**, i.e. at the correct dilution and temperature, before you commence.

The basic chemical solutions used in photography are as follows: (i) developer, (ii) stop-bath, (iii) fixer, and (iv) wetting agent.

Chemical preparation

Only two of these chemicals are really essential, (i) and (iii). The stop-bath (ii) can be replaced by a rinse in water, and (iv) can be ignored if the local water supply is clean and not too hard.

The active chemicals (i), (ii) and (iii) must first be made ready before the processing begins. The developer is the only one that will require any great care, since this solution must be accurate in its composition and temperature. The stop-bath and fixer are more easily prepared. It is essential that all chemical preparation is done with clean containers and measuring cylinders. Be careful that the fixer is put back in the correct container! Remember – developer and fixer chemicals do not mix. If either stop-bath or fixer solution contaminate the developer then the developer is ruined and must be thrown away.

All photographic processing is best conducted at temperatures of 20°C (68°F). This is known as room temperature. Obviously, if solutions are at the same temperature as a normal room, then they will be in equilibrium with that temperature and not deviate much throughout the processing cycle. Another reason for taking care with the temperature is that photographic emulsions are made with gelatin, and temperatures considerably above 20°C can affect the physical characteristics of the image, while temperatures below 15°C considerably affect the activity of some developer reagents.

It is best to use a 'spirit-type thermometer' (with coloured liquid indicating the temperature) rather than a mercury type which, although more accurate, is dangerous if broken – as can frequently happen in a darkroom – releasing dangerous mercury vapour. Spirit thermometers are accurate enough for photography and are much less expensive.

Achieving the correct temperature can be time-consuming if you are not careful. However, since stock solutions are normally diluted, you can correct the temperature by dilution with hot or cold water as required. If the temperature is still too cold, you can use a dish warmer. This is a rheostatically controlled heating plate which is useful for keeping solutions at the correct temperature. Alternatively, a simple 'water jacket' can be made up.

Water jackets are best made by placing a small (metal) dish containing the solution into a larger one containing hot (or cold) water. The dish containing the chemical solution is then heated (or cooled) by the surrounding water temperature. It is for this reason that the smaller dish should be made of metal, so as to allow heat transfer to take place.

Chemical dilution

There is frequently much confusion about the dilution of chemicals, mainly because dilution is often expressed in different ways.

If a developer is to be diluted by **parts**, e.g. 1:1, this means that one part of the active chemical is to be mixed with one part of water. Most 35 mm DDTs require 300 ml of working solution for one film. So, if a film developer is to be mixed into a working solution of 1:1, then 150 ml of developer has to be mixed (diluted) with 150 ml of water.

To take another example, if, say, a print developer is made up at 1:9, then a total of 10 parts is involved. And if we require two litres (2000 ml) of working solution, then we calculate the required amount of developer (taken from the stock bottle) as 1/10 of the total required (ten parts in all), i.e. 2000 × 1/10 is 200 ml of developer, to which we add 1800 ml of water.

If, on the other hand, chemicals are diluted according to percentage, then our first example (1:1) would be expressed as a dilution of 50%. In our second example, 10 parts are involved and the active chemical is of 100/10, giving us a 10% dilution.

The processing routine

All film processing routines follow a basic pattern. In its simplest form it is: development, followed by fixation, washing and, finally, drying. But for good

processing the recommended routine is as follows:

1	Pre-soak	5	Washing
2	Development	6	Wetting-agent soak
3	Stop-bath	7	Drying
4	Fixation	8	Film cleaning

As an example, we shall follow through a typical 35 mm film processing procedure, using standard chemicals and mentioning alternative methods as we go along.

1 Pre-soak

In order to avoid uneven development, it pays to pre-soak the film with water before pouring in the developer solution. This should be cold water and can come straight out of the tap provided it is clean (filtered water is rarely required). The water is added to the DDT via its light-proof lid and can then be poured away.

2 Development

The working solution of developer will have been prepared and is ready for pouring into the DDT. As our example, we shall take the well-known standard Kodak D-76 (Ilford ID-11), diluted 1:1 at 20°C. For a film such as Ilford FP4 (ISO 125), the normal development time is nine minutes, with **inversion agitation** every 30 seconds. Agitation can be made either by rotating the film-spiral with the agitator-rod, or by placing the plastic cap over the lid and inverting the tank.

3 Stop-bath

Since the developer is alkaline, so is the emulsion. And if this alkalinity transfers to the fixing bath, then the image suffers cross-chemical reactions which could stain it a brownish colour and that can damage its printing qualities. In order to avoid this problem, the stop-bath is used to neutralise the film's alkalinity, prior to the fixer being added to the DDT.

Stop-bath solutions can be purchased or simply made up from the following formula:

Glacial acetic acid:	17 ml
Water to make:	1000 ml

This stop-bath may be used for either films or printing papers, and has a working pH in the region of 5.8, but when the acidity drops below this figure it should be replaced. Commercial stop-baths often contain a pH indicator, which changes colour when replacement is necessary, i.e. when it loses its acidity. Once the developer has been drained from the DDT, the stop-bath should replace it for a duration of about five seconds.

Acid stop-baths are effective in neutralising the alkalinity within an emulsion. In practice, however, you can safely dispense with them, provided you rinse the film well in fresh water before adding the fixing bath. Most fixing baths, however, are of the acid type (to neutralise alkaline carry-over), and the use of an acid stop-bath helps to keep fixing solutions acid for longer.

4 Fixation

Fixation keeps the image permanent. Those silver halides that have been used to form an image are now fully developed, but the remaining salts must be removed (dissolved) by the fixer, otherwise they will eventually fog the entire image.

Typically, fixing baths use sodium thiosulphate as the solvent of unexposed silver halides, and are usually acid solutions as mentioned above.

A typical formula for a stock solution is as follows:

Sodium thiosulphate (crystals):	300 g
Potassium metabisulphite:	20 g
Water to make:	1000 ml (one litre)

For films, this solution should be used without dilution. Fixation time is ten minutes. (For printing papers dilute 1:1 for the same fixation time.) Temperature is not very important and may be ignored at normal room temperature, i.e. 20°C.

After you have drained the stop-bath, pour the fixer solution into the DDT and, after a single inversion, leave it for the required period (which with **rapid fixer** can be as short as five minutes) before

washing. Rapid fixer (ammonium thiosulphate) works faster than the normal fixer (sodium thiosulphate), but it is more expensive.

With a good fixing solution, it should be perfectly safe to remove the lid of the DDT after two minutes. If the film looks creamy (unfixed), then keep the lid on the tank and leave the film in the fixer for at least twice the time it takes to clear.

Since fixing solutions can be used a number of times, it is good practice to pour the used fixer into a bottle specially set aside for this purpose. But take care not to over-use fixing solutions, and if in any doubt replace them with fresh chemicals. Another thing to avoid is shortening fixing time in the hope that you can thereby shorten washing time. Unless fixation is complete, then washing is only superficial and a complete waste of time.

5 Washing

Washing should be done under a constant stream of (cold) running water with the spiral-reel still in the DDT, or, alternatively, placed free in a wash basin. Under these conditions, complete washing takes fifteen minutes.

If it is impossible to employ running water, satisfactory washing can still be accomplished by making seven to ten changes of fresh water, with each change lasting two minutes.

6 Wetting-agent soak

The role of the **wetting agent** is to lower the **surface tension** of the water still clinging to both sides of the film as the film is hung up to dry. In the absence of a wetting agent in the final soak, water droplets may create permanent 'drying marks' on the emulsion, caused by local differences in the drying rate. Even if the emulsion (the dull side of the film) is free of droplets, those on the back (shiny side) of the film will cool the emulsion opposite, thus slowing the drying rate in these areas and creating density differences that cannot be removed.

Only a few drops of wetting agent are required in the final soak, which should be no longer than about

ten seconds or so, depending on the concentration employed. If the concentration is too high (the solution will appear like soap suds), there is a strong possibility of creating a relief image in the gelatin, resulting in a lack of image quality.

After the wetting-agent soak, you can remove the film from its spiral-reel. Remove excess moisture either by dabbing with a perfectly clean chamois-leather, or by using the first two fingers as a squeegee. If the latter method is not as efficient, it does at least ensure that the film will not be scratched during this very important operation!

7 Drying

Drying the film is an important stage, particularly with small format negatives such as 35 mm, because it is at this time that the emulsion is most vulnerable to dust. Ideally, it will be dried within a special (heated) drying cabinet, but if this is not available, hang the film in a warm, dry space, such as a cupboard that is not subject to dust.

Most films will be dry within about 30 minutes, depending on the temperature and humidity of the drying space, but take care to ensure that both surfaces are dry before taking the film down. Try not to disturb the film during the drying period as this will promote dust, but you should inspect the film at least once or twice for water droplets which can easily be removed with a piece of blotting paper.

8 Film cleaning

Once dry, the film should be inspected for dirt and dust. If there is any present within the emulsion, the film should be resoaked and redried.

Although a film may have a clean emulsion, it may well have scum marks on the back, depending on the quality of the local water supply. These can be cleaned off with the gentle application of a damp chamois-leather to the back of the film.

Before cleaning, the film should be cut into short lengths of about five or six frames so that they may be stored in transparent negative files. It should then be placed emulsion down on to clean white paper.

Scum marks are then easily seen and removed with a soft cloth. Never apply great pressure, or worse, attempt to rub marks off the emulsion surface.

For stubborn marks, such as greasy fingerprints, spirit-based film-cleaning chemicals are available.

THE DARKROOM

Photographic darkrooms can be anything from the temporary conversion of a bathroom to the more specific conversion of an unused loft. The custom-built darkroom is ideal, of course, but far from necessary for the amateur or occasional photographer.

The most simple and economic darkroom is the conversion of a bathroom, mainly because the water supply, drainage, ventilation and limited window space are already available and require no structural changes. The main limitation of a bathroom is power supply, mainly because electrical power points are discouraged in modern bathrooms for obvious safety reasons.

The set-up shown in Fig. 4.40 illustrates a very simple arrangement within a small bathroom. Two plastic-covered planks are supported on the edges of the bath, with soft cloths protecting the latter

beneath the planks. Dishes, water jackets, etc. may then be supported on the long plank with print washing undertaken either in the bath or in the wash basin adjacent.

A simple 'bee-hive' type safelight can be purchased quite cheaply from any camera dealer and since its power requirements are very small (15 watt), it can be supplied from a shaving socket outlet and suspended over the working area. Further safelighting can be provided by fitting a yellow or red safelight bulb into an existing light fitting.

Blacking-out the bathrom window can be easily done. Many types of plastic bag are light-proof, rubbish bags particularly. The final task is to make a light-proof 'curtain' which can then be suspended over the window.

Electrical supply: power with safety

Power supply for items such as an enlarger will need to be more than that provided by a small shaving socket.

In the UK, mains supply comes at 240/250 volts, and is sufficiently dangerous to require great care with wiring apparatus direct to any mains socket. It is therefore vital to use the correct fuse with electrical equipment. To work this out, a simple calculation is used.

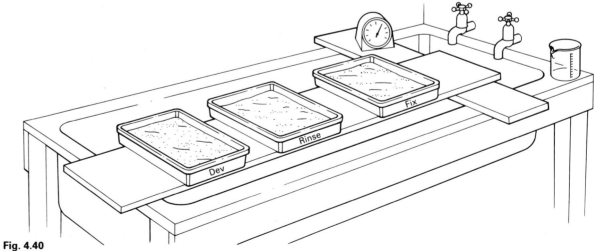

Fig. 4.40

Typically, a 35 mm/6 cm format enlarger is likely to have a 150 watt bulb installed. That is to say, the *power* rating of the bulb is 150 watt. Electrical power is designated in watts (W), just as voltage is expressed in volts (V). The current (I) flowing through the lamp may then be calculated from:

$$I = W/V \qquad \text{Eq. 4.1}$$

In this example, $I = 150/250 = 0.6$ amps.

Since our darkroom has both electrical *and* water supplies, it is essential that the two should be kept as far apart as possible. The power cable supplying a bathroom/darkroom can easily be supplied from an adjacent room via a well-sheathed power cable. In the darkroom it should be used at a small dry-bench, far from any water.

The terms **dry-bench** and **wet-bench** not only suggest safety, however, although this must be a prime consideration. In the best interests of cleanliness it is important that wet, chemical-laden hands do not come into contact with photographic materials or apparatus. For this reason, the wet and dry areas should be kept well apart, and hands must be completely dry when operating at the dry-bench. A towel is very necessary in a darkroom.

Entrance to a professional darkroom is made via a light-trap, or maze, so that opening the outer door does not let light into the working interior. As a result, work can continue, even though people are coming and going through the darkroom. This is too much to expect in a simple darkroom, however, although some measure of protection can be afforded by putting up a dark curtain over the door.

PRINT MAKING

There are two basic types of print production: 'contact printing' and 'enlarging', and both must be carried out under the correct safelighting designated for the printing material employed, usually yellow. With 35 mm negatives, contact printing is generally restricted to the production of inspection prints – useful for seeing the photographs as positives prior to making any decisions about their enlargement. Enlarging is, of course, essential with 35 mm negatives since they are generally too small (36 mm × 24 mm) to be of much use in the form of contact prints.

Contact printing

For limited work, a simple frame-type contact printer is sufficient and consists of a glass-fronted frame with a hinged back that can be opened to receive both negatives and printing paper. (See Fig. 4.41.)

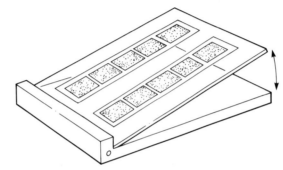

Fig. 4.41 Contact printing frame.

Strips of small negatives are attached to the glass front, with the back of the film (shiny side) facing the glass, and (under the cover of safelighting) a suitable size of printing paper cut to cover the negatives. The printing paper must be placed face-to-face with the negative emulsion, care being taken to ensure that the emulsion side of the paper (usually shiny) is placed in contact with the emulsion (dull side) of the negative. The hinged back may now be closed and the printing frame is ready for exposure.

Any 'white light' source may be used for contact printing, but if an enlarger is present, then it is convenient to use this (without a negative fitted) as a light source, with the printing frame on the enlarger easel. A test exposure is then made, and the print removed from the frame for subsequent development. If the developed print looks over-exposed (too dark), then the exposure must be reduced; too light and the exposure needs to be increased. Further corrections might include a change in the grade of printing paper, as described in Chapter 3.

Print processing

Following much the same routine as that for film processing, prints are: (i) developed, (ii) given an intermediate rinse (or stop-bath), (iii) fixed, (iv) washed in running water, and (v) dried. The main difference, however, is that prints can be inspected (in a yellow safelight) at every stage of the process.

Developing the print

Developers formulated for printing require much more energy than negative developers and a capacity to develop larger areas of sensitive material. As a result, their components are quite different from those in a typical negative developer such as D-76 (see Appendix B). And whereas a print developer if diluted can be used to develop a negative reasonably well (the results will, however, be quite 'grainy') the reverse is certainly not true!

A typical print developer is D-163 (Appendix B), generally diluted 1:3, and worked at a temperature in the region of 20°C. For printing, the temperature is not as important as it is for making negatives, but it should still be close to 20°C for consistent results. The usual print-development period is in the region of two minutes, but this will be a function of a number of things: paper type, developer type, dilution, temperature and, above all, the effect required.

The old saying that a perfect print will exhibit the best *black* and the best *white* that a paper is capable of does not allow either for subjects without clear whites and blacks, or for experimentation. Nevertheless, the commonest reason for a poor photograph is poor printing, and it is a good idea to learn to print correctly before starting to experiment.

Let us have a look at some important 'controls' as far as printing is concerned:

(a) The negative itself: its quality (exposure, contrast and definition).

(b) The quality of printing: exposure, shading, focus (enlarging).

(c) The grade of paper selected.

(d) Processing control.

We shall come to items (a), (b) and (c) later, but as processing control is the same for contact printing as it is for enlarging we shall deal with that first.

Processing control

If the ideal development time for a given developer is, say, two minutes, then this will give us an ideal print, provided we have the correct exposure, grade, etc. If, however, the print is slightly over-exposed, then it is a good idea to remove it from the developer before the full two minutes, thus preventing it from appearing too dark, although possibly at the expense of its losing some contrast and, in extreme cases, gaining a brownish appearance. Similarly, if the print appears to be under-exposed (too light), then a little extra development time could help to make the print a little darker, although this will increase its contrast.

These development controls can be extended using a two-bath processing technique, simply by replacing the stop-bath with one of fresh water. If excessive contrast is the problem (either because the negative is too contrasty, or you have no softer grades of paper), the print can be slightly over-exposed and development controlled by alternate immersions in developer and water-bath. As the image appears in the developer, the print can be swiftly transferred to the water-bath, where it continues to develop only in the highlight areas (the shadows having rapidly consumed all the developer carried over), creating a softening process, i.e. with more gradation in the grey tones. You can repeat this process between the two baths until you have the required result.

If a print lacks contrast, however, despite being printed on the most contrasty grade of paper available, it is always possible to increase image contrast by developing in a more concentrated developer solution.

Enlarging

Because of their small size, all 35 mm negatives need to be enlarged. The degree of enlargement possible is largely a question of the type of film used and how it was developed. Very fine grain films, such as Kodak Technical Pan Type 2415, can be enlarged as much as 50 times (when processed in Kodak LC developer) without the image becoming unduly 'grainy'. But 50× is far beyond normal requirements since most 35 mm negatives are rarely enlarged more than 8× or so. Typically, medium-speed (125 ISO) and even fast (400 ISO) films can be enlarged ten times without much loss of quality.

Enlargements are made by projecting the negative image on to an easel (or masking frame) designed to hold the printing paper flat. You control the size of the enlargement by moving the entire enlarger-head up or down the column, using the lens to focus the image for each change in enlargement.

There are two basic designs for enlargers and, although they are simple enough, they should be mechanically sound and of high optical quality if they are to complement the expense of a good-quality camera.

Condenser enlargers

As shown in Fig. 4.42, the basic design feature of a condenser enlarger is a large lamp house, usually holding a 150 W opal (tungsten filament) lamp, with

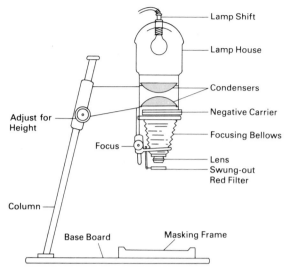

Fig. 4.42

a pair of glass condenser lenses below it. The role of the condensers is to direct light rays from the lamp to the lens so that an even illumination can be achieved on the enlarger baseboard (easel).

Even illumination is controlled by adjusting the position of the lamp by way of a lamp-shift rod protruding from the top of the lamp house. To check the illumination, a negative is placed in the negative carrier and, with the enlarger lens at maximum aperture (it has 'stops' just as a camera lens has), the image is focused on the easel. The negative may

BOX 4.1

The negative carrier is immediately below the condensers, so that the negative can be evenly illuminated, and its image projected via the lens positioned at the end of the bellows unit. From Fig. 4.42 it is clear that as the lens is focused further away from the negative (to create *smaller* enlargements) the lamp will no longer be accurately focused in the plane of the lens, but will now be above it! Obviously, this suggests further adjustment of the lamp-shift,

but in practice this is rarely necessary unless the lens is moved considerably. The same applies in the other direction, i.e. when greater enlargements are made and the lens gets much closer to the negative. The use of opal lamps helps to make such adjustments unnecessary, but if a clear tungsten lamp is employed no such tolerance is allowed – and adjustments are essential in order to avoid an image of the filament appearing over the picture.

then be removed to inspect the spread of illumination and, if necessary, be corrected by adjusting the lamp.

Clearly, condenser enlargers are precision instruments and require care in handling, but they can also give the very best quality and offer the highest contrast.

Just below the lens is a red swing-out filter, which is useful for inspecting the image when printing paper is on the easel or masking frame. Since there is no danger of fogging the print with red light, it is safe to view the image this way when applying special techniques such as double-printing, etc.

One significant problem with condenser enlargers is their height. The nature of the lamp house extends their height considerably and, in turn, can inhibit the maximum degree of enlargement if the darkroom is not very high.

Diffuser enlargers

By comparison, diffuser-type enlargers are more convenient than their condenser counterparts, and are more popular for this reason. As may be seen from Fig. 4.43, in appearance they differ only in the style of the lamp house, which has a much smaller profile since the light source is more compact and more easily ventilated.

Most small-format diffuser enlargers look like that in Fig. 4.43, with a folded light path producing even negative illumination via a diffusing light box. The light source is usually a very bright **quartz iodide lamp** which, although very hot in operation, is fitted with a heat-absorbing filter to keep heat away from the negative.

Many of these compact and efficient enlargers also incorporate a range of colour filters to form a **colour head** complete with 'dialled-in' cyan, magenta and yellow filters. Although an enlarger may be fitted with a colour head, it is still suitable for black and white printing, provided that all the filters are set to zero. Any amount of filtration will mean longer exposures, of course, but if cyan is in the light path there will be no results at all! However, the

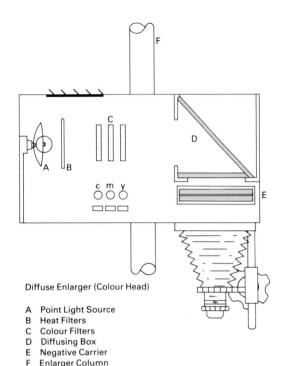

Diffuse Enlarger (Colour Head)

A Point Light Source
B Heat Filters
C Colour Filters
D Diffusing Box
E Negative Carrier
F Enlarger Column

Fig. 4.43

yellow and magenta filters can always be employed for filtering variable contrast papers such as Multigrade.

Large-format diffuser enlargers usually employ a **cold-cathode lamp**, which is a grid-shaped fluorescent tube providing almost heatless, blueish, light. Although this form of illumination is very efficient for monochrome work it cannot be used for colour printing.

All diffuser enlargers give less contrast than condenser types, in printing terms about one grade less.

The negative

A 'good' negative will have received sufficient exposure to give detail in the shadows, and sufficient development to provide a full range of tones, from shadows to highlights (bright areas of the scene or object). Over-exposure will have given more density than necessary, so that longer printing times are required and, worse, a print of poor quality – 'grainy',

with poor definition of highlight detail. Under-exposure will have resulted in dark shadow areas lacking in detail.

If the film has been under-exposed and over-developed, the resulting negatives will exhibit slightly less shadow detail but an unfortunate amount of contrast which can be expected with any over-developed negative. Under-development, for any reason, must be avoided as this creates the worst of all possible combinations – loss of detail and loss of contrast – and these are difficult faults to correct in printing.

Printing

Negatives should be placed in the carrier upside down, with the emulsion (dull side) facing the enlarger lens. In this way, the enlarged image will appear 'right way up', making subsequent operations that much easier.

Printing papers are manufactured in a number of well-established sizes, such as: 17.8 × 12.7 cm (7 × 5 inches); 25.4 × 20.3 cm (10 × 8 inches); 40.6 × 30.5 cm (16 × 12 inches). Most are available in a variety of quantities (ranging from packets of 10 or 25 sheets to boxes of 100), grades and surfaces. (See pages 67 and 72 for explanations of RC paper and multigrade paper.)

The first tasks in enlarging are to size the image within the masking frame, which you will need to have adjusted according to the paper size. If you are using 25.4 × 20.3 cm paper, then you should set your frame to about 25 × 19 cm ($9\frac{1}{2}$ × 7 inches) so that it may accommodate the paper. Now focus the image and compose the picture to your liking. It is necessary to ensure that these tasks are done at maximum aperture, not only to gain an accurate focus, but also to provide a brighter working image also.

Once the image has been composed, the lens aperture should be 'stopped-down' by at least one stop (f/No.) in order to guarantee that the image remains in focus (particularly since the thickness of the printing paper has to be taken into consideration).

You now need to consider print exposure. This will always be highly subjective: some people like darkish prints, others contrasty images, and so on. But printing is mainly a question of practical experience, correction and criticism. As you become more confident about printing, you will learn to see the relationships between printing strength, tonality, key and contrast. To begin with, however, you should concentrate on getting a reasonable printing strength (neither too dark nor too light) with the correct grade of paper.

Grade of paper

In general, a low contrast negative will require a contrasty (Grade 3 or higher) paper and, conversely, a contrasty negative will need a soft (Grade 1) printing paper. Most negatives of reasonable quality will be printed on Grade 2 or Grade 3, particularly when using a diffuser-type enlarger.

Print exposure

A good negative will represent each part of the scene in shades of varying density, and for a given printing exposure (aperture and time) each density will transmit a different amount of light energy to the printing paper. Obviously, the 'correct' exposure is a compromise at best!

If you give too little exposure, the highlights (light areas on the print) will have insufficient detail; if you give too much, these same areas will look 'muddy' and the print will lose contrast. Similarly, if you over-expose, the shadows of the print may go too dark – losing detail in these areas. A compromise in exposure should not mean a compromise in quality, however, and if there are problems in getting quality in both shadow *and* highlight areas within the same print, then a form of local exposure control known as 'shading' (or 'dodging') is called for. Note: an increase in enlargement requires a corresponding increase in exposure.

Shading is a simple technique which gives more exposure to the highlights without allowing the shadows to get too dark. With a little practice,

shading can be undertaken by using only the hands. For fine work, however, it is always best to cut a small, appropriately shaped piece of card to use as a shading mask. This 'mask' can be either an aperture or a shape, the former allowing light only to those image areas where extra exposure is required (Fig. 4.44(a)), the latter (suspended on a thin but stiff wire) being used to hold back light from a certain area (Fig. 4.44(b)).

Cutting out the correct shape, or aperture, is easily done, simply by holding a piece of card midway between lens and easel so that the required image area can be drawn in pencil. Cut it as cleanly as possible. In practice you can use quite complex shapes and apertures for shading, but you should always keep the 'dodger' somewhere between lens and easel, vibrating it gently so that 'shading' is not obvious on the finished print.

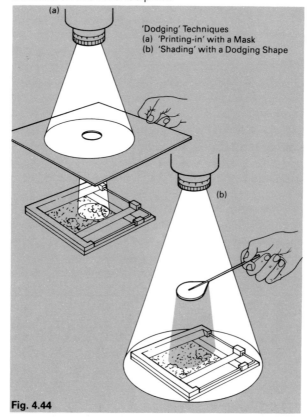

'Dodging' Techniques
(a) 'Printing-in' with a Mask
(b) 'Shading' with a Dodging Shape

Fig. 4.44

Fig. 4.45 Vignetted print. Photo: Kate Mayhew.

If variable contrast paper is being used, it is possible to shade the print with a change of filter, thus providing even greater local control to the print.

If you wish to vignette a print (in Victorian style), so that the picture fades gently out to the white of the paper (Fig. 4.45), cut an appropriately sized oval-shaped hole for the aperture.

Exposure: meters and test-strips

Enlarging exposure meters are useful aids for finding the correct exposure, and are usually in the form of a 'spot-meter' with a small cell being placed over any part of the image to measure image illuminance at that point. Before being put to work, these meters should be calibrated for the enlarger in use, and set to the appropriate paper speed. However, despite their convenience and economy, they cannot help with the question of paper grade, which is best solved by use of 'test-strips'.

Test-strips are simply thin strips cut from a

particular grade of printing paper which are then placed over significant parts of the image for test exposures. It saves time to make these strips in a series of exposure steps, much like the example shown in Fig. 3.47, increasing each exposure by constant increments of two or five seconds, depending on the exposure level. Once you have developed them and given them at least a minute of fixation, you can rinse them briefly in water and look at them outside the darkroom. From the test-strip it is possible to check both exposure level and paper grade before making the whole print.

Print fixing and washing

When you fix prints, make sure that their initial immersion into the fixing bath is complete. Being made of paper they will tend to float to the surface if not pushed well down, and inadequate fixation in these early stages can lead to yellow stains that cannot be removed. Fixation time will depend upon the type, and concentration, of fixing solution employed, but will usually be about ten to fifteen minutes for complete fixation.

Washing of RC papers can be very short, about five minutes being totally adequate. Fibre papers will require a longer period, however – at least twenty minutes for complete washing.

Print drying

Most photographic papers are of the RC variety and quite apart from their shorter washing period are to be recommended for their ease of drying. A good swab, or squeegee, will remove most of the excess moisture from RC prints which you can then hang up on a line to dry in a warm, dry atmosphere. Fibre-based prints are best hung up to dry back-to-back.

A hairdryer can always be used to accelerate drying but it should never be too hot. Alternatively, RC prints can be hung up to dry in a film-drying cabinet. Special RC print dryers are available that take wet RC prints and dry them within about ten minutes.

Double printing

Once you have mastered the art of shading, it is possible to try your hand at double printing. To take a typical example: if you print a landscape negative and find that the sky looks rather weak, devoid of clouds and altogether uninteresting, it is possible to superimpose a cloud negative to make up this deficiency. After the first (landscape) negative has been printed, the paper is left on the easel and protected with the red swing-out filter. The negative is now removed and replaced with a suitable cloud negative which can then be scaled and composed to fit the blank sky area, the print remaining safe under the red filter. Naturally, you will need to make the usual test exposures and to shade carefully to merge the two images at the skyline, but it will be even more important to match the two negatives. A common mistake is to use negatives which have very different forms of lighting, with, for example one being taken at noon and the other in the evening.

Diapositives

Black and white diapositives (transparencies) are rarely used these days, mainly because colour diapositives (for example, Kodachrome) are more popular. Nevertheless, they still remain useful for technical work and as an intermediate stage for the production of **second generation** negatives employed in image modification techniques. A second generation negative is a copy negative, sometimes made with extra or less contrast.

If you need a full-toned diapositive, the correct sensitive material for printing, either by contact or by enlarger (which can always be used at 1:1 scale) is an 'ordinary' film emulsion such as Kodak Gravure Positive (see Table 3.4). This material can be used just like printing paper under a yellow safelight, and developed in either a dilute print developer or a film developer such as DK-50. For maximum contrast, Lith film should be used, developed in Lith developer (Table 3.4). (Lith film is a very high contrast film (see p. 72) used for reproducing line drawings, etc.)

Image modification techniques

A number of image modification processes are available that can provide interesting variations with unique aesthetic possibilities. Most of these techniques require a considerable amount of patience and experimentation, however.

Photograms

Perhaps the simplest technique of all, the photogram requires nothing but an object and a sheet of printing paper to provide interesting white shapes against a black background. Glassware, flat metal objects such as keys and scissors, in fact anything that can provide an interesting shape, is a suitable subject. You make a photogram by placing a sheet of printing paper under a small light source (in the darkroom, of course), expose for a second or two, then develop the result.

Bas-relief

This plaque-like effect gives a sculptured appearance to the image, not unlike the relief found on a coin. Bas-relief images are best reproduced from softly-lit scenes or objects, particularly those with strong lines such as those found in architecture. From the negative, a diapositive is contact-printed so that when the negative and diapositive are registered together the (ideally) equal, but opposite, tones cancel each other out as far as possible. If the two are now taped on to a glass negative carrier, but in such a way that they are just slightly out of register, the enlarged composite will provide an image like that shown in Fig. 4.46 (p. 106).

'Sabattier' effect

This 'partial reversal' effect is never consistent and often requires a number of attempts to get it right. Ideally starting with a strong image, one with good lines, and printed on contrasty paper, the print is developed in the normal way for half of the normal development time. At this point, a white light over the developing tray should be switched on for about a second, taking care to ensure that it is sufficiently distant to illuminate the print evenly. Now complete

development, but without agitation. Fix, wash and dry in the normal manner. If successful, the print will have an overall greyish appearance with partially reversed tones as shown in Fig. 4.47.

STUDENT ASSIGNMENTS

1 A stock solution must be diluted 1:7 to form a working solution. Calculate how much stock solution will be required to make one litre of working solution.

2 Calculate the stock quantity of acetic acid required to make two litres of 5% working solution.

3 Select a good-quality negative and enlarge it exactly three times. Estimate the required paper grade (or filter, if variable contrast paper is used) and make a suitable four-step test-strip of equal exposure increments. Process this test-strip and, if necessary, continue with this practice until you are confident that you have both the correct grade *and* exposure. Make your final print.

4 Make a number of photograms from a selection of opaque and transparent objects and experiment with different light source to paper distances.

◀ **Fig. 4.47 Sabattier effect. Photo: Ron Graham.**

5

Flash
Photography

'I have seized the light. I have arrested its flight.'
(Louis-Jacques-Mande Daguerre, 1787–1851)

Photo: Virginia Bolton

THE NEED FOR FLASH PHOTOGRAPHY

When lighting conditions are too low for conventional exposures, you will have to resort to artificial means. For studio work or on industrial locations where mains electricity is handy, this will involve tungsten lighting in the form of spots and floodlights. But when you need a convenient and portable source of artificial lighting you will rely on a flash.

There is nothing new about flash photography. Indeed, the nineteenth-century photographer, Fox Talbot, was the first person to take a photograph with the flash of a spark, although according to the September 1864 edition of the *British Journal of Photography*, the electric means which he had at his disposal were insufficient to achieve his result. By the turn of the century, flash powder was being used. Although rather dangerous and inconvenient to handle, this proved to be very useful for press work and for commercial and industrial photography. Flash powder is still used today for very special purposes, its main advantage being the exceptionally large amount of even lighting it produces.

The flashbulb followed flash powder. The first flashbulbs were as large as a domestic light bulb and filled with aluminium foil: these were replaced by the smaller, more reliable and efficient aluminium magnesium-filled bulbs. As flash technology developed, these in turn gave way to the even smaller and more efficient zirconium foil type which are still valuable to professionals.

One of the main advantages of flashbulbs is the range of light output they provide. Professional photographers take full advantage of this and place different strength bulbs inside large interiors in order to gain balanced lighting. Clear flashbulbs come in the larger sizes with a colour temperature of 3800 K, and are intended for monochrome photography. The majority of flashbulbs, however, are coated with a transparent blue lacquer which gives them a correlated colour temperature of 5500 K and makes them suitable for daylight colour film as well as monochrome materials.

For many years now, electronic flash has taken the place of flashbulbs for the majority of users. Increased sales have brought the price down as manufacturers provided smaller units based on improved tube design and microelectronic circuitry. The average flash gun suitable for use with 35 mm cameras is capable of providing sufficient light for most purposes and will generally be fitted to the camera by means of a 'hot shoe'. Some of the more sophisticated flash guns offer an automatic flash exposure control: the flash gun is set for a given aperture and film speed, and monitors the flash that 'bounces back' to the camera, limiting the flash duration according to the distance of the object.

Electronic flash has the distinct advantage of being cheaper to operate than bulbs, since the flash tube is capable of thousands of flashes and, depending on its capacity, only requires a battery recharge or a change of battery every thirty or more flashes. Other advantages of electronic flash include a daylight colour temperature in the region of 5000 K to 5500 K, plus an inherently short flash duration.

BOX 5.1

Guide numbers

The guide number is determined by the manufacturer of the flash; however, it is always possible to modify a GN to suit your own conditions. If you want more exposure, decrease the GN; if you want less exposure, increase it. The GN can be expressed as the product of two working conditions: f/No. and distance (D), viz: distance (D), viz:

$$GN = (f/No.) \times D \qquad Eq. 5.1$$

It is, however, subject to two further conditions: the film speed (ISO) and the unit of distance (feet or metres).

Here is an example: a typical GN for use with film of 125 ISO may be 20. If you want to use the flash at a distance of 5 metres then, using the above equation:

$$f/No. = GN/D = 20/5 = f/4$$

If your subject is only 2.5 metres distant, then the f/No. becomes f/8.

If the film speed is changed, then the GN must also change. This change is not calculated proportionally, but according to **the law of inverse squares**. If, for example, the film speed is increased by a factor of two (to 250 ISO) then our GN increases not by two, but by the square root of 2. This gives us the following calculation:

$$20 \times \sqrt{2} = 20 \times 1.4 = 28$$

For a distance of 5 metres we could therefore employ f/5.6. Similarly, if the film speed is increased by a factor of four (500 ISO), then our GN is increased by the square root of 4 ($20 \times \sqrt{4} = 20 \times 2 = 40$); at a distance of 5 metres, then we can employ f/8. If we use the symbol F for the factor of increase (or decrease) in film speed, we can put these calculations more formally as:

$$GN (F) = GN \times \sqrt{F} \qquad Eq. 5.2.$$

If we now reduce our film speed from the original 125 to, say, 64 ISO, then F = 0.5. This gives the following equation:

$$GN (F) = 20 \times \sqrt{0.5} = 20 \times 0.7 = 14$$

At a distance of 5 metres, we should now have to employ f/2.8.

These same calculations also apply when two or more identical flash sources are used from the same distance.

FLASH EXPOSURE: GUIDE NUMBERS

Photographic exposure is the product of light-intensity and time, but in flash photography 'time' is dictated by the duration of the flash itself. This means you need to use a different method for estimating flash exposures. This is called the **guide number** system. (See the Box on p. 108.)

The guide number system applies to all forms of flash and for any given flash outfit relies on three basic working conditions: fllm speed, f/No. and distance from flash to subject. The guide number (GN) is determined by the manufacturer of the flash, and is an average value based on typical working conditions. Most electronic flash guns have their GNs incorporated within a simple dial-type calculator which is usually fixed to the back of the lamp head; this indicates the required lens aperture once the estimated flash-subject distance and film speed have been set. More sophisticated types of flash gun may have an automatic option, as well as a manual mode: this allows you to take flash exposures without worrying about distance, once you have set the film speed and lens aperture on the flash gun.

Fig. 5.1 (a) Flash duration 1 millisecond (1/1000 second). (b) Flash duration 10 microseconds (1/100 000 second). Photos: Ron Graham.

AUTO-FLASH

Automatic flash systems usually work on the principle of receiving some of the reflected flash back into a photo-cell in the flash head: on its reception back at the photo-cell, the flash is quenched. The time it takes for the reflected flash to return is obviously a function of the distance of the subject being photographed. For subjects at a distance of 15 metres (often the maximum distance for flash guns), the flash duration may last 2 milliseconds (1/500 second); if the subject is only one metre away, the flash may be cut as short as 40

microseconds (1/25000 second). Forty microseconds is short enough to capture a number of fast-moving subjects. In Fig. 5.1(a), for example, a balloon is burst with an air-gun dart but the flash duration, at one millisecond, is far too long to capture the action. In Fig. 5.1(b) the flash duration is now 40 microseconds, short enough to capture the burst balloon in detail.

STUDIO FLASH AND FLASH METERS

Studio flash equipment involving two or more flash-heads mounted on stands has now replaced many tungsten lighting systems in professional studios. They offer many advantages: a short duration flash exposure, synchronised with the camera shutter; a colour temperature equal to daylight (colour photography); 'cool' operation (good for foodstuffs, etc.). All studio flash heads incorporate a low-power tungsten lamp for 'modelling' (so that you can see your lighting) and most come with a useful inventory of 'snoots', 'barn-doors', diffusers and reflectors to control the spread of light.

Guide numbers are perfectly adequate for single flash operations, but they tend to be confusing when you are using multi-flash lighting, and they are totally inadequate when you are using studio flash with attachments. All good outfits, therefore, include a flash meter (with a system of LEDs) for determining

the correct lens aperture for a given film speed.

Once you have set up your lighting and are ready to make an exposure, you place the flash meter by the subject – generally facing the camera lens. A test flash (with all flash heads operating) will then activate the meter, which will signal the correct aperture to be set on the lens, for a given film speed. Flash meters are very accurate and, with experience, can be used for any type of studio lighting, i.e. high-key, low-key, diffuse, back-lighting, etc.

Usually, you have only one electrical connection to the camera, since you need only one flash head to be

Fig. 5.2 Photo: Ron Graham.

synchronised to the shutter; the other flash heads incorporate a slave cell, which picks up the primary flash (that the flash head synchronised to the shutter discharges) to fire their own head.

The full-length portrait in Fig. 5.2 was photographed with only two studio flash heads. One lamp was directed on to the white sheet background and controlled with barn-doors (so-called because when fitted in front of the lamp, each door can control how much light will be spread in any direction) to illuminate the background as well as to back-light the subject. The other lamp was used as the main light source. Placed high and totally diffused with a 'white umbrella', this lamp gave almost shadowless lighting. A flash meter was used to determine the correct exposure, and the lens aperture was set accordingly. Camera shake or subject motion was not a problem, since the effective exposure time was that of the flash, i.e. 1/1000 second! Both flash heads were fired at once: the main lamp through the shutter synchronisation, the other from its slave unit.

FLASH SYNCHRONISATION

The flash photographs of Fig. 5.1 were both taken with the shutter in the 'open' setting (B) and in a darkened room: the flash duration thus acted as a kind of shutter. But in order to capture the event at the right time, the flash had to be triggered by the event. This is *not* the usual way of things with flash, but is the required technique for high-speed events, as we shall see later.

The basic principle behind the use of flash is making sure that the shutter is fully open when the discharge takes place. If the shutter is in the 'open' (B) position, then any other lighting could quite easily creep into the picture during such an extended period. Flash must therefore be *synchronised* with the shutter for normal operation, and depends very much on the type of shutter involved.

INTER-LENS SHUTTERS

Inter-lens shutters have two types of flash synchronisation incorporated: 'X' synchronisation for electronic flash, and 'M' synchronisation for flashbulbs. When the shutter is set to 'X', the electronic flash is fired as soon as the inter-lens shutter blades are fully open – whatever the shutter speed. Even if the shutter is set to 1/500 second (the maximum for an inter-lens shutter), there is still time for the electronic flash to be completed. Flashbulbs, however, have a delay before the foil becomes totally ignited and so, when bulbs are being used, the shutter must be set at 'M'. When the shutter button is pressed, the flashbulb is fired and a delay mechanism to the shutter is released. This delay is usually of about 20 milliseconds (about 1/50 second), so that the shutter opens just as the flash is reaching half its peak intensity. If the 'X' synchronisation is used with a flashbulb there will be no picture. The shutter will open and close before the bulb has even ignited. Similarly, if 'M' synchronisation is used with electronic flash, there will be no picture since the flash will discharge before the shutter opens.

FOCAL-PLANE SHUTTERS

It is essential to consult the appropriate camera instruction booklet before using flash equipment with focal-plane shutters, since synchronisation of flash is particularly difficult with these shutters, of which there are many different types.

Fig. 3.27 shows that the focal-plane shutter blinds must be in a singular position for 'X' synchronisation, so that the entire film format is completely open. With most 35 mm cameras this will be at 1/60, or even 1/25 second, and this is marked with a 'flash' symbol against the shutter speed to be employed. You must ensure that you use only this speed for electronic flash or you will end up with results like that shown in Fig. 5.3; here, because 1/250 was

Fig. 5.3 Typical result from using a focal-plane shutter at a speed that is too fast for synchronisation, i.e. the correct 'X' synchro-setting was 1/60 second. This exposure was made at 1/250 second, just as the closing shutter blind was in the middle of the frame. Photo: Ted Johnson.

selected instead of the flash synchronisation speed of 1/60, the subject is half-obscured by the shutter blind at the moment of flash exposure!

Some cameras have an extra 'FP' synchronisation connection in addition to the 'X' input; this allows special, long-duration FP flashbulbs to be used across the entire speed range. The light emission of FP bulbs is more of a plateau than a peak and gives an almost constant light output for the time it takes the shutter blinds to traverse the film frame.

OPEN FLASH TECHNIQUES

For specialised work and studio effects you can use electronic flash with the shutter in the 'open' (B) position, and the room in almost complete darkness. As long as there are no lights or bright objects facing the camera, the shutter may remain open for a few seconds, particularly if you use a small lens aperture and have a black background behind the subject.

Set the camera on a tripod (ideally); just before the event you want to photograph takes place, open the shutter with a cable-release, fire the flash (from the

flash head), and close the shutter. Using this method, you can make multiple exposures, or you can allow the event itself to trigger the flash – as was done with the photographs shown in Fig. 5.1(a and b). Here, the flash-lead was divided: one wire was turned into a thin loop and taped to the rear of the balloon, and the other was taped inside (but not touching) the loop. Room lights were switched off, the camera shutter opened and the balloon struck. As the balloon collapsed, so the two leads made contact, the photograph was recorded and the shutter closed. Clearly, fine tuning of the trigger circuit is controlled by the size of the loop.

In Fig. 5.4, the same idea of 'triggering' was used to photograph the precise moment of a golf ball being struck by a club. One trigger wire can be seen touching the ball which, as it was struck, contacted the looped wire (hidden in the mat) to complete the circuit and fire the special 10 microsecond high-speed flash. (Note the squashed ball, where it contacts the club face).

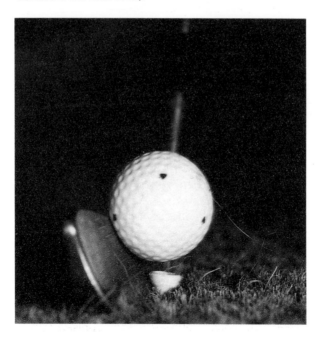

Fig. 5.4 High-speed flash (10 microseconds). Photo: Ron Graham.

Strobe flash photography ideally requires a special strobe light capable of flashing many times per second in order to get good sequence pictures of fast-moving events. You use the same 'open flash' technique with a strobe light; the shutter remains open until the total event has been captured on film. This technique is excellent for the analysis of athletics, gymnastics, fencing, etc. and is enhanced if the subject(s) are white against a totally black background. It is also possible to use a number of ordinary flash guns to make a pseudo-strobe record, as in Fig. 5.5. Here, the girl was asked to change her expression quickly as the camera (on tripod) was rotated slightly to place her image at different points in the frame. Despite the fact that three photographs were required for this particular record, it was possible to do the job with only two flash guns since the first was capable of rapid recycling and could fire again as soon as the second gun had fired. All flash guns have a **ready light** to the rear of the flash head, which indicates the readiness of the flash unit to fire again, and some will recycle completely within a second or two – allowing pictures such as this to be taken against a black background. This kind of photograph obviously requires considerable planning, and everything needs to be rehearsed before shooting.

SINGLE FLASH TECHNIQUE

Attaching the flash gun to the camera often results in the worst possible photograph. The only reason the flash is placed there (usually on the 'hot shoe' fitting) is convenience. As far as good photographic lighting is concerned, the flash gun couldn't be in a worse place.

We are accustomed to seeing shadows falling downwards when we look at faces, since the sun as a rule is above us. With 'flash-on-camera' the shadows are cast immediately behind the subject so that if, for example, you are taking a flash photograph

Fig. 5.6 Photo: Ron Graham.

Fig. 5.5 Pseudo-strobe with two flash guns. Photo: Ron Graham.

in a crowded room, with the subject close to a wall, the subject and the wall will be enjoined by the shadow. If you use the flash off the camera, to one side and above, you will avoid this. A long synchronisation lead will, of course, be necessary and if you have no assistant to hold the flash unit high you will need to use a clamp-on bracket to fit the flash gun to any convenient high point.

There are exceptions to this rule, of course. If the subject is in front of a totally black background (or unlit room), then the shadow cannot be seen in any case – as in Fig. 5.6, for example.

You can do flash portraiture very easily with a single flash gun and a white reflector, placing the latter to relieve the shadow cast by the flash lighting. You can gain soft lighting either by bouncing the flash from a white surface, or by diffusing it with white cloth material. With diffuse lighting, however, the lens should be opened up an extra aperture to allow for the loss of light. Dramatic effects, such as those shown in Fig. 5.6, are easy to accomplish if you use an appropriate model, make-up, a totally black background and a single flash placed well above the camera position (note the nose shadow).

SYNCHRO-SUNLIGHT

There is a further important use for flash when you are photographing subjects which may be seen best against the sun; in such cases, shadows fall towards the camera and there is a risk of under-exposure in these areas. Outdoor portraiture often falls into this category. In order to 'fill-in' the shadows, a flash gun can be used in conjunction with the conventional exposure. If, for example, the correct exposure is 1/60 at f/11, then the camera (with flash attached) should be used at a distance found from the guide number. And if the metric GN for the film is, say, 22, then the camera should be two metres from the

subject. In these circumstances, the exposure for the background scene and the shadows will be identical. With automatic flash equipment, the flash will change its exposure level according to the distance from the subject, which makes synchro-sun techniques very easy. Synchro-sun exposures are very useful for colour photography, particularly where under-exposure can cause colour casts, i.e. an overall colour bias covering the entire image (colour photography is the subject of the next chapter, and specific information on the lighting ratio between sun and shadow is given on page 122).

STUDENT ASSIGNMENTS

1 A flash gun has a guide number of 20 (metric) for a film speed of 100 ISO. Calculate the correct GN for the following:

 (a) Two identical guns are to be employed from identical distances.
 (b) A film speed of 400 ISO.
 (c) A film speed of 300 ISO.
 (d) A film speed of 50 ISO.

2 Use a single flash unit to take two pictures on one frame (Fig. 5.5 gives an example).

3 Use two or three frames to determine the correct guide number to be used with your flash gun, when you are using it with a white handkerchief over the flash head to reduce light output (suitable for close-up photography).

4 Use two or three frames to find the correct guide number with 'bounced-flash' technique. Pay particular attention to all conditions, i.e. the type of surface employed, its lightness, etc.

6

Colour

Photography

'For the rays, to speak properly, are not coloured. In them there is nothing else than a certain Power and Disposition to stir up a Sensation of this or that Colour.'

(Sir Isaac Newton, 1642–1727, extract from *The Opticks*.)

Photo: Virginia Bolton

THE GROWTH AND USE OF COLOUR PHOTOGRAPHY

The conventional photographic product for the casual photographer is a colour print of exceptionally good quality. Indeed, colour photography has grown to such an extent that it is now taken as much for granted as the colour television we watch at home. This is a comparatively recent state of affairs, since it was not until the 1970s that it proved possible to achieve good colour prints for everyone. Until around that time, excellent colour prints had been possible, but not on the scale we now enjoy, with rapid processing (as little as one hour from delivery of the film at the photo-shop to receipt of prints) and economic prices.

Ever since photography was invented, colour photography had always been considered the final goal. Indeed, if colour had been possible from the very start, it is doubtful whether monochrome would ever have been considered for anything other than special purposes and effects. This is illustrated by the fact that nowadays if an amateur wants to get monochrome negatives printed commercially, it is not only more expensive than colour, but it is more difficult to find a shop to do them! The entire developing and printing business is now orientated to colour, as there has been little demand for black and white photography outside professional work and that of the dedicated amateur since the colour market was firmly established, and all of the developing and printing houses have had to convert to this medium to survive.

Colour prints require much greater control in their processing. They need sophisticated machines and colour-monitoring apparatus, and colour printing has therefore become an expensive and almost exclusive technology in its own right. As a result, even most professional photographers send their colour negatives to a specialised colour-processing house, where the best-quality result can be printed at a price that is economically viable. Some

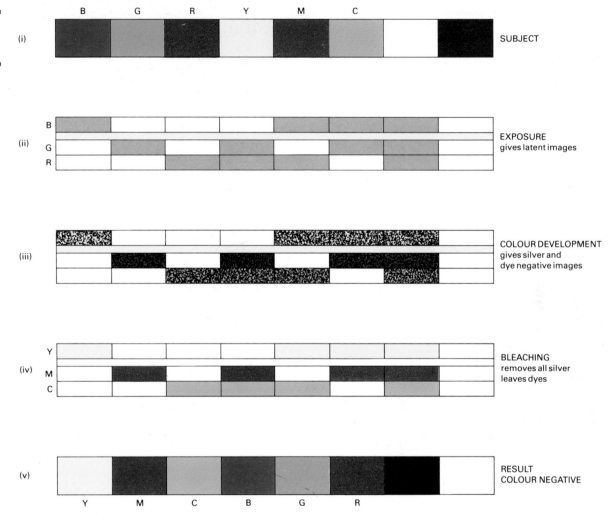

Fig. 6.1 Colour negative film.

professionals still print their own colour, of course, either because they have so much work it pays to have their own, very expensive colour-processing machines, or because their work is so specialised they need to control every stage of the printing themselves.

The technicalities of colour, its definitions and physical and psychological concepts, have been dealt with in Chapter 2, and the colour quality of light sources, colour temperature and filters have been discussed in Chapter 3. However, in order to understand the methods by which we can reproduce colour, it is convenient to take a quick look at its historical background.

THE TECHNICAL HISTORY OF COLOUR PHOTOGRAPHY

As Fig. 2.16 (p. 39) shows, the 'additive synthesis' of light suggests that any colour may faithfully be reproduced by a system that can control an appropriate mixture of the three primary colours: red, green and blue. And while a full appreciation of colour requires a model such as the Munsell colour tree (Fig. 2.18 on p. 40, where it can be seen that a simple mixture of **hues** must also be supported by the **lightness** and **saturation** of a colour), these properties can be ignored in terms of recording systems.

The first attempts at colour reproduction were based on additive principles, and the first commercial success (at the turn of the century) was gained with a 'screen plate' system known as 'Autochrome'. In the Autochrome process, starch grains were dyed red, green and blue to make tiny colour filters. Equal quantities of the three types of grain were then mixed and sifted on to a glass plate (coated with adhesive to retain them), and, finally, a panchromatic emulsion was coated on top of this random array of tricoloured filters to make an additive screen plate. The plate was then exposed via the filter network and processed by a reversal method to give a coloured image. Although the tiny coloured elements were too small to be seen with the naked eye, they became clearly visible if these transparency plates were very much enlarged.

Other screen plate processes followed the Autochrome system. The Finlay screen, for example, was marketed in 1927; this employed a separate screen plate held in contact with a conventional panchromatic plate for the exposure. After processing, a diapositive was made and then registered with yet another screen plate, this time with colours specially designed for viewing under tungsten illumination.

The most successful of these additive systems was Dufaycolor which, by the early 1930s, had become a popular material in both roll film and cut film sizes. Dufaycolor used a geometric screen pattern of about 20 lines per millimetre and a network (réseau) of red, green and blue to produce a direct colour transparency by means of the usual reversal process.

The era of the additive systems ended with the introduction in 1936 of Kodak's Kodachrome and subtractive colour film, which used the subtractive synthesis shown in Fig. 2.17 (p. 39). Still in popular use today, Kodachrome is a transparency process employing three sensitive emulsions in what is known as a tri-pack; each emulsion responds to blue, green and red light respectively, but, on processing, the image in each layer reproduces in its complementary colour – yellow, magenta and cyan. Kodacolor followed Kodachrome in 1942, a negative material which, following the same subtractive principles, enabled colour prints to be made from colour negatives.

MODERN COLOUR MATERIALS

All today's colour films and papers are based on the subtractive principles of colour reproduction and are part of a highly complex technology. In this book we are not able to discuss the manufacture and processing of these materials in any depth, but it is possible to explain their composition and working principles.

There are two main types of colour film: (a) colour negative, intended for printing, and (b) colour transparency film, intended for diapositive viewing by means of a hand viewer or projector. The colour quality of diapositive film is much better than that produced from negative–positive materials (mainly because of the increased saturation possible in such film) and can be printed to a very high quality by the graphic arts industry; as a result, many publishing houses prefer to commission their colour photography in transparency form.

COLOUR NEGATIVE FILMS

Typical colour negative films are Kodacolor, Agfacolour and Fujicolor, all of which, with a few differences in their layered structure, have the same blue, green and red layers interspaced within the usual supercoat and base. Fig. 6.1 (p. 115) demonstrates the basic tri-pack structure which, even though there are films available now with many more layers (with fast emulsions paired with slow ones for the same colour), still typifies most colour films. The diagram presents the colours of a subject (i) with, from left to right, the three primaries followed by their complementaries and the two **achromatic** colours, white and black.

On exposure, the latent image of such a subject will then be recorded as shown in (ii), with only blue being recorded on the top blue-sensitive layer. Since all photographic materials for use with a camera have an inherent sensitivity to blue light, it is necessary to block blue light from reaching the middle and bottom layers and a yellow filter layer in the film ensures this. White will be recorded on each layer, of course, as will, to a lesser extent, greys, until they reach black and are not recorded at all (under-exposure). The complementary colour magenta is made up of red and blue (as explained in Chapter 2) and consequently exposes both the top and bottom layers of the tri-pack, whereas a yellow object will expose both the middle and bottom layers.

Colour development (iii) does two things at the same time. First, it develops the latent image in the normal way (to black metallic silver); and, secondly, the oxidation products created by this action are used to **couple** with special dyes incorporated within each layer. The greater the amount of image, the greater the amount of dye. Each layer incorporates a dye which is complementary in colour to its own sensitivity, so the top blue-sensitive layer couples to yellow, the middle (green) layer to magenta, and the bottom (red-sensitive) layer to cyan.

The silver images are then removed by a bleaching solution (iv) to leave each layer with a

complementary dye-image of the subject (v). If you examine the finished negative of most colour films, you will see that there is an overall orange cast in the negative. This is the integral mask which occurs because the magenta and cyan layers both contain coloured couplers to correct these two dyes and give improved colour reproduction when printed. Fig. 6.1 does not illustrate colour masking in order to keep explanation of the principles simple.

Most people have their colour films commercially processed, but processing colour negatives is a simple enough business. A typical negative colour process is the Kodak C-41 (shown below) which, although simple enough, requires very exact colour development to get the correct colour balance: you can only vary development time and temperature minimally.

Table 6.1

Processing stage	Kodak C-41 process time (minutes)	Temp (°C)	Tolerance (°C)
Colour developer	3.25	37.8	±0.2
Bleach	6.5		24–40
Wash	3.5		,,
Fix	6.5		,,
Wash	3.25		,,
Stabilise	1.5		,,

These times may alter slightly, depending on the products or the type of processing equipment; each set of chemicals provides full instructions, which should always be read carefully before processing.

TYPES OF COLOUR NEGATIVE FILM

Most of the major film manufacturers have at least one negative colour film on the market, and the majority offer a range of types which differ mainly in their film speeds. In the Kodak range, Kodacolor Gold is a very popular film. Kodacolor Gold 100 (ISO 100) is a fine-grain, extremely sharp film with vivid colour saturation and good exposure tolerance. If you expect to make enlargements greater than about 12 × 18 cm, you should always load with Gold 100. Gold 200 is a more general purpose film; its colour quality is much the same as that of its slower companion, and for most purposes it is a better choice. Further up the speed rating, there is Gold 400, a very useful colour film for work in low light levels. The price to be paid for this speed, however, is that you cannot make acceptable enlargements to the size that you can with the slower films, and the colour rendition is also not as accurate. The fastest colour negative film in the Kodak range is Kodacolor VR 1000 (ISO 1000), which gives a grainy appearance that can be used with some landscape subjects to give an almost 'pointillist' effect.

The Fuji range of colour negative films starts with Fujicolor HR100, an excellent film in every respects, which has good colour quality and is capable of high enlargement. Fujicolor (like Kodak Gold) has 200 and 400 ISO rated films, but has an even faster film at the top end of its range, HR 1600.

At the time of writing, the fastest colour negative film is the Konika SR-V 3200. This extremely fast film reveals its graininess immediately! But it is nevertheless useful for getting colour pictures without the use of flash, and if you are looking for grainy results this is the film to use. Colour rendition suffers, as is to be expected: saturation is lost and subtle hues are reduced to their closest primary colour.

COLOUR PAPERS

Colour negative films exist only in order to provide colour prints, and if these are not printed correctly then the characteristics of a good negative are lost – just as they are in monochrome photography. Colour papers are very much like their negative counterparts, except that the emulsion pack is now based on RC paper, with different spectral sensitivities (matched more closely to printing light sources) and ordering of the emulsion layers.

Three very different types of paper exist. The main type, such as Kodak Ektacolor, is intended for printing (negative/positive) from colour negatives. The other two are for printing direct from colour transparencies, or what is known as positive/positive printing. Ektachrome paper, which is reversal processed, and Cibachrome, which uses a dye-destruction process, are examples of this paper. Our main interest here is the conventional negative/positive printing paper.

Fig. 6.2 gives the basic arrangement for a typical colour printing paper of the negative/positive type, where the top and bottom layers have been reversed. The cyan (red-sensitive) layer is on top because cyan is more noticeable than yellow, and therefore plays a more important role in image definition. The bottom layer image naturally suffers from a large amount of diffusion since the image has to pass through the upper layers, and because yellow is the least noticeable colour, the blue sensitive emulsion is placed here. Printing materials have only to deal with specified colours found in the negative, so it is possible to employ emulsions with a specific spectral range; there is thus no need for the yellow filter that is necessary with negative emulsions. The illustration shows that a pure yellow in the negative (i) will provide a response in the red (top) and green (middle) layers (ii) which, on colour development (iii), will provide a silver image and a colour-coupled image in each layer. In the top layer, the oxidation products of developed silver couple to provide a cyan image, whereas that in the centre couples to magenta. After bleaching away the silver (iv), and subsequent fixing and washing, the colour print (v) should be as close to the original (Fig. 6.1) as possible – depending on the skill and accuracy of both photographer and printer.

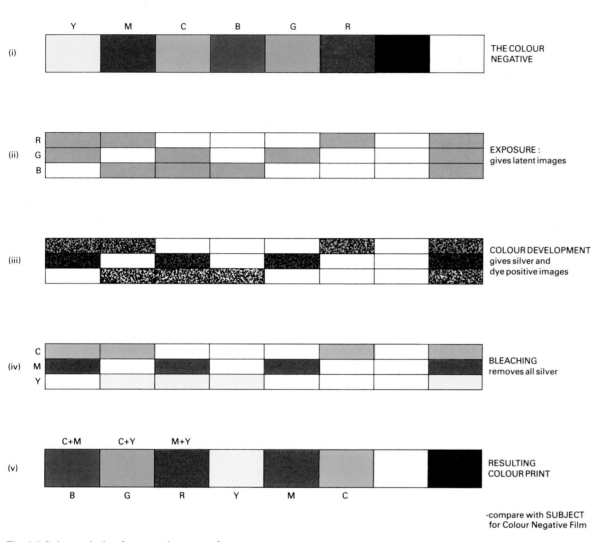

Fig. 6.2 Colour printing from a colour negative.

category (for example, Kodak Ektachrome, Agfachrome, Fujichrome or Ilford Ilfochrome), whereas there are few non-substantive types on the market: Kodachrome is one of them.

Reversal films have no subsequent printing stage, as negative films do: the image that is recorded at the time of exposure will be the image you see on the diapositive. It is vital, therefore, to minimise the risk of error at the time of exposure. For the same reason, we need one colour reversal film for tungsten lighting and another for daylight. It is possible to use each type in the lighting for which it is not primarily intended by using a colour conversion filter, but both the colour quality and the film speed will be affected (the latter as a result of the filter used).

COLOUR CONVERSION FILTERS

If you want to take a photograph in tungsten illumination with studio lights operating at 3200 K, and your camera is loaded with reversal film balanced for daylight, put a blue 80A filter over the camera lens and carry on with the daylight film. However, because of the filter you are using, your photograph will require four times more exposure! Conversely, if you are taking a daylight photograph with tungsten-balanced film, you could use an 85B conversion filter which will involve two-thirds filter factor necessary. In each of these cases, however, it is always better to use the correct film, since the colours will be more correctly balanced.

THE STRUCTURE AND PROCESSING OF REVERSAL COLOUR FILMS

Fig. 6.3 shows that the basic structure of reversal colour films is not unlike that of negative colour materials. There are the same three basic emulsion

POSITIVE COLOUR (REVERSAL) FILMS

Positive (diapositive) colour films fall into two processing categories: (a) the **substantive system**

films which can be processed by the photographer because the colour couplers are present in the emulsions, and (b) the **non-substantive system** films which have to be processed by the manufacturer because the couplers are not in the film but in the developer. The vast majority of transparency colour films fall into the substantive

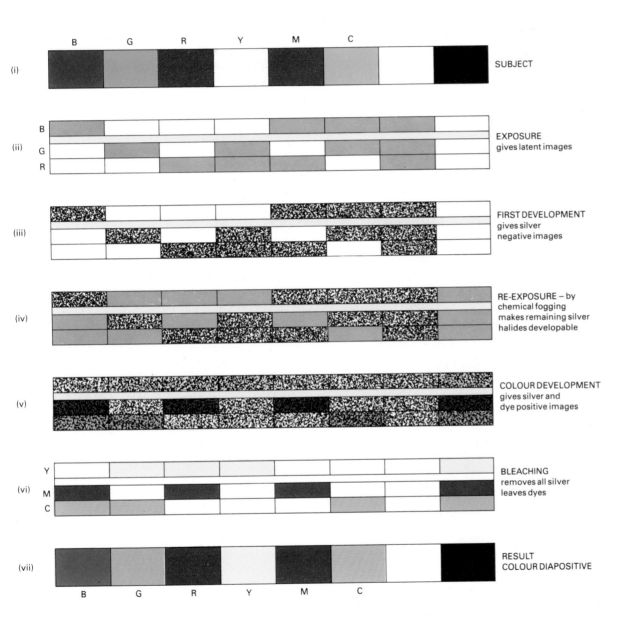

Fig. 6.3 Colour reversal film.

layers which on exposure have a latent image according to the spectral sensitivity of each layer (ii). However, with colour reversal films, the first (monochrome) development (iii) only creates a conventional silver image which will be sacrificed at a later stage. The emulsions are then chemically fogged to create a reversal image (iv); thereafter, since there is nothing left to fog, the rest of the process can be carried out in white light. The film is colour developed (v), and subsequently bleached to remove all the silver (vi), leaving a colour diapositive image of the object (vii).

Nearly all colour transparency films follow the same basic processing conditions and can be 'user-processed' in an E-6 colour processing kit. Actual processing times will depend on the film and its exposure (control of the first development, for example, allows for under- or over-exposure) and processing instructions should be followed with great care. The list given in Table 6.2 is applicable to many films.

Table 6.2

Processing stage	Kodak E-6 process time (minutes)	Temp (°C)	Tolerance (°C)
First developer	6	37.8	±0.3
Wash	2		33–39
Reversal bath	2		33–39
Colour developer	6		±0.6
Conditioner	2		33–39
Bleach	6		,,
Fix	4		,,
Wash	4		,,
Stabilise	0.5		,,

(The conditioner acts as a kind of stop-bath, to prevent cross-contamination of chemicals; the stabiliser hardens the emulsions and stabilises the dyes.)

As we said earlier, it is almost impossible to correct exposure errors with colour reversal films (unlike negative films); in general, you can only over- or under-expose by half a 'stop' without seriously

affecting the quality. If in doubt, it is always better to under-expose rather than over-expose. Over-exposure produces very desaturated colours as well as lack of detail, whereas under-exposure (as long as it is not more than one full 'stop' out) can actually increase colour saturation.

The non-substantive range of Kodachrome films boasts some of the finest colour films available, but the processing time takes a little longer than with other films. Kodachrome 25 gives strong primary colours with good pastel hues and it has first-class definition, almost free of grain. Kodachrome 64 gives excellent rich colours with good definition and is useful for more general work. Kodachrome 200 has a slightly magenta bias in neutral areas and highlights when it is used in overcast conditions.

Kodak's substantive colour reversal films carry the Ektachrome label and can be obtained in a wide range of speeds. Ektachrome 100 is a very useful film which gives excellent colour under all conditions, be they sunlight, overcast weather or electronic flash. Ektachrome 200 tends to provide rather blueish whites, but you can correct this by using either an 81 or 81A filter over the camera lens. Ektachrome 400 is perhaps the most versatile reversal colour film produced; although its nominal speed is 400 ISO, this film can be rated at 800 ISO without any significant loss in either colour quality or sharpness. If, at processing stage, you extend the first development to ten minutes, it can even be stretched to 3200 ISO – but only at the expense of quality.

In the tungsten film range, Ektachrome 50 is very suitable for still-life subjects and has an excellent latitude, but a more generally useful film for tungsten illumination is Ektachrome 160, which has good definition and reasonable speed. ('Latitude' is a term that refers to the ability of a film to accept both under-exposure and over-exposure (to some degree or other) yet still provide a reasonable negative image that can be printed.)

Also in the Ektachrome range is Ektachrome Infrared film. This film was originally designed to a military specification for revealing camouflage by aerial reconnaissance, but it is now used for the more peaceful purpose of detecting crop diseases by remote sensing. If you use this film with a yellow (Wratten No. 12) filter, you can achieve fascinating results, with almost 'psychedelic' colours.

Agfachrome 200RS gives rather warm skin tones and is considered to be ideal for portraiture: it has very good colour saturation, despite its speed (ISO 200). You can use Agfachrome 1000RS for low light levels, but the colour may not be that faithful, as you might expect from such a high-speed film.

There is a large range of Fuji reversal films capable of fulfilling almost every requirement. Fujichrome 50, for example, is a fine grain reversal film of moderate contrast that is also quite suitable for copying colour transparencies. Fujichrome 64 Professional T is the film to use for tungsten illumination, while for general daylight work there is Fujichrome 100 and Fujichrome 400D, both of which provide very strong primary colours.

COLOUR PHOTOGRAPHY IN PRACTICE

CONTROL OF COLOUR TEMPERATURE

As we have seen, there are two main types of reversal colour film: daylight and tungsten. The former is balanced for natural light at colour temperatures in the region of 5000 to 6000K (see p. 47) and also electronic flash; the latter is for use with studio lighting in the region of 3200K. A comprehensive list of various light sources and their CTs (colour temperatures) is given in Table 3.1. Generally, most films can accept variations of about 100K in colour temperature, but variations greater than this affect the colour quality: higher CTs, for example, result in a blueish appearance, and lower CTs in a yellowish one. Professional photographers usually employ a 'Colour Temperature Meter' to determine the values of their light sources.

If you use filters in front of either the camera lens or the light source, you can adjust the CT of a source to that of the film. Unfortunately, however, this is not a straightforward affair. The problem is that filters do not raise or lower the CT by a constant amount: a filter, for example, that raises a source from 2800K to 2900K will raise a 5000K source to 5300K. To perform such a calculation, we need to consider what are known as MIRED values.

MICRO-RECIPROCAL DEGREES (MIREDs)

Table 6.3 MIRED SHIFT values for Kodak Wratten filters

Positive values Yellowish filters		Negative values Blueish filters	
85B	+127	78A	−111
86A	+111	80B	−110
85	+110	82C+82C	−89
85C	+86	82C+82B	−77
81EF	+52	82C+82A	−65
81C	+35	82C+62	−55
81B	+27	82C	−45
86C	+24	82B	−32
81A	+18	78C	−24
81	+9	82A	−21
		82	−10

The colour temperature of any light source has an equivalent MIRED value which can be calculated as follows:

$$MIREDS = 1\,000\,000/CT\,(K) \qquad Eq.\ 6.1$$

As an example, let us imagine that we have studio lighting of 500 W but that we need to supplement this with flashbulbs. Table 3.1 on p. 47 shows that the 500 W lamps have a CT of 3200 K (or a MIRED

Fig. 6.4 Subject colours are highly contrasted by use of a polarising filter to deepen colour of sky. Photo: Virginia Bolton.

Fig. 6.6 Clear atmosphere conditions typical after a recent fall of rain. Photo: Ron Graham.

Fig. 6.5 Muted colours due to use of a soft-focus filter. Photo: Virginia Bolton.

Fig. 6.7 Taken with a zoom lens (150 mm) against the sun, this air-to-air shot of a microlight is spoiled by inter-lens reflections of the aperture. Photo: Ron Graham.

value of 312); the CT for clear flashbulbs is 3800K, a MIRED value of 263. We decide to put a filter in front of the flashbulb, to lower its CT to that of the studio lighting; before we do this, we must first determine the MIRED SHIFT involved (in this case, from 263 to 312, a shift of 49). Table 6.3 tells us that the closest MIRED SHIFT value to 49 is 52 and that we can achieve this with the Kodak Wratten filter No. 81EF.

Let us take another example: we want to use daylight balanced colour film suited to a CT of 5500 K (MIRED value 182) with studio photofloods rated at 3400 K (MIRED value 294). To do this, we need to alter the CT of the lighting from 294 to 182, a MIRED SHIFT value of −112. Using Table 8.3, we find that a blueish 78A or 80B filter should be selected for fitting over the camera lens.

Generally, the TTL metering system will take into account any increase in exposure that the use of a filter requires, but it is necessary to determine the appropriate filter factor in advance when you are using flash. To do this, take a TTL meter reading with and without the filter fitted to the lens. If the reading is, for example, 1/125 at f/11 without the filter and 1/60 at f/11 with it in place, then you should allow for a X2 filter factor when calculating the flash exposure.

With all outdoors colour photography, it pays to use a (colourless) skylight filter over the lens to protect the film from excessive amounts of ultraviolet radiation. These filters help to achieve optimum colour rendition and they have no effect on the general exposure.

LIGHTING RATIOS

On a clear summer's day, a typical lighting ratio between sunlit scene and shadow is in the region of about 8:1. If the scene you are photographing is one of high contrast and likely to provide either over-exposure in strong highlights (i.e. brightly reflecting objects) or under-exposure in dark areas of the scene, this ratio is likely to be too much. Before you take a colour photograph, therefore, you should

monitor the scene with an exposure meter (or the camera's TTL meter) in order as far as possible to control the luminance range. If, for example, significant areas indicate 1/500 at f/4 in the highlights of a scene and 1/60 at f/4 in the dark areas, then the luminance range is close to 10:1, which is just within the average subject luminance range that is allowed for by most negative/positive colour processes. However, if you are taking a portrait, and the luminance range is, for example, 20:1, then you should use a white card reflector to lighten the shadow areas and reduce the range to something like 10:1 or less.

The luminance range allowed for by transparency films, however, is about twice as large as this. It is nevertheless important to look carefully at the shadows when you are taking photographs out of doors. Although the moderating effects of colour constancy (mentioned in Chapter 2) might prevent the casual observer from noticing it, the shadows may well be illuminated by strong blue skylight, and the camera and colour film would certainly record this. For the same reason, always check to see if any coloured objects are close enough to reflect unwanted colour into an object; this is particularly important in studio work.

For most colour work, but particularly for most studio scenes and still-life subjects, the lighting ratio should be no greater than about 3:1, which allows for a reasonable range of subject brightness to be recorded with good colour fidelity.

Always try to use a polariser in landscape and general outdoors colour photography. Fig. 6.4 shows the effect this can have: the bright, highly saturated colours are further enhanced by the deep blue of polarised skylight. In contrast, the soft and muted colours of Fig. 6.5 have been emphasised by the use of a soft-focus filter.

A good landscape composition depends on the consideration of key elements: lighting, atmosphere, time of day, time of year, etc. Many of these elements are greatly emphasised shortly after a spell of rain, when the atmosphere has been washed free of dust, the horizons are clearer and

well spaced and low cumulus clouds add to the composition. Fig. 6.6 is an example of this kind of photograph.

LENS FLARE

All good camera lenses are coated on each lens-element surface, so that internal reflections are reduced to a minimum. If this were not done, then photographing against the light would give what is known as lens flare and a corresponding reduction in colour saturation. Nevertheless, the complex construction of some lenses can easily promote internal reflections when you are photographing against the light. Some zoom lenses are particularly vulnerable to this effect and can, as well as reducing colour saturation, often record internal reflections of the aperture diaphragm — as shown in the air-to-air shot of Fig. 6.7.

COLOUR PRINTING

There are so many commercial houses nowadays that can colour print to whatever standard is required that few are prepared to set up the expensive equipment and processing chemicals necessary for quality printing. For the same reason, we will only attempt a brief description of colour printing here.

WHITE LIGHT (SUBTRACTIVE) PRINTING

White light printing is now the most common method for printing colour negatives. It involves placing one or more subtractive filters between a white light source and the colour negative. A typical colour printing enlarger head is shown in Fig. 4.43 (p. 103) where 'dialled-in' cyan, magenta or yellow filters of varying strength control colour. Other

systems rely on a filter tray placed above the negative holder, in which you can put various subtractive filters.

These filters allow you to vary the colour balance of the projected coloured image. Usually you analyse the image either by test-strips or meter (colour analyser), or both – often with the additional aid of a 'standard negative' with known filter requirements. If the first attempted test-strip appears to have a colour cast then a filter (or filters) of the same colour as the cast should be added in order to remove that colour.

Colour printing (CP) filters usually come in a range such as, taking the example of yellow filters, CP 05Y, 10Y, 20Y, 30Y, 40Y, 50Y. The same range applies to the CP Magenta and CP Cyan filters. In practice, shifts of 10 units only result in a slight change, whereas 20 units are easily noticed.

ANALYSIS AND ADJUSTMENT OF THE FILTER PACK

Let's take an example: our first test-strip, printed with a filter pack of 15Y + 20M, is found to have a slight cyan cast, so we add 10C to the pack for the next test – giving 15Y + 20M + 10C. However, since there are at least 10 units of each subtractive colour in the pack, we have neutral density of ten units that does nothing but increase the exposure time! So, we make the next test with: 05Y + 10M which will remove the slight cyan cast from the print.

If, on the other hand, the original test-strip has a somewhat stronger green cast, then we would add, say, 20 units of green filtration (as Chapter 2 shows, this can be made up by subtractive synthesis) from 20Y + 20C. The required filter pack would then be an addition of 20Y + 20C to the original 15Y + 20M, which results in a final pack of 15Y: there is less exposure required since there are fewer filters involved!

The manufacture of colour printing papers is never consistent: each *batch* of paper, as sold, therefore has its own 'Paper Filter Adjustment' (PFA) printed on the package. So if our original print was correct with a printing pack of, say, 25Y + 10M, and the paper had a PFA of, say, – 10M + 10Y, then the PFA should be subtracted from the printing filtration to give the basic filter value, viz.:

Filter pack for (first) correct print:	25Y + 10M
minus (first) PFA:	−10Y − 10M
Basic filter value:	15Y + 20M

If, after some time, another print is required and it has to be printed on a new batch of paper with a PFA of, say, 20M − 10Y, then the new PFA should be added to the basic filter value as:

Basic filter value:	15Y + 20M
Plus (new) PFA:	+ −10Y + 20M
Filter pack for new emulsion:	05Y + 40M

This new filter pack should then give a colour print much the same as the original, but it will need to have the exposure adjusted according to the Exposure Factor recommended with the new batch.

STORAGE OF COLOUR MATERIALS

Colour materials are much more vulnerable to changes in heat and humidity than their monochrome counterparts. Severe changes affect the three colour layers in different ways, resulting in relative changes of speed between the emulsions which can upset the delicate colour balance they have with each other. The shelf life of colour materials is more limited than that of monochrome materials, and can only be assured if they are stored according to the manufacturer's instructions.

Avoid keeping colour films at temperatures above 21°C for any length of time; if you are storing films for weeks, or even months, put them in a fridge (i.e. at a temperature of 13°C or less). Always remove film from the fridge 24 hours before you plan to use it, to allow it to become accustomed to room temperature. If you don't, moisture will condense on to the cold film surface and spoil it completely!

When a camera is loaded with colour film, take care not to leave it in a hot place – like the back of a car during summer, or near to a radiator.

Always attempt to get the film processed as soon as possible after exposure; if there is any delay, keep the film as cool and dry as you can. This is more of a problem in countries where the temperature is above 25°C and the humidity above 60%: in these conditions, put the exposed film in a sealed container with some silica gel crystals – to remove the humidity – then place the film in a refrigerator until it can be processed.

STUDENT ASSIGNMENTS

1 A tungsten colour film is balanced for 3200 K and is to be used indoors with domestic tungsten lamps. Use Tables 3.1 and 6.3, to find an appropriate filter to be placed over the camera lens.

2 You are to use a daylight colour film (balanced for 5400 K) in 'Daylight' Fluorescent-tube lighting. Which filter would you use in front of the lens? Use Tables 3.1 and 6.3, for reference.

3 You are going to reprint a colour negative which was correctly filtered with a basic filter value of 10Y + 20C. The new colour paper has a PFA of − 10M + 05Y, giving a new filter pack of 15Y − 10M + 20C. In order to remove the negative Magenta filtration (which can only exist in theory) add an appropriate neutral density to give a working filter pack suitable for printing.

7

Presentation and Display

'An excellent conception can be quite obscured by faulty technical execution, or clarified by faultless technique.'
(Edward Weston, 1886–1958)

Photo: Virginia Bolton

INTRODUCTION

The final stages in the production of a photographic image for presentation or display are in many ways the most important. Presentation can make or break an image: it governs how much impact an image has and it can, if carried out with sensitivity, enhance even a mediocre print. The steps involved are time-consuming and require patience and a professional working manner, but once the techniques of mounting and spotting are mastered, the rewards will be many.

PRINT FINISHING AND TRIMMING

Once a photographic print has been processed and what was once latent is now visible, there are many further creative controls open to you.

Between fixation and print mounting there are some important decisions to be made. First and foremost, the quality and permanence of the image must be secured. Indeed, you may want to make the print 'archivally' permanent (i.e. protected from deterioration, staining or fading over the years to come) which is of special importance for exhibition work or prints that are to be sold. You can achieve this by using a rapid fixer and hardener or by using **selenium toning** (see Box 7.1) before washing the print for 60 minutes in running water. Whatever you intend doing with the print, you must make sure that the print wash water is clean and well filtered so that there is no risk of surface scratches on the final image.

Ordinarily, a fixed print is washed for twenty minutes if it is made on fibre-based material, or for five to ten minutes if it is on resin-coated (RC) paper; then it is dried. Prints on RC paper may be dried by hairdryer or by a specially designed print-drying

cabinet with racks for accommodating many prints at once. Alternatively (and more cheaply), they may be dried by removing excess water with a squeegee and hanging the print on a line with clips. With fibre-based papers, however, such drying methods can result in curled prints, particularly with single-weight papers, which are very difficult to handle unless they are flattened under a mass of heavy books! Fibre-based papers should therefore be dried in a 'flat-bed' (or rotary) dryer in which the print is held firmly between a hot metal surface and hessian cover: this stops it curling during drying.

At this stage you can convert a 'glossy' surfaced print to a 'glazed' one, simply by placing the emulsion surface of the print on to a perfectly clean 'glazing plate' (flat-bed dryer) or directly on to the glazing drum of a rotary dryer. Glazed prints have a perfectly shiny surface, whereas the ordinary gloss surface reflects less. Glazing is not an irreversible process, however, since a glazed print can always be re-soaked in water and dried with its emulsion next to the hessian cover, which yields a print with a glossy but unglazed appearance.

Choice of print surface depends on your personal preference and should largely be determined by the nature of the subject and what it is that needs to be

┌──────────── BOX 7.1 ────────────┐

Selenium toner is one of many print baths available; other toners offer overall print colouring, such as sepia, which is a two-bath toner, or blue toner, which requires only a single bath. There is now a wide range of brighter colours available – red, yellow and green, for example – manufactured by companies like Colorvir. You can tone a print immediately after processing it (after the washing stage) or at a later stage from a dry print; in this case, however, the print should always be pre-soaked in water before it is treated.

└─────────────────────────────────┘

expressed. Matt surfaces give a softer feel to an image and, because of the diffuse nature of the surface, are free from those irritating reflections which so often spoil the viewing of a displayed print. Conversely, glossy and glazed print surfaces have much greater contrast because of the increased density of the 'blacks' (see Fig. 7.1), but they reflect light in a direct (specular) fashion which makes the viewing angle something of a problem.

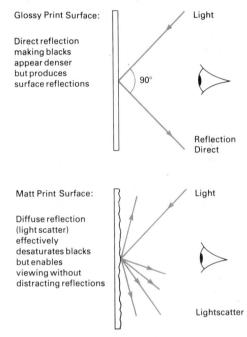

Fig. 7.1 Light reflection from print surface.

In general, prints intended for publication (magazines, reports, etc.) should be submitted on glossy (unglazed) paper, whereas prints intended for display are often better on matt, semi-matt, lustre or pearl-surfaced papers. It is certainly easier to spot and retouch non-glossy prints, but if you have any difficulty in achieving print contrast you should always select glossy paper for the richer and deeper blacks that you can obtain with this surface.

Once the print has been dried, look at it again to see if it is shown to its best compositional advantage: it is always possible to eliminate

Fig. 7.2 Using 'L' shapes to mask off print before trimming.

extraneous subject matter by trimming (cropping) the print. But before you pounce, scalpel in hand, take some time to decide. It may help you to use a pair of 'L' shapes cut from card, which can be used as masks over the print surface to present many alternative ways to trim the image, as shown in Fig. 7.2.

Trimming is a task which must be carried out meticulously – if you do not take careful measurements and check for the right angles with a setsquare, you could end up with a print with sloping edges or even of postage stamp size after several re-trims! Once you have measured the print and marked it carefully, you can trim it by hand using a scalpel and safety ruler (with a guard for your fingers)

or a rotar-trim cutter. Whichever you use, check that the blades are sharp before you begin – this should be done with a spare print, not with your fingers! If you intend to dry mount your work for presentation, you would do well to leave any necessary trimming of prints until a later stage.

PRINT MOUNTING

You can mount photographs in many ways – using adhesive sprays, glue, or double-sided tape. However, the most permanent and clean method is that of **dry mounting**.

To dry mount on to a card, a tacking iron, heat press, dry mounting tissue and silicon release paper (non-stick) are needed, as shown in Fig. 7.3.

The procedure for dry mounting (illustrated in Fig. 7.4) is as follows:

(a) Use the pre-heated tacking iron to tack one sheet of mounting tissue to the rear of the print – marking a cross shape as you do so. Be sure to leave the corners untacked and do not press too hard or a mark will show through on the print surface.

(b) You can trim the print and its backing tissue together, which ensures that both are exactly the same size and that no tissue protrudes.

Fig. 7.3 Photo-finishing equipment. (a) Heat press, (b) Tacking iron, (c) Silicon release paper, (d) Dry mount tissue, (e) Safety ruler, (f) Set square, (g) Knife, (h) Bevelled edge cutter, (i) Cutting board, (j) Spotting dyes.

(c) The mounting card should now be marked lightly with a pencil to indicate the position of the print: generally, the best proportions for borders around the print are equal space at the top and sides, with twice that space below the print. Do not cramp the image by using too small a mount, unless you want to 'flush mount' the print, i.e. have the print the same size as the mounting card.

Fig. 7.4 Dry mounting procedure.

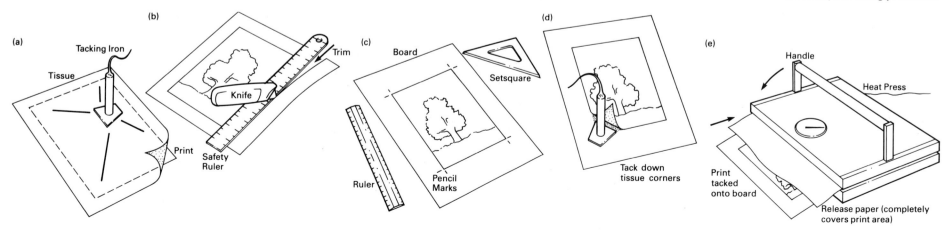

(d) Holding the print carefully in position, lift each corner in turn, to reveal the tissue beneath, and tack these corners to the card. Make sure there are no ruckles in the tissue which may lead to visible lumps under the print.

(e) Once you have tacked the print into place, you can then place the entire card in the heat press to bond the two surfaces permanently together. Ensure that the temperature setting of the heat press does not exceed 93°C (200°F) and that the silicon release paper covers the entire print surface in order to protect it. Hold the press down for about 10 to 15 seconds and then remove the print and check it. If the print has not fully stuck to the card, replace it for a further 5 seconds, but be careful: if you overheat the print, there will be a blistering of the print surface which cannot be corrected. The press is too hot if you find the tissue is firmly attached to the mount alone (particularly if the print shows blisters as well); but if the tissue is only sticking to the print and not to the mount, it is not hot enough.

Once you have dry mounted the print, remove all pencil marks from the board.

If you are mounting several images together on one board, think carefully about the spacing (avoid crowding), sequence and balance. Do the images tell a story? Is the sequence logical? Do the images look pleasing to the eye? Always ask the opinions of others before making a final decision about layout. It is up to you whether you leave prints with or without borders, but avoid mixing the two on one mount and remember that it is always better to have no borders at all than to have uneven ones!

Finally, you can place an additional 'window mount' over the top of mounted prints to add a kind of '3D' effect in presentation. These mounts are best made with a specially designed 'bevelled edge' cutter to give a 45° angle to the inner edges of the window. This can look extremely professional, but it is time-consuming. You can achieve a similar mount, without angled edge, using an ordinary scalpel. The

only slight drawback to this is the final weight of the mounted print, thanks to the extra layer of card – not a small consideration when you are carrying a portfolio of work about!

Fig. 7.6(a), and (b) Hand colouring on to resin-coated paper using photo-oils. The colours blend and appear more natural when applied to a sepia-toned image.

PRINT SPOTTING AND HAND COLOURING

Fig. 7.5 'Spotting out' a black and white print. With a fine brush and spotting dyes, white blemishes on the final print can be 'camouflaged' to blend in with the surrounding grey tone.

Even when a print is finally mounted it may not be complete and ready for presentation. Very often, no matter how well negatives are cared for, prints may have small white dots on them from dust that has accumulated during printing. It is vital that the final appearance of the print is as good as possible, so these little imperfections must be 'spotted out'. This is one of the first skills you should master when learning photography. Spotting can be done using special photo-dyes or watercolour paints, both of which are available in grey, warm-black and blue-black. These dyes can be watered down and applied almost dry with a very fine (0 or 00 sized) watercolour brush in a 'dotting' fashion to the areas required (Fig. 7.5). If watercolours are used, it pays to apply a little

gum (from the sticky flap of an envelope) to the brush, particularly when spotting glossy prints – the gum helps to give a bit of a gloss to the spotting.

Brush strokes should never be used (as they will show up boldly on the print surface) but, by building up layers of grey by 'spotting', the white areas can be gradually blended in with the surrounding tone. Even a white blemish within a dark area should be built up in layers of grey rather than one layer of black, since the latter may cause the spotting dye to adhere to the extremities of the blemish rather than to disguise it.

Dark spots are best treated with iodine bleach, applied with a similarly small brush, before the print is mounted. This bleaches out the dark spot (which is usually caused by scratches on the negative, or dust spots on the film at the time of exposure) so that it may then be spotted in the manner described above. A suitable iodine bleach can be made up as:

warm water:	750 ml
potassium iodide:	16 g
iodine:	4 g
water to make up:	1000 ml

It is best to apply the bleach to a damp print and keep it under control with a damp cotton wool swab. The yellowish stain that often follows bleaching can be removed by putting the print in fixing solution and washing and drying it in the normal manner.

HAND COLOURING

You can apply colour selectively to a mounted print in a similar way to spotting; this can produce a more subtle image than one made in full colour from colour film.

Dilute oil colours with turpentine and apply them with a fine brush, allowing each colour to dry fully before applying additional colours. Use watercolours on fibre-based papers: if large areas are to be coloured, watercolours are better applied as a wash to an unmounted damp print. Watercolours used in this way are wetter and may be swabbed with cotton wool pads to produce an even colour finish.

If you want to give a sepia tone to a print (which gives a warmth to the image), do this before colouring; this produces a more natural appearance when you hand colour the print. An example is shown in Fig. 7.6.

Whatever colouring method you use, remember that blacks will not show colour while mid-tones and highlights will paint-in more effectively. In other words, if you expect to hand colour a print, take care not to print it too dark.

In the world of advertising, a great deal of hand colouring is used to create effects that make products more appealing to the eye. This colour is usually applied by a graphic artist using an **air brush**. This is a spray gun which uses compressed air to project a fine jet of ink and requires a great deal of skill and practice to use effectively.

PERSONAL PORTFOLIO

Try to decide early on how you wish to present your work and adopt a personal style and continuity throughout. This will avoid any last-minute panic before interviews (at college, or with employers), when you suddenly feel that your portfolio lacks strength and organisation. Reprinting and remounting at a later stage is time-consuming and should be avoided wherever possible.

Think about the most convenient method of presentation. How large a portfolio do you need? There are many ways to present work, for example, dry mounted and stacked in a neat box, or in a loose-leafed folio with acetate sleeves. The decision depends upon the nature of your work and how much you can afford to spend, but whatever you decide, make sure to give a 'clean' look to your work. Try to maintain continuity in mount size even if you have no consistency in print size. Professionals in art and photography work with what are called 'A' sizes which are the standard dimensions of portfolio cases, sheet card and paper. (The old 'foolscap' size, for example, has now been replaced by A4, and a sheet twice that size is A3, etc. See Fig. 7.8.) One of these sizes may be a convenient size to work with.

The colour of a mount is important: avoid bright colours which tend to swamp a picture, especially a black and white one. If you wish to use a coloured mount for a colour photograph, try to select a subtle shade which occurs in the image so that the mount enhances the image instead of drowning it out. Black and white work tends to look best on white mounts, or occasionally on black or grey. A small image on a large mount can be more intimate, inviting closer examination; a large print flush-mounted can look bold and undistracted

Other ways of giving a flow and continuity to the body of work might be a consistent use of border, or your signature and date under each print. You can use captions to explain what or where something is – possibly to make clearer the intentions behind the photograph. You can add this kind of written information with dry-transfer lettering, but generally your own handwriting looks far more personal and inviting.

Fig. 7.7 Personal portfolio. How you decide to present your work is a personal choice. Here, a series of window-mounted images are presented in a folio.

Remember that the presentation of your work is a personal and creative statement. In many ways, a portfolio should speak for the individual and stand alone. Presentation is therefore of the utmost importance, and is not something to be ignored or rushed. After all, a personal portfolio can be the key to a future in the creative media of photography, art or design (Fig. 7.7).

Before the invention of photography, as we reminded the reader towards the beginning of this book, the capacity for image-making was confined to those lucky few with artistic ability. Photography has changed this entirely, making it possible for everyone, regardless of talent, to produce creative images.

Since the invention of photography, there have been fierce arguments between those people who claim photography as a legitimate art in its own right and those who deride it as a talentless pseudo-art. That argument is not the subject of this book, but we need to remember that the final product of photography is, like a painting, a two-dimensional picture, be it in colour or monochrome, and is still subject to those criteria already established in the world of art. Like the best paintings, the best photographs combine an originality of vision with a technical mastery of the medium.

As we have seen, however, a good photograph need not be technically perfect in order to attract attention. Indeed, it may lack elementary composition or even be blurred a little, as is the case with many acclaimed photographs. Very often it is the event itself, or perhaps the sheer audacity of the photographer, that makes the image appealing. And, whether it is art or not, there is no need for any photograph (regardless of its content) to be boring.

The essential thing is to keep experimenting to extend your photographic skills; good camera work, clean processing and careful printing all lead to a 'picture' that is worthy of exhibition. At that stage, with the picture carefully mounted and hung, who is to say that photography requires no talent or is not an acceptable form of art?

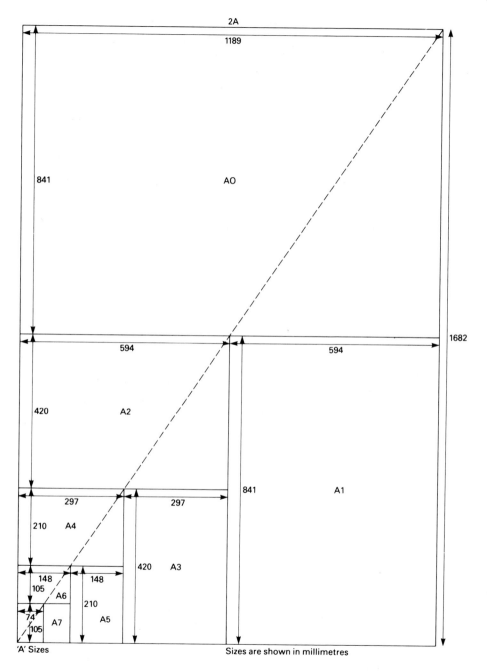

Fig. 7.8 'A' sizes.

AO = 1189mm × 841mm
A1 = 841mm × 594mm
A2 = 594mm × 420mm
A3 = 420mm × 297mm
A4 = 297mm × 210mm

'A' Sizes

Sizes are shown in millimetres

Appendices

Appendix A – Contemporary Applications of Photography

MASS COMMUNICATION

While many might disagree with the statement, 'The camera never lies', few would dispute that its images are considered 'real' and 'believable', a view of something that happened, or of someone who truly exists. This communicative quality of the still image makes it the ideal medium by which to illustrate a news event or sell a product.

The still photograph is an integral part of our everyday life. Imagine a textbook without pictures, a street without posters, a magazine without advertisements or an album without snapshots. It is for this reason that we should be aware of the ways in which this continual exposure to photographs affects us – and perhaps why.

Do you think the 'camera never lies'? Look at the photographs on the news and in advertsing. Are they truthful or just one way of looking at an event or product? Could there be another way to represent this reality? A different viewpoint perhaps, or camera angle or selected moment?

What about the comment, made recently by a fashion designer, that it is no longer necessary to 'sell' the clothes, but rather to use a photograph to sell an idea, a lifestyle – and the clothes will sell themselves. Are you aware of the way in which 'images' are being created in advertisement photography whose appeal is essentially to the subconscious of the viewer?

PERSONAL COMMUNICATION

The amateur 'hobby' market has the greatest turnover of money spent on materials and cameras.

Indeed, the number of 'One Hour' or '24 Hour' processing labs in your town today is an indication of the increasing number of image-makers around.

This end of the market may be considered neither relevant nor important by 'serious' photographers, but it would be narrow minded not to wonder why this growth has occurred and what effect it has had upon the photographic industry as a whole. Most certainly we would not be able to take advantage of our sophisticated but relatively cheap 35 mm cameras were it not for the massive sales involved.

The appeal of making images, and, more importantly, portraits or personal documents, is as widespread today as it was in the earliest years of photography. So why do we take so many photographs of the family, babies, places visited, things done? And, moreover, why do we keep these and collect them in albums? One answer is that personal documents act as proof. A photograph of the scene of a crime can be used as proof or supporting evidence in a court of law, and a photograph of Aunty Maude in front of the Eiffel Tower can similarly be evidence that she has really been to Paris, and proof that she was having a good time (well, she *is* smiling!). Another answer is that human beings have a need to reflect upon past experiences, fun had and places seen. In this way we achieve a kind of immortality through photographic documents.

Photography is one of the most popular hobbies in the world and this popularity (and the money it generates) has in turn fuelled the advance of photographic technology which has always striven to meet the demands of its users, to make it possible to photograph everything the eye can see with greater ease, quality and, hopefully, less expense.

This is true of the 'serious amateur' end of the market as well. The 35 mm SLR owners now have an endless range of equipment at their finger tips, from autofocus lenses to special effects filters. And there are many magazines on the market encouraging amateur photography through advertisements for cheap equipment or tempting holidays for competition winners. For some, photography is mainly an abiding interest and understanding of technical equipment: a love of instruments and the ergonomic pleasure of handling sophisticated cameras. Many are the negatives that never get printed! But, for the majority, the camera is simply a means to an end – the photograph is the thing.

However we may choose to use photography, it must be appreciated that it is a personal means of communication for many many people, whereby everyone can use whichever piece of equipment or approach necessary to meet their needs. A creative image in a gallery may be no more worthy of acclaim than a snapshot which serves only to recall happy memories – after all, beauty is in the eye of the beholder.

DOCUMENTARY AND REPORTAGE PHOTOGRAPHY

One of the uses of the photograph is to document the reality of a situation. This is the domain of the documentary photographer.

Working independently or as a team, the documentary photographer's aim is to produce honest, visual evidence of events in the world (the Ethiopian famine was partly brought to the consciousness of developed countries by such work). In theory, these images should be unbiased and objective. However, each photographer sees the world in a different light and by so doing puts a little of him or herself into each photograph taken. This involvement in the subject matter can lead to

powerful images of great visual impact. An example of this work is the Farm Security Administration project discussed in Chapter 1, which produced such powerful images as Dorothea Lange's 'Migrant Mother' (Fig. 1.29).

A documentary photograph may be seen singly as an image which attempts to tell the whole story, or as one in a photo-series; both types of documentary photograph are published in books, pamphlets or presented as exhibitions. These pictures, clearly, cannot on their own ever truly express the scale of war and suffering; the task of the documentarian is rather to 'represent' through photographs the cost of human life or the pain of hunger. These 'representative' photographs help us, the viewers, to form a comprehensive picture of events in our mind.

The documentary photographer is not dissimilar to the reportage photographer or 'press' photographer in that he or she has to be where the action is, to work quickly and sensitively with small or medium format cameras, and, most of all, to reach a wide public with the final images. And, similarly, he or she must also capture the essence of an event in an image which attracts public attention. So what is the difference between these two image-makers?

One saying has it that a documentary photograph should be an unbiased teller of truth, whereas the truth that the reportage image may tell is dependent upon the political viewpoint and camera angle of its photographer.

The press photographer works for a competitive publication, perhaps with strong political or financial backing. He or she must therefore meet deadlines, beat the competition and possibly convey a particular side of a story to suit the politics of his or her employer.

A news image grabs attention through its ability to express the action of an event, and provides an element of human interest which meets the needs of an inquisitive public. These photographs tend to fall into two categories – drama and gossip.

Through your own photography, you can appreciate how the appearance of a scene can be greatly altered by changing viewpoint, camera angle or through selection of moment. Consider photographing a riot of striking picketers confronted by police. From where do you take your photographs? Behind the picket lines looking towards the oncoming and ominous line of uniformed men? Or perhaps from behind the policemen who walk towards a barrage of angry faces, brandishing banners and sticks? Do you think the two photographs would tell the same story? Would each

show a different side of the event? (See Figs. A.1 and A.2.) We must not lose sight or appreciation of the tremendous courage and compassion with which the world's photojournalists work in the troubled areas of the world. Their images are destined for the wider audiences available through the international press; and these are the people who bring the world and the full evidence of the 'human condition' to our breakfast table.

INDUSTRIAL AND COMMERCIAL PHOTOGRAPHY

It could be said that these two broad categories are the lifeblood of professional photography, since they cover such fields as advertising commercial products (fashion, food, hardware, toys, etc.) as well as providing essential records of industrial work (engineering, building, research projects and the like).

Most large companies either have a photographic department staffed by in-house photographers, or have an established contract with a local firm of commercial photographers. In some circumstances, the nature of the work may be too specialised for a local photography business, for example, high-class fashion photography where contact with models and the rest of the industry is of paramount importance, or aerial photography, where the right kind of experience is essential if the cost of the operation is to be justified.

Most industrial and commercial photographers have been college trained, and can command good salaries once they have served about five years with a photographic business concerned with quality work. As may be expected, the equipment required is both extensive and expensive. On location work the photographer usually works with an assistant (under training), mainly to help carry and set up the large amount of equipment to be used. The essence of location work is preparation, but it pays to take

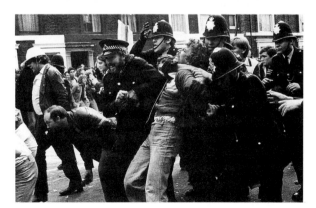

Fig. A.1 The Rioter – The Victim? Photo: Chris Steele-Perkins.

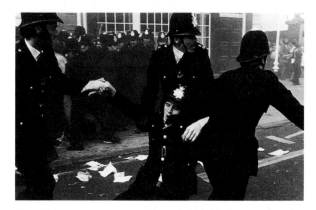

Fig. A.2 The Policeman – The Victim? Photo: Chris Steele-Perkins.

Two photographs taken by the same photographer show how interpretations of an event can alter depending on the 'decisive moment' and the political persuasions of the viewer.

every precaution for the unexpected; flashbulbs, electronic flash, reflectors, studio lighting, background paper, spare films, tripods, flash meters, exposure meters, colour-temperature meters, filters, lens-hoods, changing bag, extra three-core cable, tools, spare fuses, electrical plugs, distribution boxes . . . the list seems endless! Most photographers will take along a number of cameras, a view-camera (5 × 4 inch (12.7 × 10.2 cm) format), TLR and SLR cameras, plus close-up attachments. Even though the crew may have been led to expect a simple task, they know from experience that when on location there is always the 'While you are here perhaps you would photograph this as well' situation!

There are two other factors photographers should be prepared for when photographing industrial interiors, etc. One is that it will seldom be possible to disrupt working staff to achieve the perfect composition; and the other is that people tend to 'pose' for the camera. In these conditions, a photographer needs to possess considerable patience and an ability to make easy contact with people, as well as all the necessary technical skills.

SCIENTIFIC PHOTOGRAPHY

From the beginning, photography was considered as much a science as an art, and although its importance as a tool of science is no longer as great as it was before the growth of electronics, it still plays an important role in all sciences.

In Chapter 4 we looked at Record Photography and saw some of the techniques involved in the faithful recording of laboratory-type subjects. But scientific photography means much more than this, since its main role is to detect, discriminate and record phenomena unseen by the naked eye. The list of applications is almost endless but the following will give you an idea of the scope of scientific photography.

ULTRAVIOLET AND INFRARED RADIATIONS

We know that the human eye can see within a short range of wavelengths extending from 380 nm to 760 nm. But all photographic films are inherently sensitive to ultraviolet radiation down to about 300 nm (below which ultraviolet radiation tends to be absorbed by the gelatin). In this region, medical photographers often use the ultraviolet for photographing skin problems and lesions.

For recording in the infrared region, film can be sensitised to about 1200 nm for spectroscopy (measuring radiation), but most infrared photography is done with special infrared sensitive films which are sensitive to about 920 nm. For this work, a special infrared transmission filter is required, which is opaque to visible radiation. Filters such as the Kodak 87 are generally employed for work in aerial photography – detecting crop failures, marshlands, etc. – and also for medical work.

One of the more well-known attributes of infrared photography is its ability to detect forgeries (forensic science) and, as shown in Fig. 3.57, to do useful work in the analysis of paintings by penetrating materials that are opaque to the eye. A further example of this is shown in Figs A.4(a) and (b). In Fig. A.4(a) we see an infrared photograph of an old map (Fareham, *c.* 1826) printed on to varnished wood. A conventional photograph (Fig. A.4(b)), however, shows exactly what is seen by the human eye – nothing except stained wood!

HIGH-SPEED AND TIME-LAPSE PHOTOGRAPHY

Examples of high-speed photography are shown in Figs 5.1(b) and 5.4, where it can be seen that very short duration flash exposures can capture events that are too fast for the human eye to follow. These techniques also include high-speed cinematography with phenomenal rates of pictures up to 25 000 000 frames per second (although you only get a few frames at framing speeds as high as this!), which, when projected at normal rates, slow down the recorded event many times so as to allow scientists and engineers an opportunity to analyse that which they cannot normally see. As an example, a machine part may be photographed at a rate of 24 000 fps (frames per second), but when projected at the normal rate (24 fps) the fast moving action is slowed down 1000 times! Typical applications of this kind of photography include human motion studies (sports and medical), engineering, aerodynamics (with special optical systems to illustrate air-flow), explosions, etc.

At the other end of the timescale, there is time-lapse photography. No doubt most of us have seen the beautiful films of flowers growing from the bud, or changing cloud patterns. Here, time is speeded up on projection. A series of photographs of a growing plant bud, taken with a ciné camera at, say, one picture every half hour for a few weeks, will show a speeded-up version of the plant's growth when projected. Such methods are very useful when used over a microscope, for example, to look at the growth of micro-organisms.

LASERS AND HOLOGRAPHY

Lasers have been used in scientific photography for the past 30 years or more, not only because of their unique optical properties which allow for ultra-high-speed discharges of great energy (ruby lasers) and very narrow beams (useful as trigger devices for high-speed flash), but mainly because of their *coherence*. Normal light sources do not give a uniform single wavelength of light that stays coherent (with all the waves in step) for long, but lasers can, and as a result they are able to form three-dimensional images known as holograms. The hologram is now an art form and many exhibitions are promoted each year in this field.

Fig. A.3 The Roofs of Iceland. Photos: Virginia Bolton.
An example of a strong theme within a photo-series, where the photographer has made use of highly-saturated colours and their contrasts, enhanced by blue sky brought about by a polarising filter. The theme is carried through by conscious use of viewpoint, and the resulting series could be used as editorial illustration, photo-library stock or extended to form an exhibition.

Fig. A.4(a) Infrared photograph. Photo: P. S. Jones.

Fig. A.4(b) Panchromatic photograph. Photo: P. S. Jones.

These days, scientific photography is usually the domain of scientists and technicians rather than photographers, but in many industries the subject is still very much in the hands of scientific photographers who run specialist departments in various scientific and engineering laboratories. Training in photographic sciences is given in various colleges and polytechnics within the UK, leading to a BSc (Hons) degree in at least one institution (Polytechnic of Central London).

EXPRESSIVE PHOTOGRAPHY AND FREELANCE WORK

While professional photographers working in a commercial field or in the area of photojournalism will always express something of themselves through their work, they are nonetheless bound by contracts, working briefs, deadlines and editorial controls which will undoubtedly have a marked effect on the final appearance of their work.

But what are the creative units for the individual who seeks only to produce images as a reflection of inner emotions, attitudes and responses to the environment? While the talented artist can draw many ideas and concepts together on to canvas, a photographer with the same artistic inclination must use the realities of the world as his or her creative material. The visual awareness of the creative photographer must be acute and he or she must be able to organise material well to form an image that aptly communicates all that was intended. If the bounds of realism are to be broken, image-derivation techniques can be employed; a surreal result can be created through use of montage, high-contrast materials, Sabattier effect or hand-colouring, to name but a few methods.

The subject matter for photography is as varied as the photographers taking the pictures, in the same way that any subject can be approached in a number of ways. If, however, the images are required to be a complete body of work, then a strong theme should be adopted. A 'series' of related images can suggest a stronger direction and make the communication between photographer and viewer sharper (see Fig. A.3).

Even if the aim is merely to produce a collection of varied images of aesthetic appeal, the way in which these are used should be considered.

Photographic work may be compiled in a portfolio or for exhibition in a gallery or local library. The decision really depends upon what audience is intended and what facilities are available. A thematic series can be appropriate in an exhibition context, while a collection of successful but unconnected images may be sold to collectors, magazines or photo-agencies. The latter usually buy photographs in quantity from the independent or freelance photographer and pay out royalties when an image is used. The amount of money paid depends on the

context in which the photograph is used, e.g. national paper or local advertisement, and on the prestige of the photographer or photograph.

If photographers do not intend to make a living from their work but only to use the medium as a means of creative expression, there are many groups of similarly minded independent photographers or camera clubs. The former are usually small groups of individuals who encourage each other, perhaps with the aim of exhibiting photographs on a given theme. The latter tend to involve a much wider membership with different interests; these camera clubs organise regular competitions, lectures and demonstrations to inform and encourage their members.

We may conclude from this that photography is an extremely diverse medium – offering both creative potential for the individual and a wealth of career opportunities in many fields. At the same time, however, as 'viewers' as well as 'photographers' we must remain aware of the importance of the medium within society as a means of recording, exploring and informing the world as a whole.

Appendix B – Developer Formulae

D-76: THE 'STANDARD' FINE-GRAIN DEVELOPER SUITABLE FOR ALL FILMS

Stock Solution:
Metol (reducing agent):	2 g
Sodium sulphite (anhydrous preservative):	100 g
Hydroquinone (reducing agent):	5 g
Borax (alkali:accelerator):	2 g
Water to make up to:	1 litre

Working Solution: Dilute with water 1 + 1
Typical development times at 20°C:
Ilford FP4 (125 ISO): 9 minutes
Ilford HP5 (400 ISO): 12 minutes

D-163: A STANDARD PRINTING PAPER DEVELOPER SUITABLE FOR ALL PAPERS

Stock Solution:
Metol (reducing agent):	2.2 g
Sodium sulphite (anhyd preservative):	75.0 g
Hydroquinone (reducing agent):	17.0 g
Sodium carbonate (anhyd alkali: accelerator):	65.0 g
Potassium bromide (restrainer):	2.8 g
Water to make up to:	1 litre

Working Solution: Dilute with water 1 + 3
Typical development time at 20°C: 2–3 minutes

LITH DEVELOPER (AN-79b): FOR DEVELOPING LITHOGRAPHIC FILM

The stock solution is in two parts since this highly active developer will oxidise within a few minutes of being mixed together. The working solution should be discarded as soon as it has been used, or when it oxidises to a dirty brown solution – whichever is the sooner.

Stock Solution A:
Sodium sulphite (anhyd):	1 g
Paraformaldehyde:	30 g
Potassium metabisulphate:	10.5 g
Water to make up to:	1 litre

Stock Solution B:
Sodium sulphite (anhyd):	120 g
Boric acid (crystals):	30 g
Hydroquinone:	90 g
Potassium bromide:	6 g
Water to make up to:	3 litres

Working Solution: 1 part A and 3 parts B
Development time: 2 minutes at 20°C

Appendix C – Rapid Fixing Solution

The following formula provides a rapid fixing bath suitable for both films and papers.

Ammonium thiosulphate:	175 g
Sodium sulphite (anhyd):	25 g
Glacial acetic acid:	10 ml
Boric acid (crystals):	10 g
Water to make up to:	1 litre

Fixing times: 30 to 90 seconds for films
30 to 60 seconds for papers

Note: Always take care to ensure that this bath is not worked beyond its capacity. At the first sign of yellowish staining on prints, renew the solution.

Appendix D – Farmers Reducer

Solution A:
 Potassium ferricyanide: 100 g
 Water to make: 1 litre

Solution B:
 Sodium thiosulphate (crystal): 200 g
 Water to make: 1 litre

Working solution: 10 ml of A to 200 ml of B. Use immediately after mixing. The rate of reaction is controlled by varying the amount of Solution A in the mixture.

Appendix E – Conversion of Units Metric to UK Imperial

Length and Area

Millimetres (mm) to inches: multiply mm by 0.039
Inches to millimetres (mm): multiply inches by 25.4
Metres (m) to feet (ft): multiply metres by 3.28
Feet (ft) to metres (m): multiply feet by 0.305

Square metres (m^2) to sq ft (ft^2): multiply by 10.76
Square feet (ft^2) to sq m (m^2): multiply by 0.093

Volume and Weight

Millilitres (ml) to fluid
 ounces (fl oz): multiply by 0.035
Fluid ounces (fl oz) to
 millilitres (ml): multiply by 28.4
Litres to fl oz: multiply by 35
Litres to gallons: multiply by 0.22
Gallons to litres: multiply by 4.55

Grams (g) to ounces (oz): multiply by 0.035
Ounces (oz) to grams (g): multiply by 28.35
Kilograms (kg) to pounds (lb): multiply by 2.2
Pounds (lb) to kilograms (kg): multiply by 0.454

Temperature scales

°Celsius (centigrade)
 to °Fahrenheit: multiply by 1.8 then add 32
°Fahrenheit to °Celsius: subtract 32 then multiply by 0.56

Index